Other Publications:

The Time-Life Library of Boating
Human Behavior
The Art of Sewing
The Old West
The Emergence of Man
The American Wilderness
The Time-Life Encyclopedia of Gardening
Life Library of Photography
This Fabulous Century
Foods of the World
Time-Life Library of America
Time-Life Library of Art
Great Ages of Man
Life Science Library
The Life History of the United States
Time Reading Program
Life Nature Library
Life World Library
Family Library:
How Things Work in Your Home
The Time-Life Book of the Family Car
The Time-Life Family Legal Guide
The Time-Life Book of Family Finance

LIFE LIBRARY OF PHOTOGRAPHY

# Color

BY THE EDITORS OF TIME-LIFE BOOKS

TIME-LIFE BOOKS, NEW YORK

ON THE COVER: This transparency —shown resting on a black film holder —demonstrates the startling effects that color film, creatively used, can achieve. It was made by Japanese photographer Nob Fukuda, who drew a targetlike design on a piece of paper and colored in the concentric circles. He then lay the paper flat and suspended a piece of ribbed glass over it. The glass produced the effect of the three-dimensional slices that Fukuda caught with a view camera aimed straight down from above his subject. The film was Ektachrome, type B, and a studio floodlight provided illumination.

# Contents

How Color Film Works   **1**   9

The Search for a Color Process   **2**   51

Colors of the Day   **3**   77

Techniques of Color Photography   **4**   99

An Innovator in Color   **5**   129

Do-It-Yourself Color   **6**   167

Colors That Never Were   **7**   205

Appendix   233
Bibliography and Acknowledgments   235
Picture Credits   236
Index   237

## LIFE LIBRARY OF PHOTOGRAPHY

Editorial Staff for *Color:*
EDITOR: Robert G. Mason
*Text Editors:* Peter Chaitin, James Maxwell
*Designer:* Raymond Ripper
*Assistant Designer:* Herbert H. Quarmby
*Staff Writers:* Kathleen Brandes,
George Constable, John Paul Porter
*Picture Associates:*
Erik Amfitheatrof, Carole Kismaric
*Chief Researcher:* Peggy Bushong
*Researchers:* Sondra Albert, David Harrison,
Monica Horne, Gail Hansberry, Shirley Miller,
Don Nelson, Kathryn Ritchell
*Art Assistant:* Jean Held

Editorial Production
*Production Editor:* Douglas B. Graham
*Assistant Production Editors:*
Gennaro C. Esposito, Feliciano Madrid
*Quality Director:* Robert L. Young
*Assistant Quality Director:* James J. Cox
*Associate:* Serafino J. Cambareri
*Copy Staff:* Eleanore W. Karsten (chief),
Ruth Kelton, Barbara Quarmby, Florence Keith,
Pearl Sverdlin
*Picture Department:* Dolores A. Littles,
Catherine Ireys
*Traffic:* Carmen McLellan

*Portions of this book were written by Paul
Trachtman. Valuable assistance was given by the
following departments and individuals of Time
Inc.: Photographic Laboratory, George Karas and
Herbert Orth; Editorial Production, Norman Airey;
Library, Benjamin Lightman; Picture Collection,
Doris O'Neil; Photo Equipment Supervisor, Albert
Schneider; TIME-LIFE Photo Lab Color
Technicians Peter Christopoulos, Luke Conlon,
Henry Ehlbeck, Robert Hall; TIME-LIFE News
Service, Murray J. Gart; Correspondents Elisabeth
Kraemer (Bonn), Maria Vincenza Aloisi (Paris),
Margot Hapgood (London), Ann Natanson (Rome),
Mary Johnson (Stockholm); Revisions Staff,
Carolyn Tasker (Editor), Isabelle Rubin
(Assistant Editor).*

In 1935, after more than a century of experimentation in Europe and America, a fully practical color-photography process for mass use was at last announced. Before that year, the practice of color photography had been limited to a relative handful of professionals and dedicated amateurs. But in the decades since the 1935 film was first marketed, the popularity of color photography has soared to the point where more color than black-and-white film is now sold in the United States.

In part, this phenomenal growth is due to the simple fact that color adds an exciting dimension to almost every kind of subject from the family snapshot to the carefully conceived and executed still life. In addition, it stems from the increasing ease of shooting and processing color. But perhaps most important of all has been the public's growing awareness that photography in color is not just the process of making pictures in black and white to which hues have been added, but a challenging medium of expression.

In this volume the LIFE Library of Photography undertakes to examine the demands of color in all their various aspects in order to inform the reader how modern color film was invented, how it works and how he can take and process his own color pictures. And more: it attempts to show him the beauty that can be achieved with color. For color photography is a medium in which the only limit to creativity is the photographer's own imagination.

*The Editors*

## Capturing the Colors in Light 12

To Make Colors, Add or Subtract 14
For Slides, Reversal Images 16
For Prints, Negative Color 18
Matching Film to the Light Source 20
Filters to Balance Color 22
A Film for Every Taste 24

## Extra Dimensions of Color 26

Romantic Color 28
Sensuous Color 31
Proud Color 33
Restless Color 35

## The Colors of Time and Place 36

Early Yellow, Late Gold 38
Cold Spring, Rich Sunset 40

## Color for Color's Sake 42

The Delicacy of Natural Color 44
Color Found or Furnished 47
Abstracting Color 48

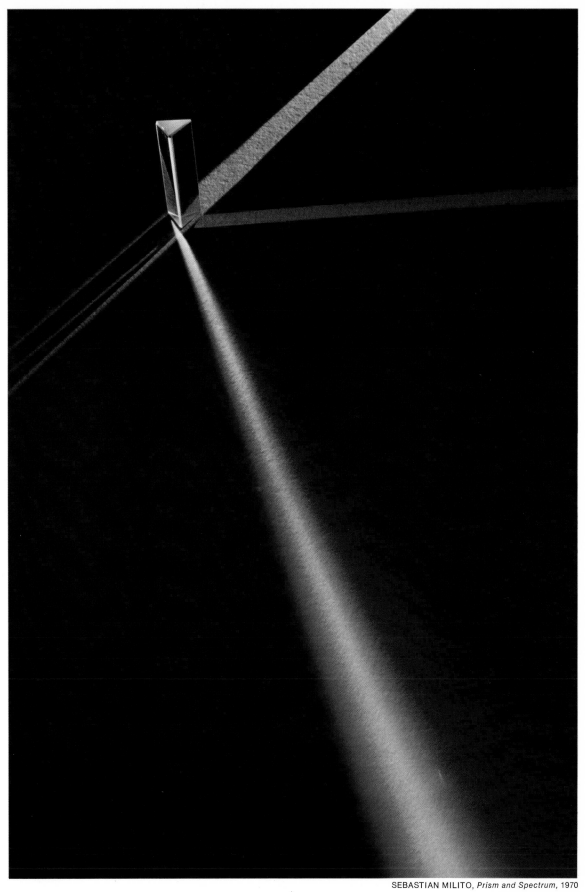

SEBASTIAN MILITO, *Prism and Spectrum,* 1970

# Capturing the Colors in Light

From the first Stone Age hunters who painted images on the walls of their caves to the first moon voyagers who turned their cameras back upon a swirling blue planet alight in the dark sea of space, men have always sought to capture the colors of the world. The colors they capture—whether in pigment on a cave wall or on film in a camera—are, strictly speaking, not the colors of the material object pictured, but of the insubstantial light by which the object is viewed. For all color is the color of light, and all light possesses color, whether men perceive it or not. The particular color associated with an object depends on what happens to light that strikes it.

That light is the source of color was first demonstrated in 1666 by the 23-year-old English genius Isaac Newton, who was simultaneously busy inventing calculus and devising equations for gravity. Newton passed a beam of sunlight through a glass prism, producing the rainbow array of hues of the visible spectrum. This phenomenon, demonstrated on page 11, had often been observed before, but it had always been related to latent color that was said to exist in the glass of the prism. Newton, however, took this simple experiment a step further. He passed his miniature rainbow through a second prism that reconstituted the original white beam of light. His conclusion was revolutionary: color is in the light, not in the glass, and the light men see as white is really a mixture of all the colors of the spectrum.

A prism separates the colors of light by bending each color to a different degree. More commonly, the colors of light are separated in other ways. When light strikes a surface, for instance, some of the colors may be absorbed; then the only colors we see are those the surface reflects. An eggshell, in the example at right, reflects all colors of light, and so the eye perceives it as white. But an apple (opposite) reflects mainly red light, and absorbs most other colors, so the apple, in our eyes, looks red. Things that transmit light—such as color slides—also absorb specific colors, allowing others to pass through. Whether we look at a color transparency of an apple, a color print of an apple, or the apple itself, it is the color of the light that reaches our eyes that makes the apple look red.

The blue of the sky is the result of another method of natural color separation. As sunlight passes through the atmosphere, the air molecules redirect, or scatter, the wavelengths of light at the blue end of the spectrum more than those at the red end. What we see as the sky is the blue light scattered out of the sun's rays. The reds of the sun itself at sunrise and sunset also result from scattering. When the sun is on the horizon, its direct rays pass through more of the atmosphere than when it is overhead. Over this extra distance, so many of the blues are scattered out of the direct rays of the sun that mainly reds are left to color the image of the sun that reaches us.

How the objects of the world—from atmospheric molecules to apples

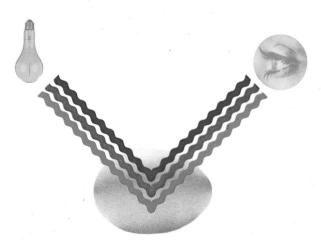

An eggshell looks white because it reflects all the hues, or wavelengths, of white light that reach it. The light supplied by an incandescent bulb includes wavelengths from all parts of the spectrum (reds, greens and blues), and this mixture, reaching the eye, appears white.

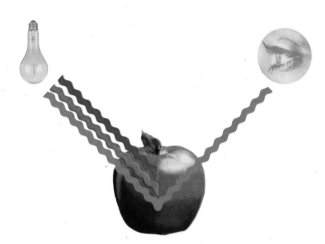

*An apple's skin appears red because it absorbs most of the light waves reaching it, but reflects those in the red part of the spectrum. As illustrated above, most of the green and blue wavelengths in the light from an incandescent bulb are absorbed and never reach the eye.*

—interact with light to separate its colors could not be fully understood before Einstein showed that matter and energy are, in effect, the same. Light is a form of electromagnetic radiation, which moves in waves rather similar to the ripples on a pond, except that light is vibrations of electric and magnetic forces. Described thus, light behaves as a form of energy. But whenever light interacts with matter—as when it is absorbed by a substance or emitted from a lamp—it behaves as a form of matter, composed of a stream of infinitesimal particles called photons.

The color properties of light depend on its behavior both as waves and as particles. Light is sometimes absorbed by an object, for example, because certain of its photons are captured by the molecules in the object. Different sorts of molecules capture photons of different colors. The chlorophyll in leaves captures photons of red light but not of green; the green photons bounce back out, providing the green light that gives the leaves their color.

For all practical purposes in photography, however, it is most convenient to consider light as waves rather than as photon particles. The lengths of these waves—the distance from wave crest to wave crest—determine their hues. The spectrum of colors we see ranges from reddish light, of relatively long wavelength, through a middle range of greens, to the blues of shorter wavelength. The difference between the shortest and the longest visible wavelengths is only .00012 of an inch, and within that small span are approximately 1,000 distinct hues. Ordinarily, however, "pure" colors of light composed of a single wavelength rarely reach our eyes. Most colors are mixtures of many wavelengths, and what we "see" as a color is the sensation that mixture produces in the human brain. The red light reflected from an apple, for example, consists mostly of wavelengths from the red region of the spectrum, but it also includes a certain portion of blue and green wavelengths (for simplicity these have been omitted from the drawing at left).

It would seem that each such complex mixture of wavelengths would have to be duplicated individually to reproduce the colors of an object in a picture. This was indeed attempted in the first color photographs *(Chapter 2),* and some success was achieved. But this direct recording of color has not proved practical. Modern methods of color photography take advantage of the fact, long known by painters, that nearly all the colors visible in light can be reproduced by mixing only a few basic colors. Color films are made with three color-sensitive layers, each of which records the wavelengths of light in a different third of the spectrum. Paradoxically, the initial recordings are not even in color; they are black-and-white representations of the three colors. From these three separate color impressions, all the colors of the subject photographed can be mixed during processing of the film—and the result provides light in colors that seem to duplicate the original.

# To Make Colors, Add or Subtract

Photographically, there are two basic ways to create colors that will match those of the world's visible objects. One method, called additive, starts with a few lights of distinct colors and adds them together to produce some other color. The second method, called subtractive, starts with white light (a mixture of all colors in the spectrum) and, by taking away some colors, leaves the one desired.

In additive mixing, as illustrated at right, the basic colors, or primaries, generally used are red, green and blue lights (each providing about one third of the wavelengths in the total spectrum). Mixed in varying proportions they give nearly all colors—and the sum of all three primaries is white. In the subtractive method, illustrated opposite, the primaries are the pigments or dyes that absorb red, green and blue wavelengths, thus subtracting them from white light. These dye colors are cyan (a bluish green), magenta (a purplish pink) and yellow—the "complementary" colors to the three additive primaries. Properly combined, the subtractive primaries can absorb all colors of light, producing black. But, mixed in varying proportions, they too can produce nearly any color in the spectrum.

Whether a particular color is obtained by adding colored lights together or by subtracting some light from the total spectrum, the result is usually the same mixture of wavelengths and will look the same to the eye. The additive process was employed for early color photography. But the subtractive method, while requiring complex chemical techniques, has turned out to be more practical in use and is the basis of all modern color films.

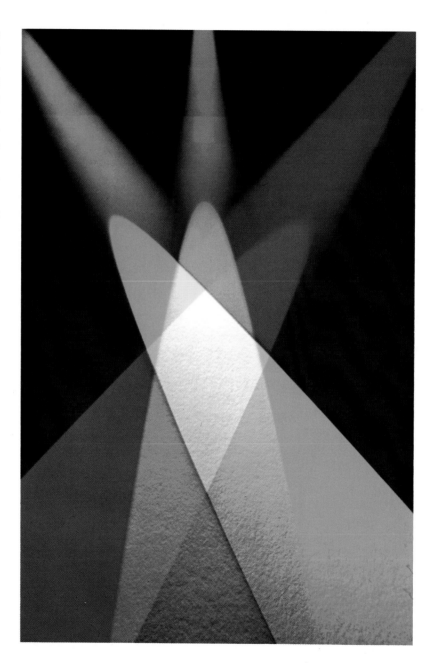

*Separate colored lights combine to produce various other colors in the additive method—a mixture of the red plus the green giving yellow, for example. When all three of these primary-colored beams of red, green and blue light overlap, the mixture appears white to the eye.*

**cyan filter blocks red**

**magenta filter blocks green**

**yellow filter blocks blue**

*The subtractive process works by taking some colors away from white light and permitting the remainder to come through. The three disks above are yellow, cyan and magenta filters. Superimposed in pairs over a source of white light, they pass red, green and blue. Where all three overlap, all wavelengths are blocked, producing black. As shown at right, each subtractive filter transmits two thirds of the spectrum and blocks one third. For example, a cyan filter (top right) transmits both green and blue wavelengths but blocks red.*

# For Slides, Reversal Images

Color photographs begin as black-and-white negatives. Color film consists of three layers of emulsion, each layer basically the same as in black-and-white film, but sensitive only to one third of the spectrum (blues, greens or reds). Thus, when colored light exposes this film, the result is a multilayered black-and-white negative.

To make color transparencies, color is produced as shown graphically at right. After the negative images are developed, the undeveloped emulsion remaining provides positive images by "reversal." The remaining emulsion is exposed (chemically or with light) and the film developed a second time with a different developer. As it converts the light-sensitive silver compounds to metallic silver, the developer becomes oxidized and combines with "coupler" compounds to produce dyes. The three dyes formed, one in each emulsion layer, are the subtractive primaries yellow, magenta and cyan. All the silver is then bleached out and each layer is left with a positive color image.

Thus reds in the subject produce a heavy silver deposit in the red-sensitive layer in the negative—but no trace on the other layers. In the positive, reversal has produced no image in the red-sensitive layer, but a yellow image and a magenta image in the other two layers. When white light shines through the transparency, the red wavelengths pass through all three layers, but blues and greens are absorbed by the yellow and magenta images. Thus the transparency produces the image of one color by subtracting the other colors from white light. Similarly, the superimposed subtractive primaries reproduce all the colors of the original subject.

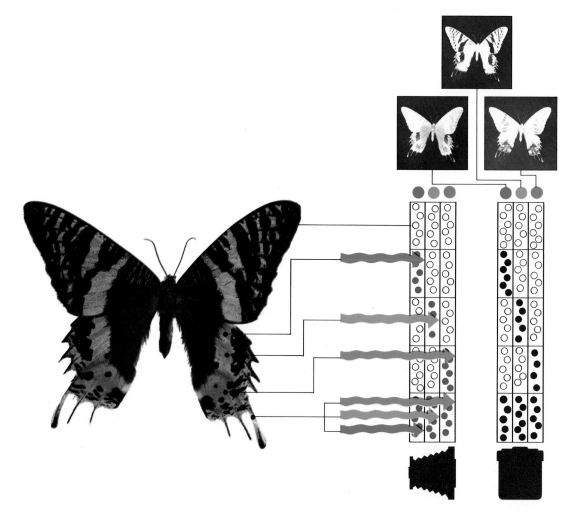

Colored light reflected by a moth is recorded on color-reversal film as three superimposed black-and-white images in three layers of emulsion, each sensitive to blue, green or red light (as indicated by color dots atop the film cross sections). In the exposed film (camera symbol) light of each color produces an invisible latent image, shown by gray dots, on the emulsion layer sensitive to it. Where the moth is black, no emulsion is exposed; where the moth is white, all three layers are exposed equally. During the first development of the film (tank symbol) each latent image is converted into a metallic silver negative image (black dots). Thus, three separate negative images (top) indicate by the density of the silver they contain the amount of each primary color in the moth.

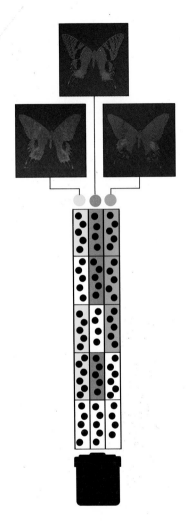

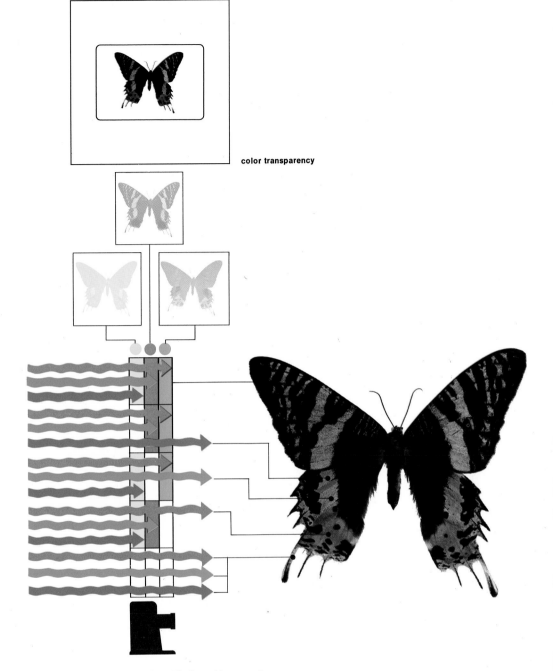

color transparency

Positive color images are created in the exposed film by the reversal process. The emulsion is exposed a second time, either by a flash of light or by means of a chemical agent that serves the same purpose. Silver which has not been previously deposited in the negative images can now be deposited by a second development to form black-and-white positive images (black dots) in the emulsion. As in the first development, the developer is oxidized as it converts the newly exposed silver compounds to metallic silver. The oxidized developer then combines with chemical couplers to produce dyes, forming three positive color images combined with the metallic silver positive images (top). In each layer the dye produced is the complement of the color of the light that was recorded there—yellow dye is formed in the blue-sensitive layer, magenta in the green-sensitive layer and cyan in the red-sensitive layer, as indicated by the color spots above the film cross section.

A color transparency is produced by bleaching out all silver in the emulsion, which leaves only the positive color images in each layer (top). When a beam of white light (projector symbol) is projected through these superimposed color images, each of the colors of the moth is reproduced by the subtraction of the other colors from white light. To reproduce the blue of the moth, for example, magenta and cyan dye images have been formed, but no yellow image has been formed. The greens and reds of the projector's white light have been subtracted by the magenta and cyan dyes, leaving blue. Similarly, varying mixtures of dyes in the transparency produce the whole range of colors of the moth. Black is produced where all the colors of white light are subtracted, white where no color is subtracted by a dye.

17

# For Prints, Negative Color

The film that is used to make paper prints in full color works in essentially the same way as reversal film, but with one important exception: it is processed into a negative of the subject —that is, light areas show as dark areas, and colors appear as their complementary hues.

The negative color results because the dyes are formed during the first, rather than a second, development. After exposure, each emulsion layer is developed into a black-and-white negative. The oxidized developer and couplers then react to form a dye. Once the silver is bleached out, the three emulsion layers contain superimposed yellow, magenta and cyan images, each a complement (and a negative) of the original blues, greens and reds.

When white light is passed through this color negative, the layers of subtractive primaries absorb all the original colors of the image and transmit their complements. Where there was a red spot on the original, for example, red light is absorbed by its cyan image on the negative, while a spot of green and blue light is transmitted. Similarly, blues and greens in the original appear as their complements, yellow and magenta, in the negative image.

A color positive can be made by printing the color negative image on a three-layered emulsion like that of the original film (except that it is paper-backed). Once again, colors exposing the emulsion are recorded by complementary dyes, laid down with the silver that forms a black-and-white negative. When the silver is bleached out, a cyan spot of light has been recorded as yellow and magenta spots. This gives the red that was in the original.

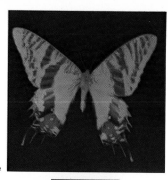

color negative

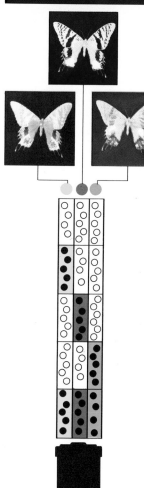

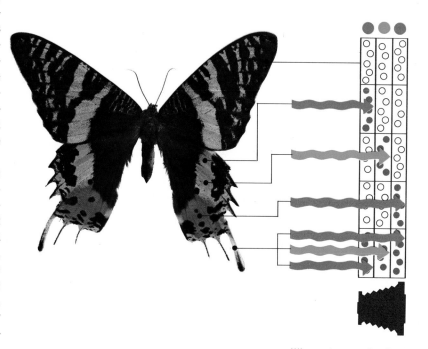

When color negative film is exposed, the blue-, green- and red-sensitive layers of emulsion (color spots) record latent images (gray dots) that can be developed into black-and-white negatives, just as with reversal film. Blue light, for example, is recorded in the blue-sensitive layer, but leaves no impression in the other two. Colors that are mixtures of the primaries are recorded on several layers. Blacks do not expose any of the emulsion, while white light is recorded in all layers. Each color thus leaves a corresponding negative black-and-white impression on the emulsion.

When exposed color negative film is developed, a black-and-white negative image is produced in each emulsion layer (black dots). During this development, a colored dye is combined with each black-and-white negative image. The dyes are cyan, magenta and yellow—the complements of red, green and blue. Once the silver is bleached out, the three layers (colored dots) show the subject in superimposed negative dye images. The color negative has an overall orange color or "mask," (top) to compensate for distortions that would otherwise occur in printing.

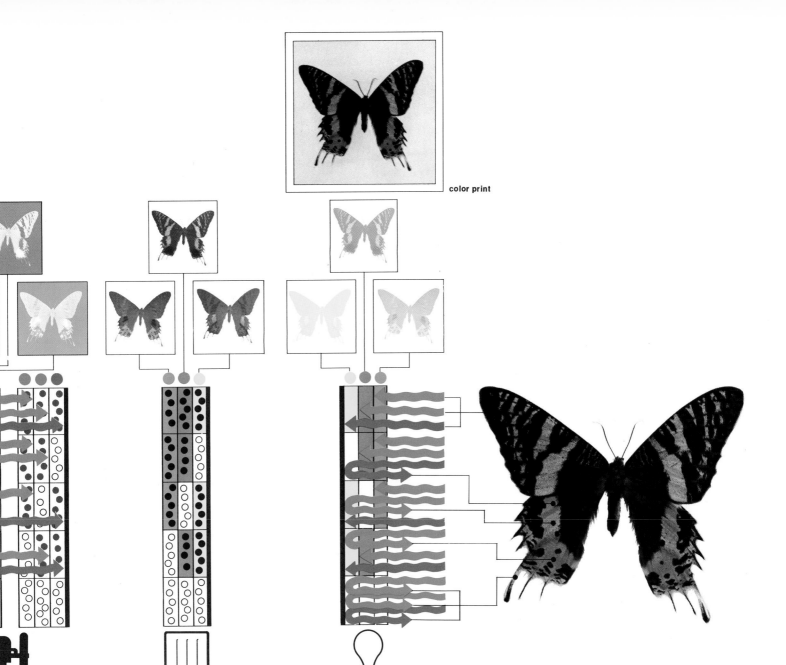

**color print**

After all silver has been bleached away, three dye images —negatives of the moth's colors —remain (top). This negative color image is then printed (enlarger symbol) on paper with three emulsion layers (coded by color spots atop the paper cross section), like those in film. Where there is a clear area in all negative layers white light creates a latent image (gray dots) in each layer of print emulsion. But where the negative has a yellow dye image, for example, only red and green light passes, exposing only the red- and green-sensitive layers in the print emulsion.

The print is developed (tray symbol) by a process much like that used for the negative. Each layer of the exposed emulsion (color spots) develops into a black-and-white silver image—a positive image—corresponding to one third of the spectrum. As the silver is deposited, dyes are formed—for example, magenta and cyan in the layers affected wherever green and red light passed through the negative. The result is three positive images —each consisting of dye plus silver—as shown above. The silver is then bleached out, leaving the color images.

The colors that appear in a color print are those reflected back to the eye from the white light (lamp symbol) falling on the print (which above faces the opposite way from the preceding diagram). A blue spot in the moth, for example, looks blue in the print because cyan and magenta dyes in the emulsion layers absorb red and green wavelengths from the incident white light, and only blue lengths are reflected. The full colors of the print (top) are a product of the colors subtracted from white light by the three superimposed dye images, shown separately just above the diagram.

# Matching Film to the Light Source

Color films sometimes record colors that the photographer did not see. When this happens, the picture may look wrong, but this is not the fault of the film. The colors of the world are recorded by the brain, which remembers the way things ought to look and automatically compensates for some changes in color. Although a white shirt looks white both outdoors in daylight and indoors in artificial light, light from incandescent bulbs has more red wavelengths and fewer blue wavelengths than daylight; thus the white shirt reflects more red light indoors than outdoors. In consequence, it acquires a yellowish cast. Color film records such subtle differences. Therefore, color emulsions are formulated to balance colors in an image as we would see them, not as the balance of wavelengths in the light itself would dictate.

The balance of colors in light is measured by a quality known as color temperature. Temperature serves as a gauge because the spectrum of wavelengths emitted by an incandescent light source varies as it heats up; the temperature of the source, in addition to its composition, determines what colors of light are emitted. At the same temperature, for example, a glowing carbon bar and a tungsten filament give off a similar range of wavelengths. The temperature reading is measured on the Kelvin scale commonly used by physicists, and serves as a standard comparative measure of wavelengths present in the light we see.

Each color film is designed for use with light of a particular color temperature, with the sensitivities of its emulsion layers adjusted to reproduce colors the way we expect them to look.

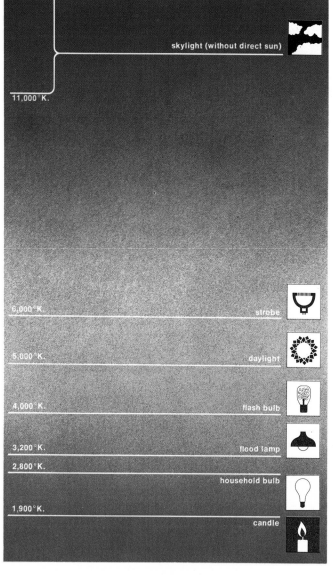

*The color temperature chart above indicates the approximate color temperatures of "white" light sources a photographer may encounter. Light of low color temperature has more red wavelengths; light of high color temperature has more blue in it. Noon daylight, which is evenly balanced, has a color temperature of about 5500°K. Unless a color film is chosen to match the color temperature of the illumination, the resulting picture will have an unnatural color cast. It will be either too red or too blue.*

skylight (without direct sun)

11,000°K.

6,000°K.          strobe

5,000°K.          daylight

4,000°K.          flash bulb

3,200°K.          flood lamp

2,800°K.

household bulb

1,900°K.

candle

*The pictures opposite illustrate how color film ▶ formulated for different conditions of light-color balance—or color temperature—records different colors when exposed in the same light. The top pictures were all taken in daylight (color temperature 5500°K.). Photographed with daylight film (left), the colors of the bus look normal. When shot with indoor (tungsten) film formulated for 3200°K. (center), the bus takes on a heavy bluish cast. If a corrective 85B filter is used, however, indoor film can produce normal colors from outdoor light (right). The bottom row of pictures were all taken indoors in 3200°K. light. The bride looks normal when photographed with indoor film (left), but daylight film in the same light produces a yellowish cast (center). But a corrective 80A filter can produce a near normal color rendition even when daylight film (right) is used to record the illumination from an incandescent bulb.*

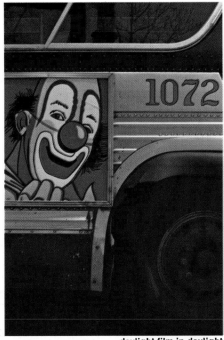

daylight film in daylight

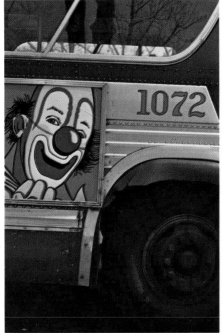

tungsten film in daylight

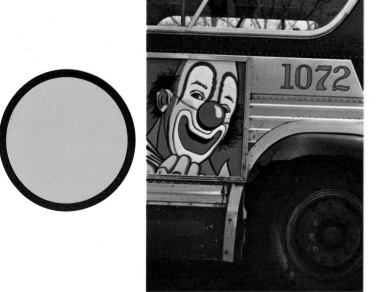

tungsten film with 85B filter

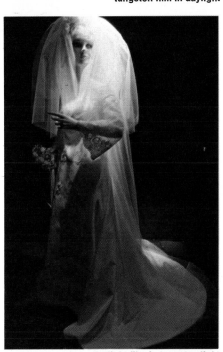

tungsten film in tungsten light

daylight film in tungsten light

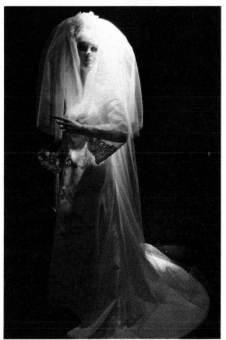

daylight film with 80A filter

# Filters to Balance Color

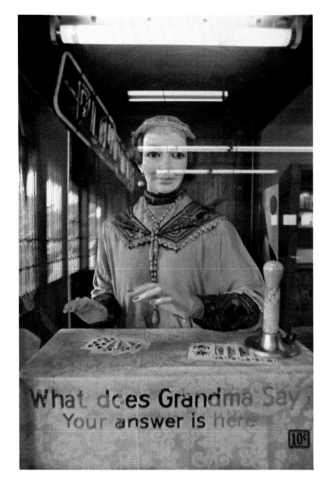

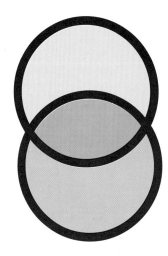

*When a penny arcade fortunetelling machine under fluorescent light is photographed with daylight film (left), it takes on a greenish cast, produced by the predominance of green wavelengths in fluorescent light. But a combination of two very pale filters—a 5M, which absorbs greens, and a 20B, which absorbs reds and greens—alters the light exposing the film so that the color image will look normal, the way the brain expects it to.*

The various types of color film are balanced to match the color temperatures of only a few common light sources —daylight and two popular types of incandescent lamps. Any other lighting conditions give color that may appear inaccurate unless filters compensate for the imbalance.

Such imbalancing light colors are far from rare. They are found late in the day, when the light is reddish (low color temperature) because of the low-lying sun. They appear in outdoor scenes in shadows, which get no direct sunlight but are illuminated only by the scattered, high-color-temperature blue.

In a picture of a field of snow having a dark shadow, for example, the shadow area will be illuminated mainly by clear blue skylight, and the shadowed snow comes out blue when photographed with ordinary daylight film. A pale "skylight" filter, designed to block some of the sky's light, would reduce the bluish cast of the shadows as the film records it. Actually, very careful ex-amination of a snowfield under such conditions will disclose the bluish cast in the shadows—but, ordinarily, the brain adapts what the eye sees to what it expects the snow to look like.

A similar problem is posed when a light source does not emit a smooth distribution of colors across the spectrum, but gives off concentrations of one or a few colors. Fluorescent lights are examples of this kind of "discontinuous" spectrum, having, in addition to other colors, especially large amounts

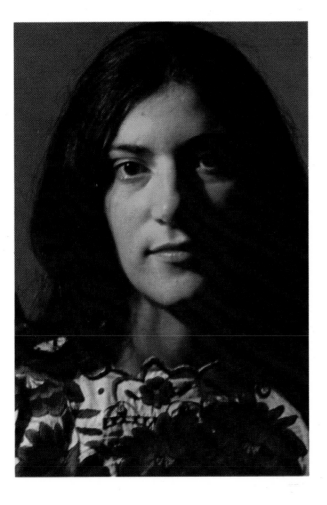

The portrait of a young woman illuminated by a dim incandescent bulb has a reddish tinge when photographed with tungsten film (left), because low-wattage lamps produce light of low color temperature. In this instance, an 80A filter compensates for the predominance of red in low-color-temperature light, and the same film gives an image (right) that appears normal.

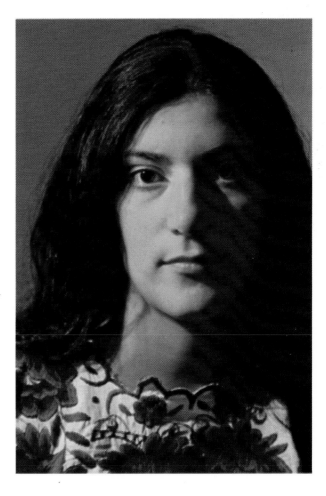

of blues and greens. Although the eye compensates for such uneven distribution, photographic emulsions cannot, and there are no color films that can record such light as the eye sees it.

The examples on these pages illustrate the inability of films to balance the colors in light from fluorescent and dim incandescent lamps. In each case, a corrective filter adjusts the light so that the image produced matches what the eye would see.

To take photographs with good col-or rendition, it is necessary to know the color temperature of the illumination and to match the film and filters to that temperature. A chart of the temperatures of common light sources appears on page 20. Detailed information for matching film and filters to the illumination is supplied by the film manufacturers. Most photoflash and floodlights are marked with their color temperature. Color-temperature meters are also available to help gauge unusual lighting conditions.

# A Film for Every Taste

**slow color reversal films, ASA 25**

**medium-speed color reversal films, ASA 50-64**

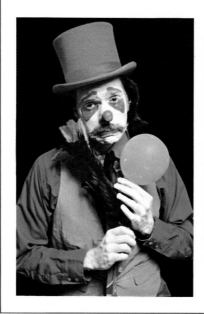 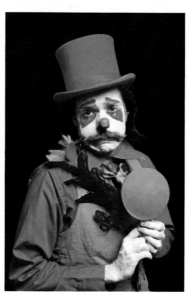

*The array of color films available to a photographer is impressive, and his choice of brand and speed-rating ultimately depends on what values of color he prefers in a transparency or print. On these pages, the same subject, under the same lighting conditions, was photographed by the same photographer, using 12 different emulsions. Careful inspection will show that every picture differs in some respects from every other. The reproductions of transparencies, made with color reversal films, are grouped by speed. Faster films offer some obvious advantages, but there are also some sacrifices in color values as the speed goes up. Generally, in faster films, the color is grainier, less saturated, and shows less contrast. But even within the same speed groupings, each film produces a different color image. There are striking differences in the yellows of the clown's balloon, the reds of his hat, and the hues of his hair—which, remarkably, range from reddish brown to blue. Prints from color negative films (far right) may show differences in color rendition due to printing process variations—but the negative can always be reprinted and the colors of the picture adjusted.*

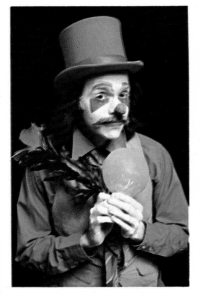

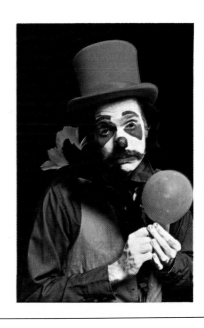

# Extra Dimensions of Color

The single physical dimension of color paradoxically becomes many dimensions in a photograph, multiplying a picture's impact in several different ways. Color adds to a photograph's esthetic appeal. But less obviously, it also adds to a picture's meaning. Color can set a scene in time—of day, of year, even of period. (For how to take color pictures at various times of day, see Chapter 3.) It can mark a place, indicating the kind of locale that appeared before the camera. And it can add to what pictures tell about people, identifying them and illuminating not only their ideas but also their emotions.

Color discloses time because colors change with time. The color of the light illuminating a scene alters as the day progresses from sunrise to sunset and as the year goes from season to season. And even intrinsic colors of the objects in a picture may vary. Foliage goes through changes that can be captured only on color film: not just such obvious color variations as those of autumn leaves, but the subtle nuances in shading that can be seen as blades of grass progress from April's newest, lightest green to June's lush green,

then to August's drier yellowish green and November's autumn brown.

In pictures of people, color becomes a badge that identifies the wearer and establishes him as a specific person in a particular context—and sometimes it even reveals what he is doing at the moment. The team colors of a young athlete's uniform *(page 32)* are such a badge. So too are the personal designs New Guinea natives at right have painted on their faces.

In creative hands, color can bring out subtleties of personality and complex emotions. Marie Cosindas uses color to create an atmosphere of nostalgia around the people she photographs *(pages 28-29)*. LIFE photographer Gordon Parks gives proof in the picture on pages 34-35 that colors in the right combination can evoke such an abstract human response as restlessness.

And for many great pictures, color provides even more than extra meaning by adding beauty. Color is its own justification. It *makes* the picture in views of glowing sunsets, blue eyes, wild flowers, painted deserts, azure oceans —and even the red-and-yellow-daubed natives of New Guinea.

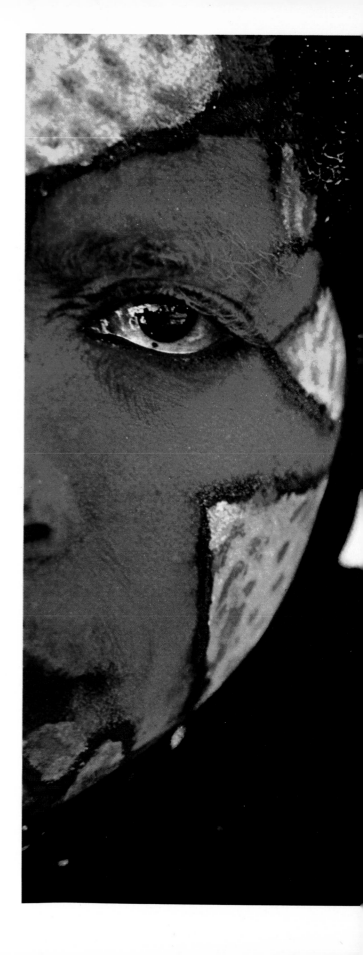

*Vividly painted faces of two women were photographed by Pete Turner at a celebration in the highlands of North-East New Guinea. The colors and designs were until recently traditional, identifying the tribe, but their original purpose has been forgotten and they are now created to suit individual tastes. To keep the colors strong and evenly lighted, Turner posed his subjects in the shade, with only tropical sunlight showing between them.*

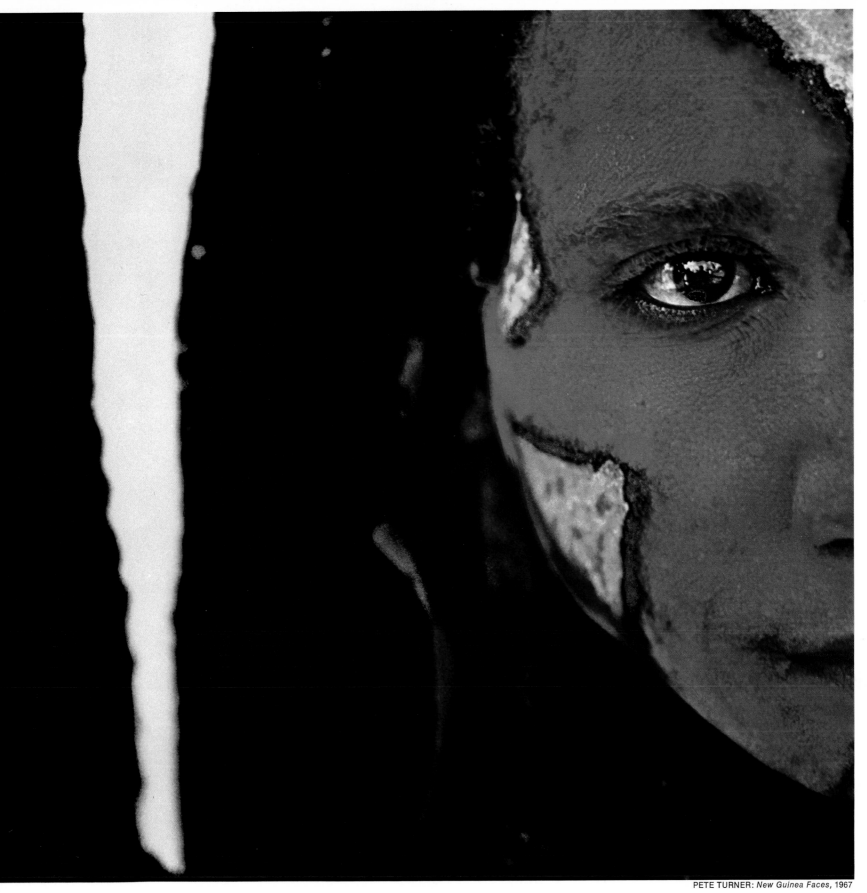

PETE TURNER: *New Guinea Faces*, 1967

# Romantic Color

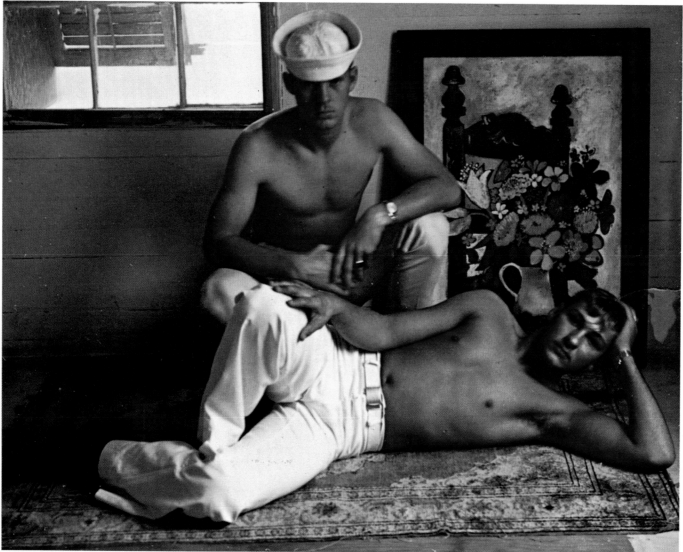

MARIE COSINDAS: *Sailors, Key West, 1966*

*Marie Cosindas met these two sailors by chance while traveling in Key West, and by the special genius she has shown in using Polacolor film, placed them in a scene that suggested a romantic novel of the '20s. The effect she creates comes partly from muted colors and is caused partly by subdued light, often by long exposure times (as much as 10 seconds) and by extended developing time (as much as 90 seconds, instead of the regular 60 seconds).*

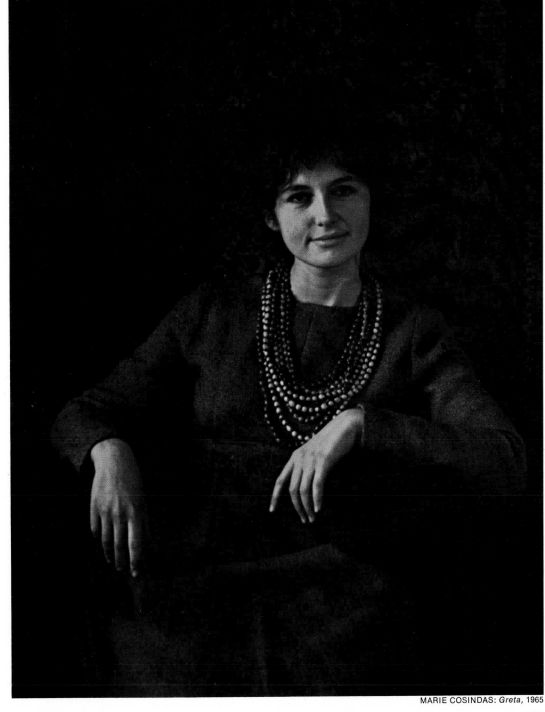

*Softened color surrounds Miss Cosindas' friend Greta Hale with the romantic aura of a bygone time, giving this affectionate portrait the look of a faintly old-fashioned painting. The prolonged exposure and development technique employed by Miss Cosindas makes the most of the limpid, rich tones that Polacolor film provides. She feels that the colors give a sense of quiet and of timelessness—and adds that with this film "I have a darkroom in the palm of my hand."*

MARIE COSINDAS: *Greta,* 1965

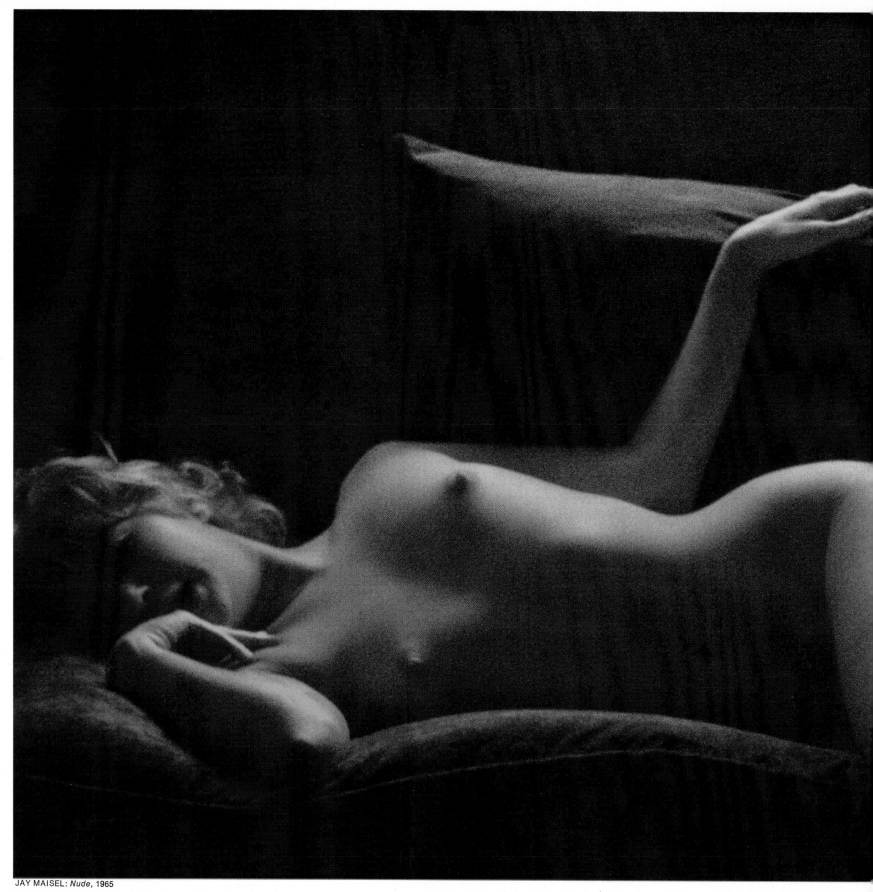

JAY MAISEL: *Nude,* 1965

*Jay Maisel's picture of a model shows how color
can mold the contours of the human form and
convey a sense of the soft texture of skin. Low-key
background colors and low-level lighting
contribute to the sensuous intimacy of the scene.*

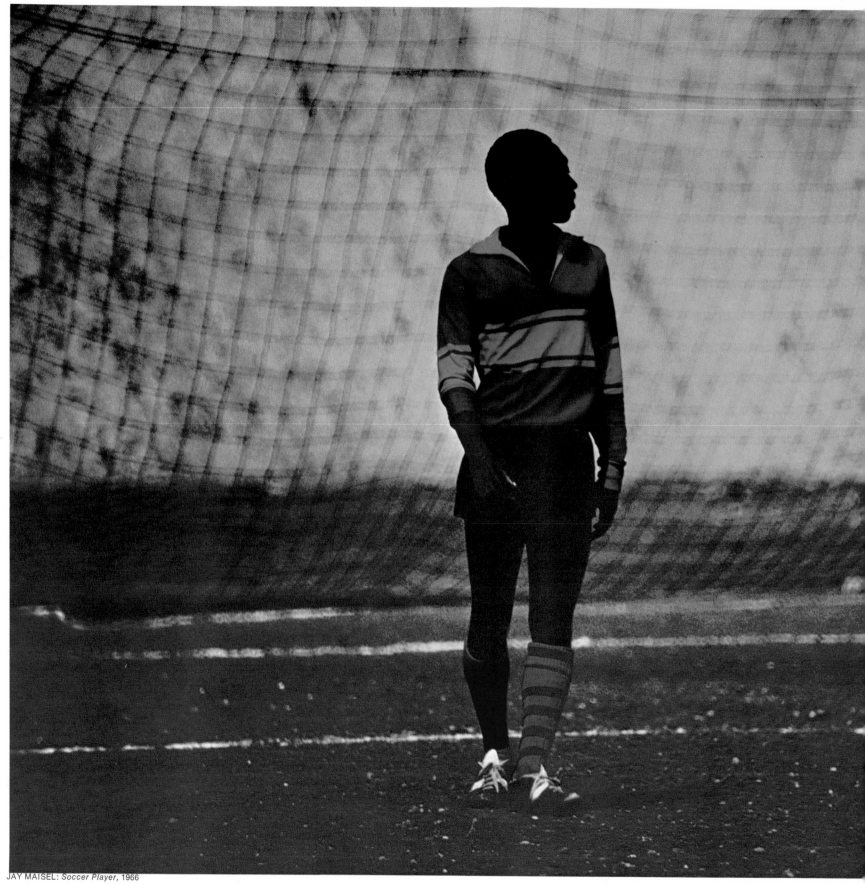

JAY MAISEL: *Soccer Player,* 1966

32

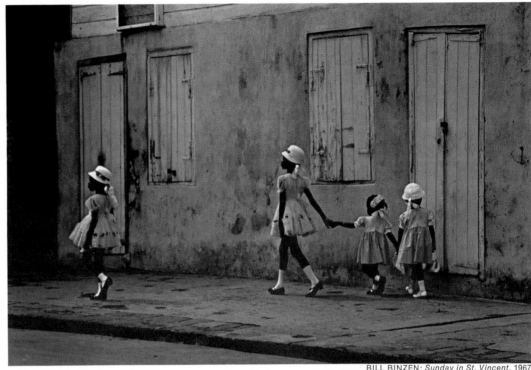

BILL BINZEN: *Sunday in St. Vincent, 1967*

*Four little girls, gaily flaunting the pink of their Sunday dresses, make their way to church in St. Vincent in the remote Windward Islands of the Caribbean. They caught the eye of photographer Bill Binzen, who saw in the fresh pastel colors a subtle sign of the naturalness of a people and an island still little affected by the outside world.*

*Bold stripes of color in this soccer player's uniform are a proud badge of identification for his team in Dakar, Senegal. The colors, seeming to vibrate against the dark field and the yellowish light filtering through the goal cage, draw the eye directly to the figure in the center of the picture and add an intensity, believes photographer Jay Maisel, that the scene could not have attained in black and white.*

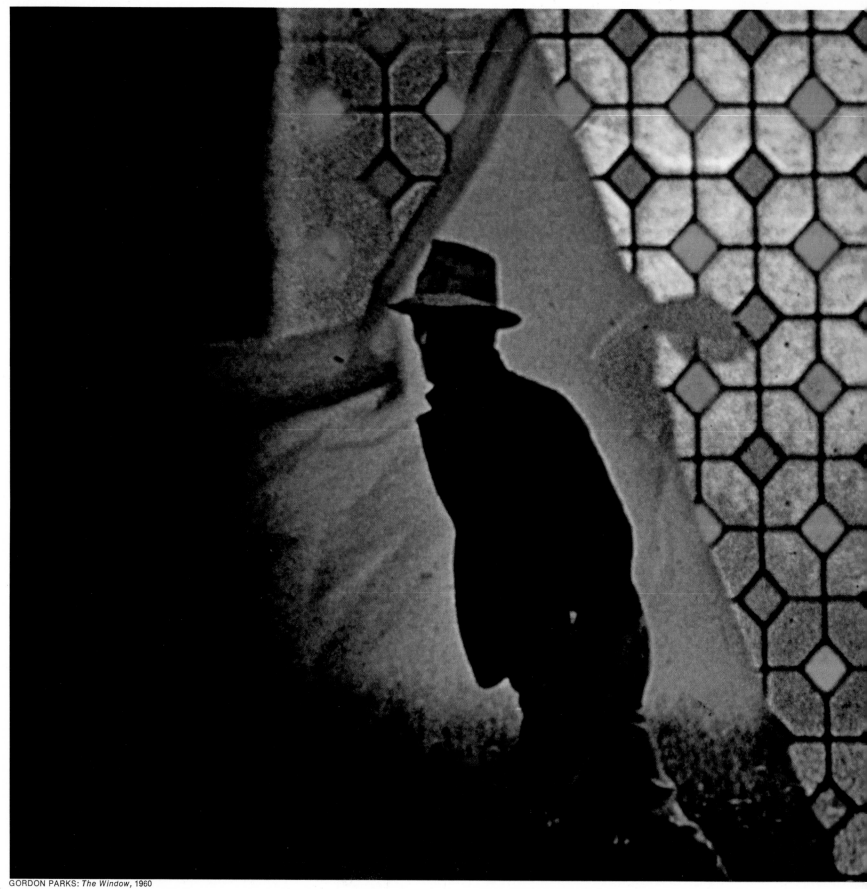

GORDON PARKS: *The Window,* 1960

This picture, taken to illustrate Robert Frost's poem "Reluctance," about man's quest for a meaningful life, deliberately uses jarring colors to reflect the poem's mood of restlessness. The colors come from a shattered stained-glass window and a garishly painted wall that LIFE photographer Gordon Parks found on a movie set. He then arranged the hunched, shadowy figure, hurrying by outside the jagged window, to symbolize part of the poem: "The heart is still aching to seek,/But the feet question 'Whither?'"

# The Colors of Time and Place

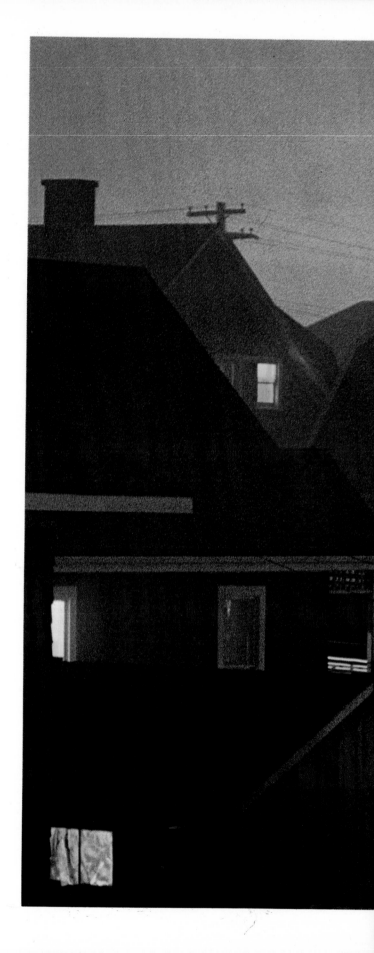

In pictures of places, whether familiar or far away, spectacles or vignettes, color has a curious power to make the viewer identify with the scene, as if he had been there and knew just where and when the picture had been taken. Sometimes the clue is direct and physical—the easily recognized deep blue of the Mediterranean Sea, for example. But more often it is indirect and emotional, depending on remembered color associations. For colors evoke the same responses in many people, photographers and viewers alike.

The little cluster of houses in the picture at the right seems familiar—even though we may never have been near it. The haze of dusk suggesting evening tranquility, the yellowish glow of lighted windows in houses nestled hospitably close, speak to the viewer of homes he has known. These are the impressions that photographer Harald Sund felt when he came upon this scene, and they are the impressions that the colors in his picture convey.

The sense of time that color brings is remembered, too, but perhaps more often in specifics. The brisk yellow of early morning sticks in the mind of anyone who has been up when the sun first comes brimming over nearby mountains *(page 38)*. Midday light is clear white. But late afternoon tends again to yellow, now usually more golden *(page 39)*. And it takes only a touch of color to set the season in a picture.

These color cues to time and place are learned associations, each with a meaning that depends on its context. The purple in the portrait on page 29 may evoke the musty sweetness of a Victorian parlor. But the purple in the picture on page 41 will make almost anyone think of a particular, spectacular sunset he once saw—even though it may have been quite another purple and in quite another place.

*Bathed in the soft afterglow of sunset, this cluster of houses in a small northern California community attracted Harald Sund for a sense of evening tranquility that the colors brought out. "When I use color," he says, "I am interested in the emotional or ethereal quality of what I see. Color helps me express it." Sund used a long-focal-length lens—300mm—to alter the apparent perspective, making the houses appear to be huddled cosily together.*

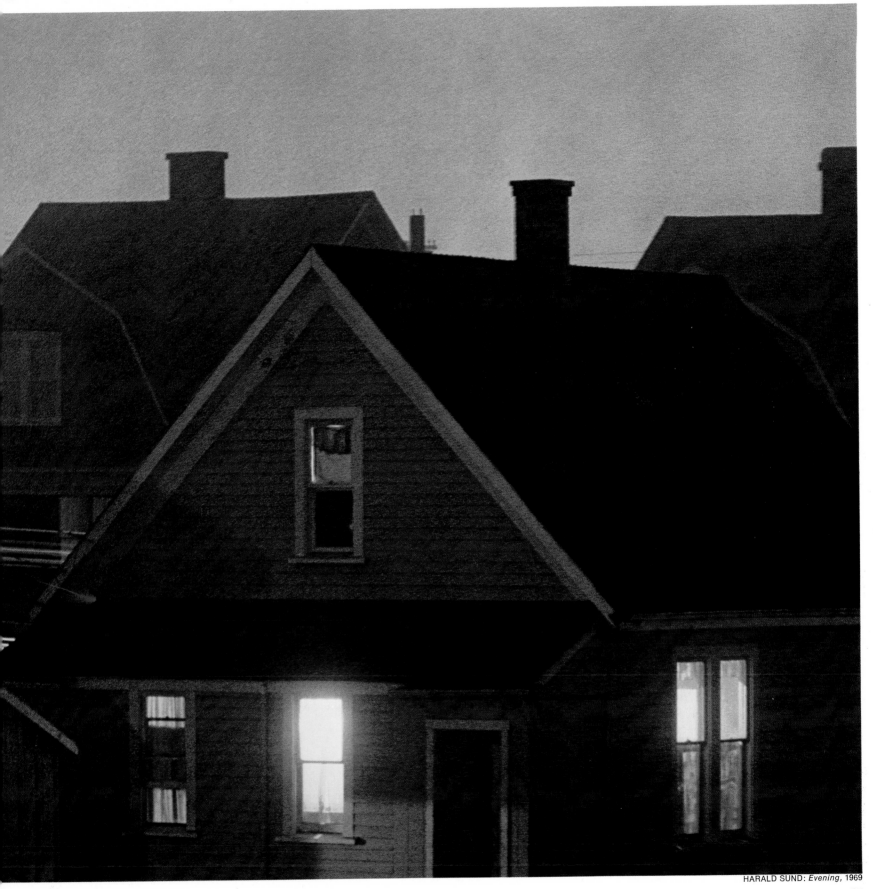

HARALD SUND: *Evening,* 1969

# Early Yellow, Late Gold

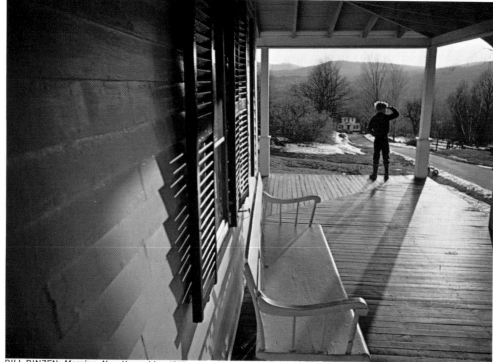

BILL BINZEN: *Morning, New Hampshire, 1965*

*The brisk yellow light of early morning is a
clear, invigorating color, its freshness
reinforced in this picture by the newly painted
porch. The scene's sense of time is strangely
related to its evocation of place. This is New
Hampshire, but it might be any small town in the
New England mountains where the air is
pure and small boys get up early to enjoy it.*

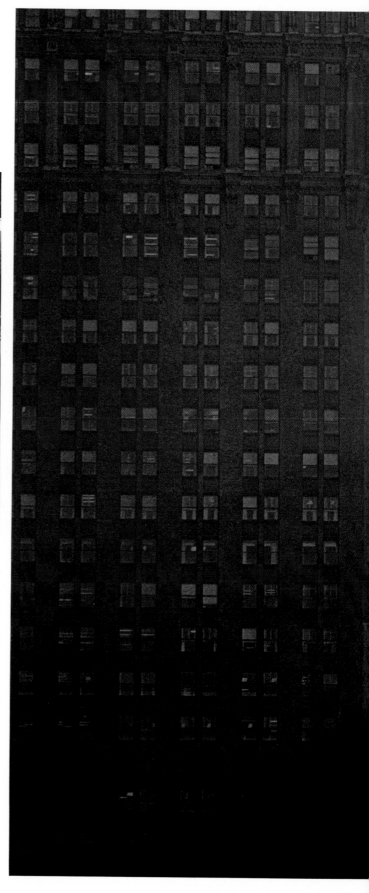

*The smoky yellow of Jay Maisel's picture of
Manhattan skyscrapers draws quite a different
response from that of the yellow in the picture
above. Here the time is late afternoon; the light
lies heavily on the buildings, which are made
to seem unnaturally crowded by the narrow view
of a long—500mm—lens. The sultry color and
the closed-in perspective give the picture
an air of both power and urban congestion.*

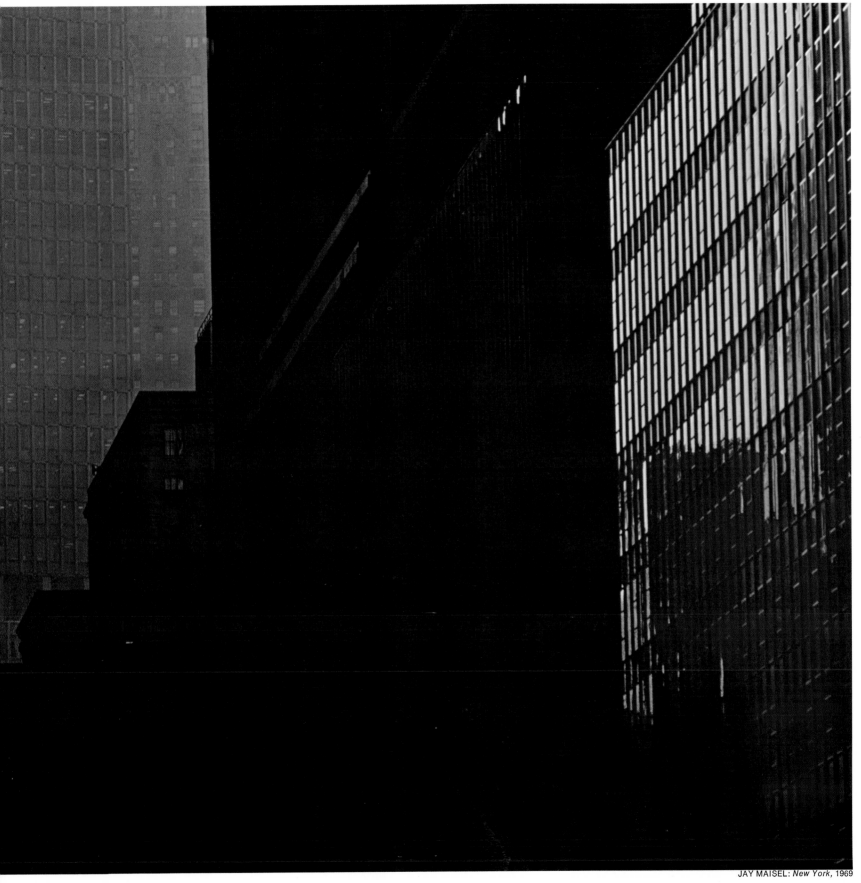

# Cold Spring, Rich Sunset

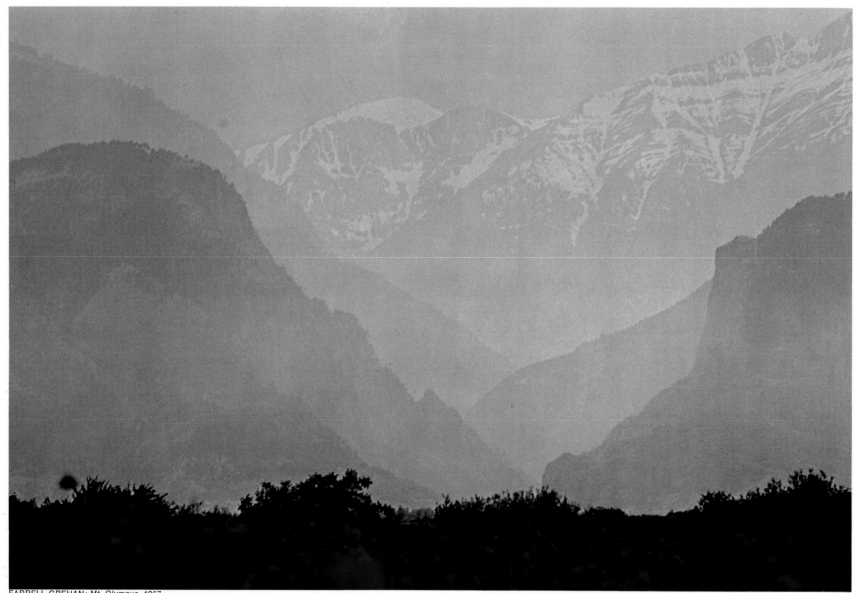

FARRELL GREHAN: *Mt. Olympus*, 1967

*Shrouded in an icy haze, the Olympus
Mountains of Greece overlook a springtime field
of poppies. LIFE Photographer Farrell Grehan,
assigned to photograph this legendary home of
the gods, was attracted by the poppies,
which brought near and distant elements
into a cohesive view. To keep the red from
overwhelming the more subdued colors, Grehan
put the poppies slightly out of focus.*

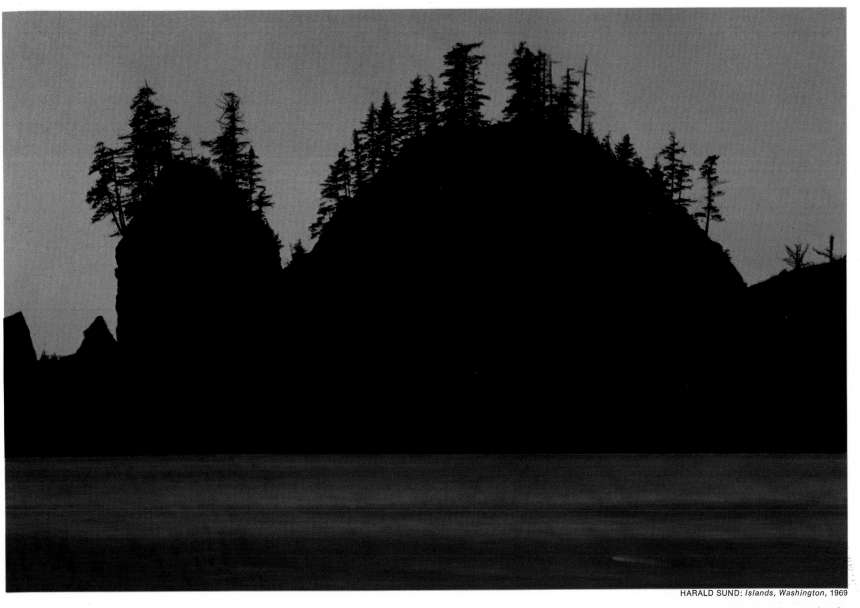

HARALD SUND: *Islands, Washington,* 1969

*Unworldly colors light sky and water after the
sun has set behind the headlands of some small
islands in the Pacific Ocean off Washington.
Harald Sund, who likes to use only two or three
hues at a time, made blue-green water purple
and a rosy sky magenta with a very long
exposure time (and small aperture), which so
alters the normal response of the film as to
exaggerate the vivid colors of sunset.*

# Color for Color's Sake

In some of the best color photographs, color itself becomes the subject. One can no longer say of such photographs that color is what helps to make the picture; it is the picture.

A few adventurous photographers synthesize color for such purposes. They use a variety of techniques to deliberately distort, reverse and transpose the hues of the real world, or introduce tints of their own making, often with striking effect *(Chapter 7)*. But most photographers of color as color focus on the hues the eye can see. They use these natural colors in sophisticated ways in order to convey unabashed sensory pleasure. The colors communicate nothing in the way of literal meaning, and little if anything of atmosphere or emotion. They are simply there for the viewer to enjoy. And yet the approaches to such a pleasurable use of color are surprisingly varied.

Sometimes, as in the picture on the opposite page, the photographer deliberately adds to his scene extra color of his own selection, using this visual spicing to enhance an essentially colorless object. The silverware might well

gleam as brightly in a black-and-white picture as it does here, but the addition of color completely transforms a shot that might otherwise have looked like a routine catalog photograph. More often the colors inherent in the subject are their most interesting aspect—what the subject actually is matters less than its coloring—and the impact of the picture depends on the skillful arrangement and isolation of these colors; pale pieces of fruit, if carefully arranged in a white bowl against a white background become a loving evocation of natural beauty *(pages 44-45)*. And in some pictures the actual physical look of the subject is ignored. The color brings out a design that would be all but invisible in black and white—on page 50 transforming a familiar glass of soda into an exotic oriental pattern.

In such pictures the tail exuberantly wags the dog. Color takes over as the center of attention and the ostensible subjects—spoons, fruit, door handles, cucumbers and other ordinary objects —are just excuses for a photographer to celebrate the unsuspected beauty of the world's colors.

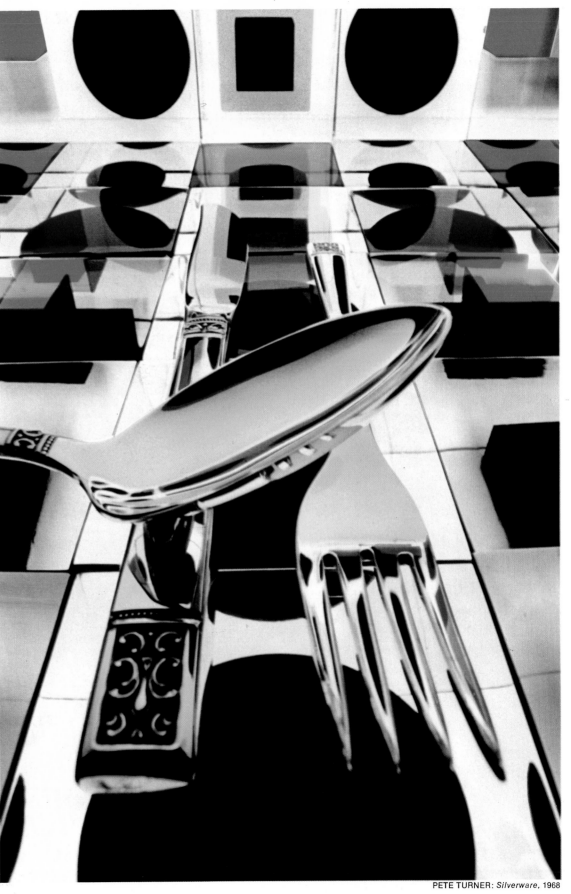

Inherently colorless objects like the silverware in this picture are given new interest by being photographed with highly colored objects. Pete Turner made this composition of silver against clear and geometrically colored blocks while doing a series of pictures on fabrics and home furnishings for use in a fashion magazine.

PETE TURNER: *Silverware,* 1968

# The Delicacy of Natural Color

Unusually soft colors in a Japanese dessert, which includes fruit and lavender-pink squares of kanten, a decorative gelatin made from seaweed, challenged Peter Worth to keep as much naturalness as possible in this picture. He did so by surrounding the colors with white, which brings out colors in their truest hues; he shot the picture in brilliant white light—sunlight diffused through a skylight—and used a pure white earthenware bowl and a white background.

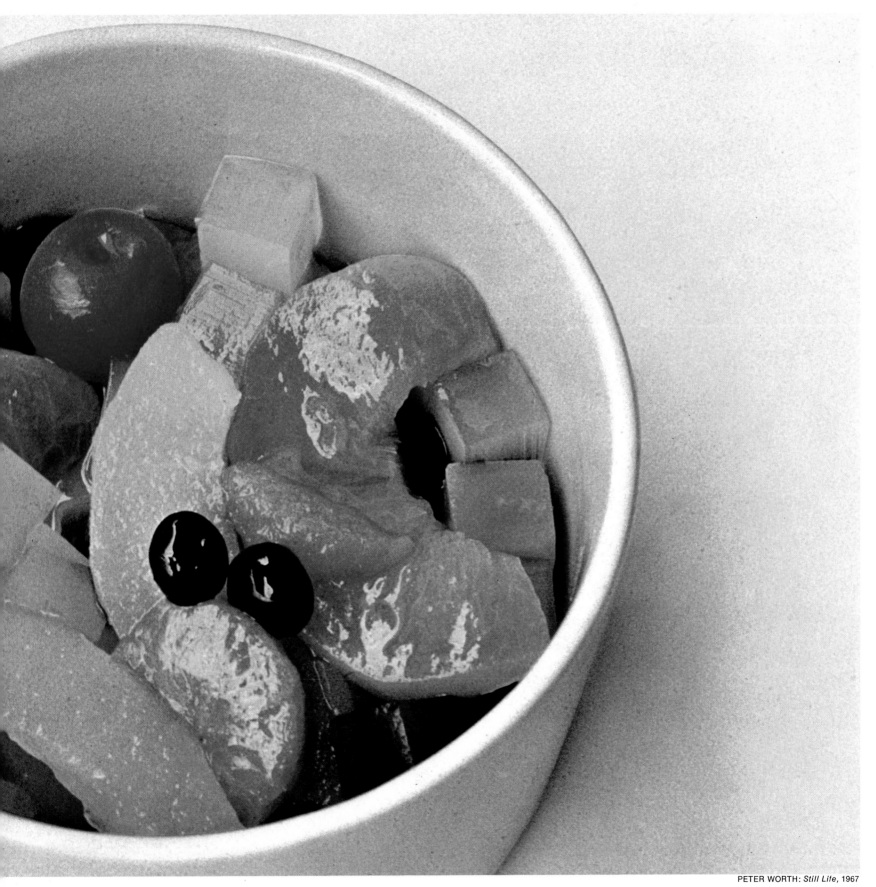

PETER WORTH: *Still Life*, 1967

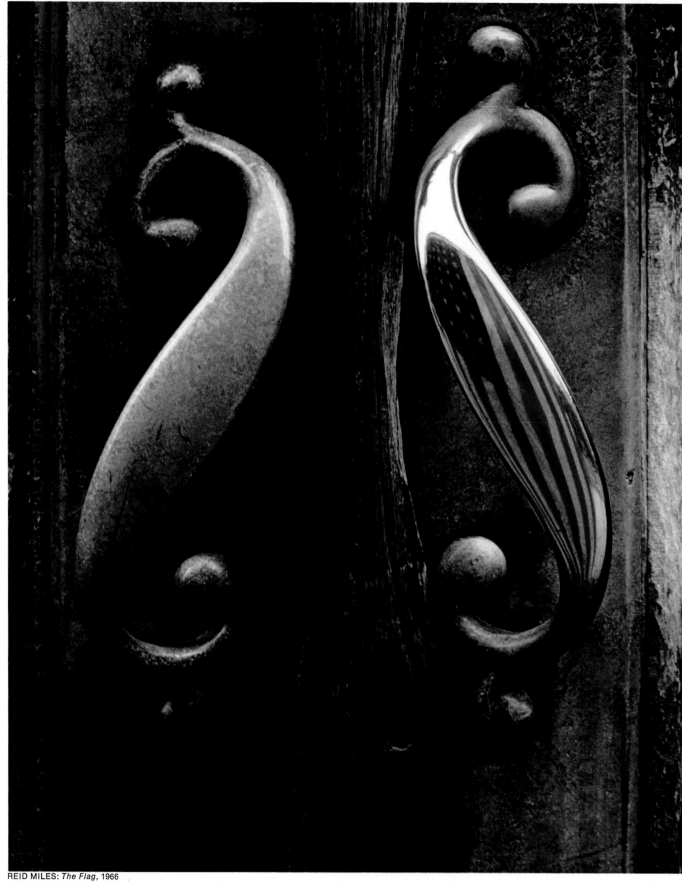

REID MILES: *The Flag*, 1966

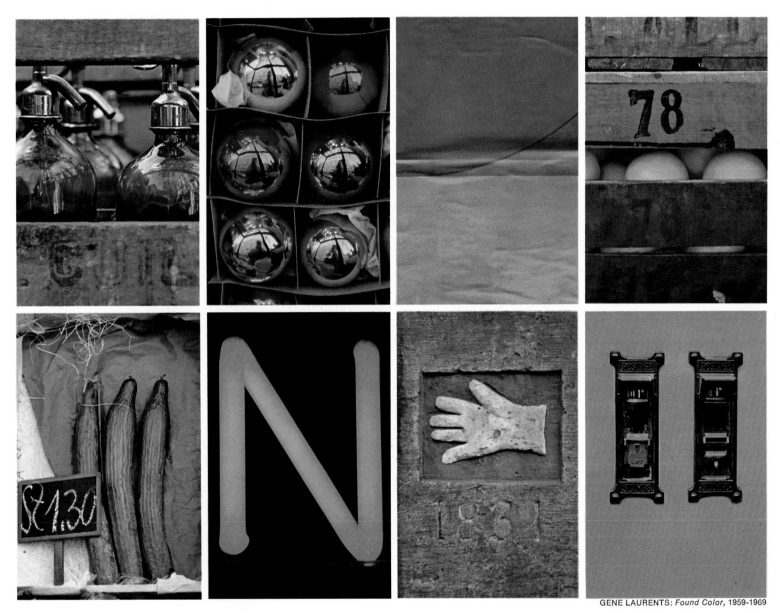

GENE LAURENTS: *Found Color,* 1959-1969

◄ *For a magazine cover with a patriotic motif, Reid Miles carefully set up this picture of a flag reflected in an antique brass door handle. Leaving nothing to chance, he first hunted up a door with an appropriate background color (it turned out to be the entrance to a bar in New York), then draped a nine-foot flag so its reflection fit the handle. "For me, composition is the most important thing," says Miles.*

*"A visual game," is the way Gene Laurents describes his quest for colorful commonplace objects like the strange assortment—bottles, fruit, signs, hardware—shown above. "I just like shapes and colors," he says. Though the pictures look casual, they were chosen for their strong, saturated colors and composed to eliminate distractions. Laurents started his collection during a trip to Europe in 1959.*

# Abstracting Color

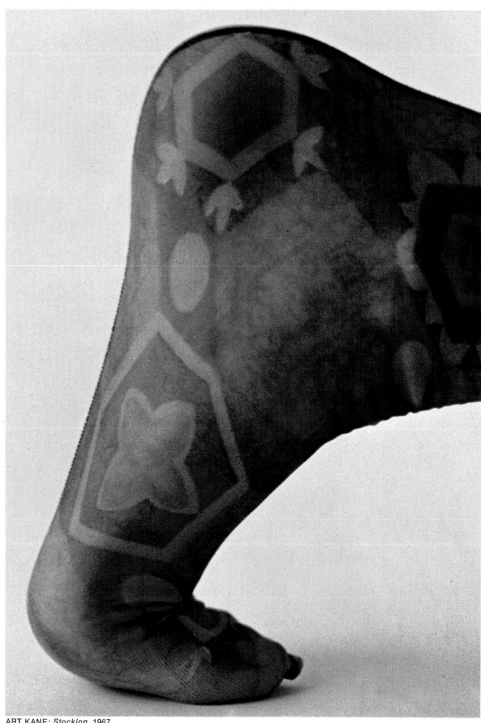

Art Kane took the picture at left to illustrate
a fashion magazine story about women's colored
stockings. Using his combined experience as a
photographer and an art director, he picked
decorative stockings whose colors would blend
easily into semiabstract but still recognizable
shapes such as the bent foot shown here.

Syl Labrot, who is a painter as well as a ►
photographer, ran across this curious paint job
(right) on the back of a parked truck in
Colorado. Why it was painted this way he never
found out, but Labrot was so taken with the soft,
flat color abstraction—"it was such a wild-
looking thing"—that he took a whole series of
pictures with his 5 x 7 view camera.

ART KANE: *Stocking*, 1967

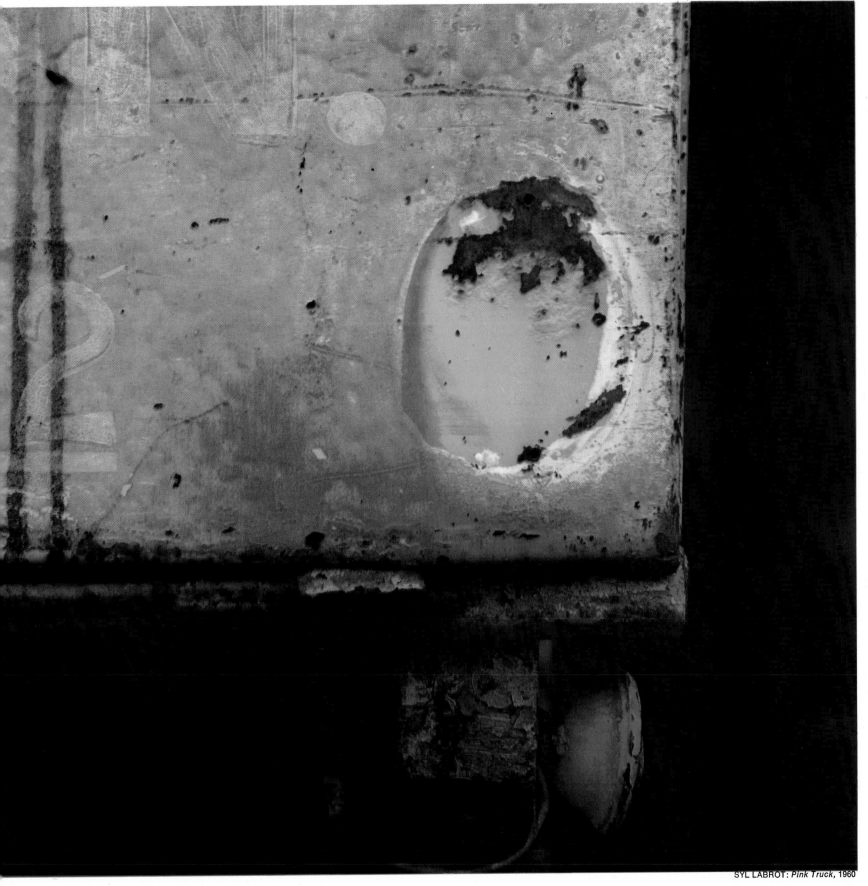

SYL LABROT: *Pink Truck*, 1960

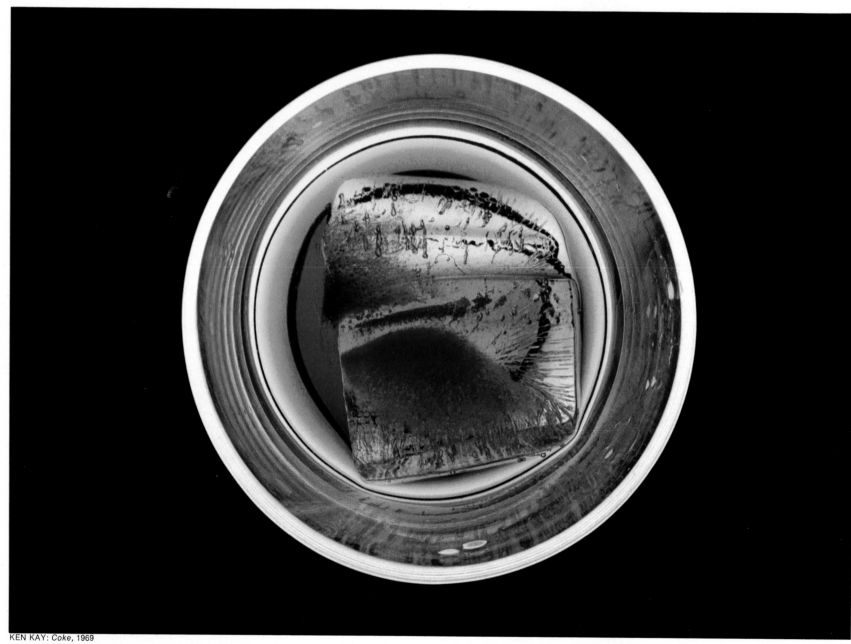

KEN KAY: *Coke,* 1969

Shooting down into a glass of iced cola, Ken
Kay transformed a familiar object into an exotic
design. With the glass lit from below, the
beverage becomes so luminous the viewer hardly
sees that the picture has but one main color.

**The Musicians Who Found the Key to Color Film** 54

**The Color of the Past** 70

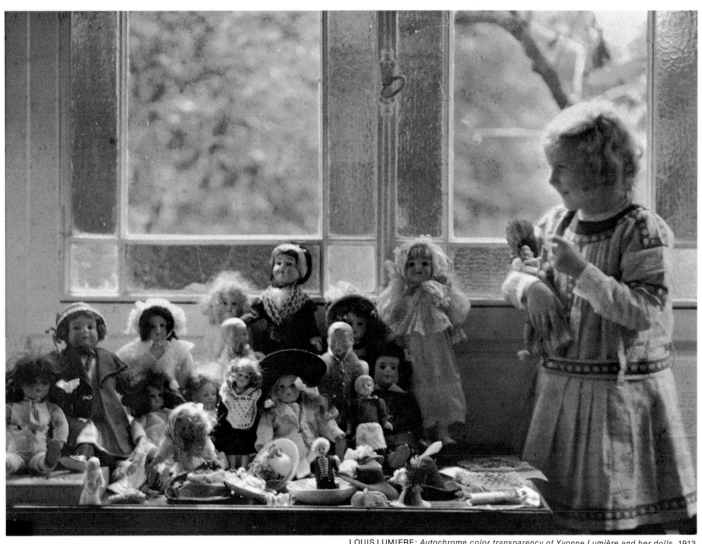

LOUIS LUMIERE: *Autochrome color transparency of Yvonne Lumière and her dolls*, 1913

# The Musicians Who Found the Key to Color Film

The Kodak Research Laboratories in Rochester, New York, noted for its developments in esoteric areas of chemistry and physics, is not exactly a place where one would expect to find professional musicians. But working away in an equipment-filled section there in the early 1930s were two fine young instrumentalists, a pianist and a violinist, who were about to alter the course of photography by inventing the first simple and effective means of taking pictures in natural color. They were Leopold Godowsky Jr. and Leopold Mannes, scions of two well-known musical families and friends since their school days. What had begun as a teenagers' fascination with photography had now led them to put aside their musical careers and pursue the technological will-o'-the-wisp of color photography. They had formidable competition, for many photographic researchers were experimenting with color processes, and scientists at the famous Agfa plant in Germany were successfully developing methods very similar to their own. But the two young men won out; they became the first—if only by a few months—to produce a workable modern system of taking pictures in color.

The triumph of "Man" and "God" (as the young musicians were affectionately nicknamed by their Rochester colleagues) was an appropriate climax to a century-old search. It had intrigued all manner of men. Some of the greatest scientists of the 19th and 20th Centuries contributed basic methods. There were a number of swindlers promoting "secret color processes" that did not work. Also engaged in the search were a Baptist minister, a French Army captain, a cabaret entertainer and pioneer movie makers—as well as the men who invented black-and-white photography in the first place. For one of the strangest facts about color photography is that, while a method that was both simple and effective was not developed until 1935, fairly good color pictures could be made—if anyone wanted to take the trouble —as early as 1868. And color photographs of a sort were, according to some authorities, produced almost as soon as the first black-and-white ones were, in the 1820s.

The French lithographer Joseph-Nicéphore Niepce, who became the first man to take an actual photograph with a camera, wrote to his brother Claude, "I must succeed in fixing the colors." Louis Jacques Mandé Daguerre, who later formed a partnership with Niepce to create a commercially practical form of black-and-white photography, also worked on color. Evidently these efforts achieved some limited success, for Niepce wrote his son in 1827: "M. Daguerre has arrived at the point of registering on his chemical substance some of the colored rays of the prism. . . . But the difficulties which he encounters grow in proportion to the modifications which this same substance must undergo in order to retain the several colors at the same time. . . . My process seemed to him much preferable and more sat-

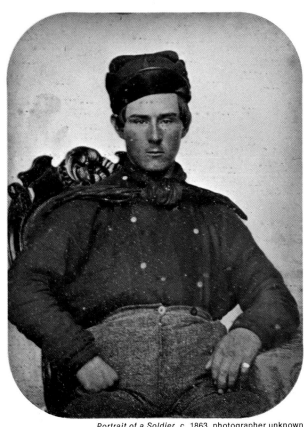

*Portrait of a Soldier*, c. 1863, photographer unknown

*Long before color photography became practical, black-and-white photographs like this portrait of a Civil War soldier were hand-tinted to satisfy the public's desire for color. Only the sitter's skin and shirt were colored while the rest of the picture was left the normally rich tone produced by the ambrotype process that the photographer used—such partial coloring-in by hand was a common practice of the mass-production studios.*

isfactory, because of the results which I have obtained." Exactly what processes were explored by Daguerre and Niepce remains lost to history. Certainly it is a measure of the problems to be overcome that, fully a hundred years before "Man" and "God" made color photography simple enough for anyone to use, Niepce and Daguerre had shown it to be possible.

The pioneers' lead was followed by many other inventors, including a number who were highly controversial. One such claimant was the American Baptist minister Levi L. Hill. He made color pictures by 1850, but how he did it he either would not or could not explain. Samuel F. B. Morse, the noted artist-inventor and a leading photography enthusiast, saw some of Hill's work and was enthusiastic: "The colors in Mr. Hill's process are so fixed that the most severe rubbing with a buffer only increases their brilliancy, and no exposure to light has as yet been found to impair their brightness . . . Mr. Hill has made a great discovery. . . ."

The minister was naturally pressed for a description of his process, most of all by professional daguerreotypists, whose business fell off for a time after Hill's work was publicized (their patrons, believing color photography was just around the corner, postponed sitting for portraits). Hill's only response was that he would make his invention available "when I think proper." Somehow the "proper" time never came. According to a photographic journal published shortly after Hill's death in 1865, he "always affirmed . . . that he *did* take pictures in their natural colors, but it was done by an *accidental* combination of chemicals which he could not, for the life of him, again produce!"

It now seems likely that Hill's pictures—and those of Niepce and Daguerre as well—reproduced color because some silver compounds will, under certain circumstances, actually record not only the intensity of light but something of its color as well. That is, the sensitive material adopts the color of the light reaching it. Wherever the emulsion is struck by green light waves —such as those reflected from grass—it turns a greenish shade, and wherever it is struck by blue light from the sky it turns blue. This direct color method was explored by a number of men, including Niepce de Saint-Victor, Joseph-Nicéphore Niepce's cousin. As early as 1851, the year after the Reverend Mr. Hill's announcement, Niepce de Saint-Victor duplicated Hill's accomplishment. The French photographer's claims were well established and he was able to produce naturally colored photographs over and over again, but his pictures, once taken, could be viewed for only a short time. When exposed to light so that they might be seen, they faded, and no way could be found to fix the colors permanently.

The lack of a fixer for direct-color coatings proved an insurmountable handicap (as it still is). So ingenious experimenters turned to indirect meth-

ods. They quickly realized that they could start with a black-and-white photograph and use its shades of gray to control color introduced into the picture at a later stage—either during processing or when the photograph was being viewed.

The first to succeed was a 30-year-old professor at Kings College in London, one of the greatest physicists of all time: James Clerk Maxwell, the man who formulated the mathematical equations connecting magnetism, electricity and light, conceived the idea of electromagnetic waves, and laid the basis for radio and television. Maxwell was primarily a theoretician, not an experimenter (for example, although he must have realized radio waves could be broadcast and received, he never bothered to try). His demonstration of color photography was an infrequent excursion into experimentation, and it was used, not to advance photography, but to illustrate a public lecture about color vision.

In those days of the Victorian era, when science was at least as popular a subject among educated people as it is today, the lecture platform was the principal means for communicating the latest discoveries to the public. And in 1861 a large crowd jammed London's Royal Institution to hear Maxwell expound a now partly superseded hypothesis: that the eye is sensitive to only three colors in the visible spectrum—red, green and blue—and sees all other colors, including black and white, as mixtures of those three. To demonstrate this notion, Maxwell had three black-and-white photographs taken of a tartan ribbon. One negative was made with a red filter in front of the camera lens, intended to pass on to the emulsion only the red rays and absorb light rays from all other colors. The second was made with a blue filter on the lens, to pass only blue light, and the third with a green filter, to pass only green light. Lantern slides were then made from each of the three negatives, producing positive transparencies. The slides were all black and white, but each had tones that represented the amount of one of the three colors in the ribbon. To produce a colored image of the ribbon, each slide was placed in a projector fitted with a colored filter appropriate to the slide: red for the slide made with the red camera filter, blue for the slide made with the blue camera filter and green for the remaining slide. These filters colored the light passing through the slides so that now the "red" slide cast a truly red image, and so on. When the three projected images were thrown on a white screen so that they were precisely superimposed, the colors combined, in the additive method of color mixing *(pages 14-15)* to reproduce a single image of the tartan ribbon in its original hues.

Maxwell's demonstration of color photography was all the more amazing because it should not have worked nearly so well as it did. Although the physicist did not know it, the emulsion that had been used was sensitive only

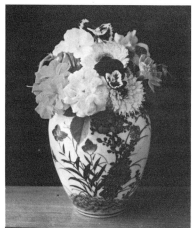

**red filter**

**slide for red**

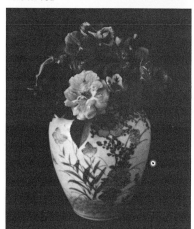

**blue filter**

**slide for blue**

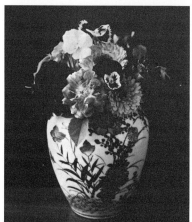

**green filter**

**slide for green**

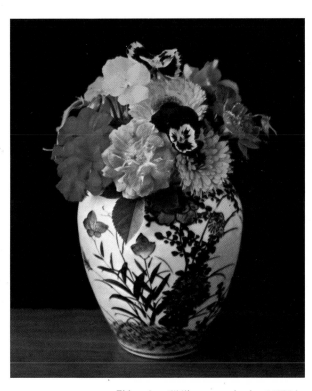

*This color still life was made about 1900 by Frederic E. Ives from three black-and-white pictures like those at left. Using the additive method, his camera took three negatives at once, each through a different color filter. Positives were made and projected (below) through filters like those on the camera, the images overlapping to form a color picture.*

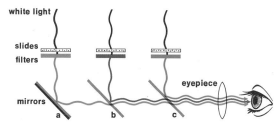

white light

slides
filters

eyepiece

mirrors
a    b    c

*Ives built a viewer using the principle above to display his pictures. The three slides are set above filters like those used to make the negatives. Light, passing through the slide and filter for red, reflects off mirror (a) and passes through one-way mirrors (b) and (c) to form a red image before the eyepiece. Light from the slides for blue and green is similarly transmitted. The images overlap to create a color picture.*

to light coming from the blue end of the spectrum, and was insensitive to both green and red. How then could he have recorded anything for his "green" and "red" slides? For a century this question puzzled researchers, and not until the one-hundredth anniversary of the experiment was the answer found. To commemorate the accomplishment, Ralph M. Evans of Eastman Kodak repeated the experiment, using materials like those available to Maxwell. Evans found that Maxwell had been helped by two phenomena he was unaware of. His green filter looked green, but it also passed some blue light; it was this blue that registered on the emulsion and gave an image for the green slide. Red appeared because the red cloth in the ribbon reflected not only red light rays but also ultraviolet rays, which are invisible to the eye but registered on the emulsion. Thus all three slides had images that became colored to the eye only because they were projected through color filters. It was simple coincidence that these false colors combined to produce a natural looking image of the tartan ribbon. But there was nothing wrong with the method; used with sufficiently sensitive emulsions, it works very well indeed.

Not long after Maxwell staged his demonstration, two young Frenchmen thought of another system that was to prove more significant. Although they worked independently of each other—and of Maxwell—they announced their ideas almost simultaneously.

The first report was the work of Charles Cros. Cros was a man of unusual and varied talents. During a lifespan of only 46 years he not only described a landmark process of color photography but studied philology, taught chemistry, practiced medicine, wrote poetry and humorous fiction, and described a device for recording sound the year before Thomas A. Edison patented the phonograph. But perhaps the accomplishment most highly appreciated in the bohemian circles of Paris was his revival of the art of the comic monologue, for Cros was often to be found in Left Bank bistros amusing the patrons as a standup comedian. In 1867, Cros deposited with the French Academy of Sciences an envelope that contained his theories on color photography. According to his instructions, the envelope was to remain sealed until 1876 (presumably to give him time to develop his ideas commercially). However, in 1869, Cros changed his mind and made his process public; he had just learned that his fellow countryman, Louis Ducos du Hauron, was preparing to publish a detailed account of his own accomplishments in color photography. While du Hauron's monograph, *Les Couleurs en Photographie, Solution du Problème,* described several alternative methods, one of them —historically the most important—closely paralleled Cros' speculations.

Du Hauron, born in Langon, near Bordeaux, in 1837, the son of a tax collector, was Cros' antithesis in almost every way. Where Cros was a

Louis Ducos du Hauron

Charles Cros

cosmopolitan, a friend of poets and intellectuals, du Hauron was a provincial. Where Cros—with charming features, a moustache and erect bearing —cut a dashing figure, du Hauron, his body wizened and his small, sharp features hidden by a scraggly beard, seemed the model of a small-town pedant. Where Cros was ebullient and flamboyant, delighting in his ability to arouse laughter, du Hauron was serious. Where Cros flitted from one project to the next without fully exploring the practical possibilities of any, du Hauron was single-minded and determined. Yet despite their dissimilar personalities—and a flurry of antagonism when both claimed credit for inventing the same color process—they eventually became friends.

What Cros and du Hauron had developed was the process now called subtractive *(pages 14-15)*. This is the method that has become the basis of all present-day systems of color photography *(pages 16-19),* creating colors by combining dyed images instead of by mixing colored lights, as Maxwell's additive method does. Like the additive method, it requires three black-and-white negatives representing the red, green and blue in the subject. But the positives made from these negatives are not black and white, as they are in the additive process. Each positive image is transformed by a complex series of steps into an image made of a dye, and the dye images are superimposed to provide a single picture with the color already in it. Du Hauron made many color photographs this way, and the few that survive are even today—a century later—astonishingly good renditions of colors.

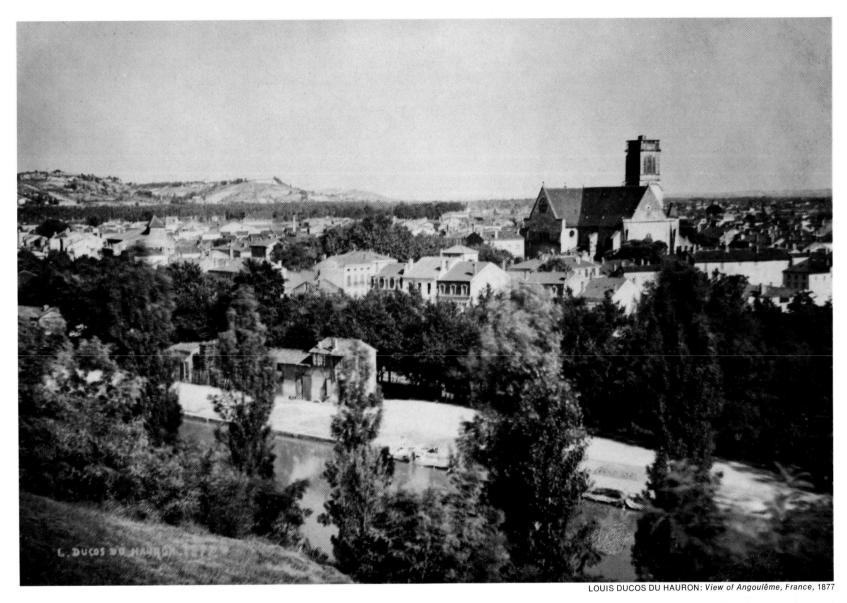

LOUIS DUCOS DU HAURON: *View of Angoulême, France, 1877*

*A century ago this full-color landscape of Angoulême, France, was made by a subtractive method—the basis for all color photography today. It is a print composed of three layers of separately dyed images, each made from a separate negative, and was taken by Louis Ducos du Hauron (opposite, left). He proposed the method in 1869, the year Charles Cros (opposite, right) suggested it independently. Subtractive techniques proved impractical, and they were put aside until the mid-1930s.*

Although the subtractive method eventually became pre-eminent, it did not do so until the 1930s, when Mannes and Godowsky and others finally overcame the complexities that had made it very difficult to use. For three quarters of a century Maxwell's additive method was more practical.

Both the subtractive and additive methods try to reproduce all the world's colors by mixing varying proportions of a few "primary" colors, usually but not necessarily three. This, unfortunately, never quite works, and some natural shades are omitted or misrepresented (how many depends on the number of primaries used as well as on the skills of the chemist making the film and the photographer using it). There is only one known method of reproducing all colors exactly as they are in nature, and as might be expected, it turns out to be impractical. It was demonstrated in 1891 by a professor of physics at the Sorbonne, Gabriel Lippmann (and won for him a Nobel Prize in 1908). His process made use of the phenomenon of light interference, the interaction of light waves that produces the brilliant arrays of colors seen in soap bubbles and oil slicks. It required a very fine-grain emulsion backed by a bath of mercury; reflections from the mercury surface created the interference in the emulsion that recorded the colors in black and white. Interference in viewing re-created the colors, which were unsurpassed as a literal replica of reality. But since the plate had to be held at a precise angle to the light if the colored image was to be seen at all, and the exposures required were lengthy, limiting subjects to still lifes and landscapes, Lippmann's accomplishment remained a scientific curiosity.

The first practical color photographs were made by variations of Maxwell's additive process, which could be put to work when black-and-white emulsions that were sensitive to the entire visible spectrum became available toward the end of the 19th Century. Both du Hauron and Cros had suggested several ways to simplify the additive system. One of the first such efforts to achieve a degree of success was developed by Frederic E. Ives, a Philadelphian who among other accomplishments introduced an essential element in the modern photoengraving process. In 1892 he built the first of a series of cameras that made three negatives on a single plate—each negative through a different color filter. From these negatives positive transparencies were made and placed in a viewing device—also an Ives invention—called a Kromskop. Filters on the Kromskop restored the colors, and mirrors in the device superimposed the images projected from the three transparencies. The viewer, peering through a peephole in the Kromskop, saw the picture in startlingly vivid color.

A further simplification was patented in 1893 by a Dublin physicist named John Joly, who combined the three separate plates for red, green and blue images into one by dividing the picture into minute interleaved strips (a vari-

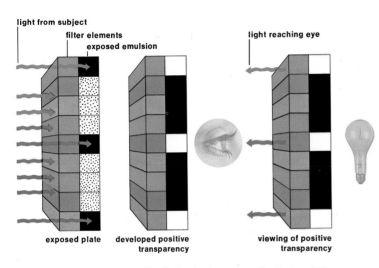

light from subject
filter elements
exposed emulsion
light reaching eye

exposed plate

developed positive
transparency

viewing of positive
transparency

*The first color transparencies that could be
taken and viewed like modern ones adapted the
additive color system to work with a single plate
as diagramed above. In front of the emulsion
thousands of microscopic color filters (left),
break up the picture into minute fragments, each
fragment on the negative recording (in black and
white) the amounts of red, green and blue light
coming from the subject. Red light, for example,
passes beyond only the red filters and exposes
only the emulsion segments behind them; it
cannot pass the blue and green filters to expose
their emulsion segments. After development, the
negative image is chemically reversed to a
positive (center), giving clear areas where red
light has passed the red filters, opaque areas
where red light was blocked by blue and green
filters. When the transparency is viewed (right),
the filters color the light passing through the clear
segments, re-creating the original hues.
Many variations of such a "screen plate" were
devised; these illustrations show a greatly
magnified section of the filters and the emulsion
(their glass support is omitted) of the first
screen plate patented by John Joly in 1893.*

ation of an idea the foresighted du Hauron had also proposed). Joly covered
a glass screen with thin transparent lines in the three colors in an alternating
sequence, 200 to the inch. The screen was bound to a black-and-white plate
and the sandwich was placed in a camera so that the plate was exposed with
the light passing through the screen before it hit the light-sensitive emulsion.
Each colored line acted as a filter for the narrow strip of emulsion behind it.
One-third of the strips recorded the scene's red light, while alternating strips
recorded green and blue. After the negative was developed and a positive
transparency made, the lined screen was again affixed to the positive, each
colored line being superimposed on a strip for the image of that color in the
transparency. When light passed through this sandwich of screen and slide,
each line added the appropriate color to the strip of image behind it, and the
interleaved strips blended to reproduce the colors of the original scene.
(Modern color television works on a similar principle.) The Joly method,
while certainly an improvement on all that had gone before, had distinct dis-
advantages. The placing of the screen and transparency together, for
example, was a matter of critical importance, for if the colored lines and im-
age strips failed to overlap in precise register by even a thousandth of an
inch the color balance was ruined. And of course any great enlargement of
the image made the individual strips apparent, breaking up the image into
separate streaks of red, green and blue.

Many variations of this idea were later developed. Some employed col-
ored line screens in various patterns—such as zigzags or crosshatching
—and others such as the Autochrome plates *(pages 70-76)* invented by
Auguste and Louis Lumière, who are most famous for their pioneering work
in the movies, used colored dots. All suffered from many of the defects that
plagued Joly's plates, but a number of the adaptations—the Autochromes in
particular—were practical enough to find considerable use among profes-
sionals and some amateurs. They required no special equipment—the
plates fitted into standard cameras and could be developed by fairly routine
methods. The color that resulted, while hardly a precise rendering of nature
by scientific standards, was generally quite pleasing. During the first quarter
of the 20th Century, photographers like Edward Steichen, Alfred Stieglitz,
and Louis Lumière himself turned out hundreds of delicately hued pictures,
and the National Geographic Magazine displayed before millions of readers
the exotic color photographs its correspondents brought back from Egypt,
India and other romantic lands.

But during the years of World War I two schoolboys decided they could do
better with color photography. Leopold Godowsky Jr. and Leopold Mannes,
then in their mid-teens, were classmates at the Riverdale Country School in
New York City. Mannes was a promising young pianist whose father was the

noted concert violinist, David Mannes, and whose mother, Clara, was a sister of Walter Damrosch, the eminent conductor. Godowsky was a student of the violin and son of the internationally known pianist, Leopold Godowsky Sr. In addition to being the talented sons of famous musicians, the two boys were avid amateur photographers and they often went out on joint picture-taking excursions. In 1917, the year after they met, the two went off to a movie together, for they were interested in seeing a short called "Our Navy," which was billed as a color motion picture. And indeed the film was in color—of sorts, murky and unnatural tones in which only a portion of the spectrum was reproduced. The boys felt cheated. "We were blissfully ignorant," Godowsky recalled many years later, and with youthful bravado they set out to perfect color movies.

They got permission to use the school physics lab, and proceeded to reinvent Maxwell's additive system, as many another dabbler in color photography has done before and since. They designed and built a camera and a projection device with three paired lenses and filters, one for each of the three primary colors. The projection device had some ingenious features for superimposing the images, and these were sufficiently new to win them a patent—the first of many they would eventually hold. The elder Manneses and Godowskys were suitably impressed and, hoping to encourage their sons in this harmless but intellectually rewarding activity, they offered a loan of $800 for the purchase of equipment. It was a step both sets of parents would have second thoughts about in later years.

Even the boys' graduation from the Riverdale School in June 1917, did not stop their research. Godowsky went off to study at the University of California and to accept positions with symphony orchestras in Los Angeles and San Francisco, and Mannes registered at Harvard, where he continued to study music while working for a degree in physics. While they were separated by a continent, Mannes and Godowsky continued their collaboration by mail, exchanging ideas on improving color processes. During the summers or mid-year holidays they met, either in New York or in Los Angeles, to test their latest brainstorms.

One of these was an idea for an additive color movie process using only two primary colors, but, they hoped, capable of superimposing the color images more reliably than could similar methods that were then in use. Two color filters were used on a double-lens camera to take matched pairs of pictures, side-by-side on a single strip of film. The double-lens device was then transferred to a projection machine for showing the film. To test their idea under actual operating conditions, Mannes and Godowsky prevailed upon S. L. Rothafel, a well-known impresario of the period, under his nickname, "Roxy," to allow them to use his Rialto movie theater in New York. After fit-

JOHN GEORGE CAPSTAFF: *Portrait of George Eastman*, c. 1915

*A natural color portrait of George Eastman was made about 1915 in an early attempt to produce dye-tinted transparencies somewhat like those of today. The process was invented by John George Capstaff, a Kodak researcher who contributed a number of key techniques to color photography; it produced a glass sandwich of green- and red-tinted plates, but its color range was limited and it was abandoned.*

ting one of the projectors there with their own lens and filter setup, the two young men settled back in their seats to watch the new age of color motion pictures dawn on the mammoth screen. The color that they saw turned out to be quite satisfactory, but they ran into trouble with the theater's projectionist, who refused to be bothered with the chore of having to set up his machine specially to show their films.

Despairing of re-educating the country's projectionists, Mannes and Godowsky almost gave up their experiments altogether. But they soon decided that their approach was wrong: instead of trying to introduce color with filters in an additive process, they agreed to switch to the dyes of a subtractive process. Then the color would be in the film itself, and projection would present no special problems.

By now Godowsky had given up his orchestra jobs in California and rejoined Mannes in New York City, where both worked as musicians during the day and experimented with color photography in their spare time. Their parents' apartments were their laboratories, and they went about their research with single-minded enthusiasm. No bathroom, kitchen or closet in either home was safe from requisition as a makeshift darkroom. Nor was there any way of knowing where the amateur scientists would strike next. Shooed out of one room they merely moved down the hall to another, taking their equipment with them; expelled from one apartment, they invaded the other. But within a few months the two young men had produced a two-layer photographic plate; each layer of emulsion was sensitive to a different portion of the spectrum and could be dyed an appropriate color. Realizing that this was something scientists had been trying to achieve for a quarter century, Mannes and Godowsky quickly took out a patent on their process.

The success that they achieved was all the more remarkable considering the conditions under which they worked. Facilities for coating plates enjoyed by professional researchers in the field were unavailable to them. And their knowledge of chemistry was too limited to permit them to make their own emulsions. Instead, like other amateur photographers, they bought their photographic plates at retail outlets. Then, working entirely in a darkened room, they soaked the plates in water to swell the emulsion, scraped it off, melted it in a pot and recoated it on the glass.

At this point they desperately needed assistance. And, thanks to the first of a number of very timely interventions by influential people, they received it. Robert W. Wood, a renowned physicist at The Johns Hopkins University (and inventor of a not-very-practical color process of his own), was an acquaintance of the Manneses—the two families had been summertime neighbors at a New York beach resort. He had been shown the equipment made for the Rialto movie demonstration, and in 1922 he wrote in Mannes'

and Godowsky's behalf to Dr. C. E. Kenneth Mees, director of research at Eastman Kodak Company.

Mannes and Godowsky met with Mees at the Chemists' Club in New York, and Mees, after satisfying himself that the two young men were indeed making progress, offered to send them specially coated, two-layer plates prepared to their specifications. But while Mannes and Godowsky were finding allies in the worlds of academia and industry, they were rapidly losing the support of their parents. The elder Manneses and Godowskys were fed up with having their bathrooms and kitchens turned into laboratories. The final straw came when Godowsky Sr. walked into a bathroom and stepped into a tray of chemical sensitizers. What had started out as an admirable adolescent enthusiasm had by now become a source of concern to the parents. From their point of view, their sons—both promising musicians—were slighting bright careers in favor of futile tinkering. Both families took drastic action: eviction. If their sons wished to continue experimenting, it would have to be done somewhere else, not at home. Nor would there be a loan to finance a rented laboratory.

But now help came from an unlikely and unexpected source—the Wall Street investment firm of Kuhn, Loeb and Co. The secretary to one of Kuhn, Loeb's senior partners had struck up an acquaintance with Leopold Mannes aboard ship, while both were returning from a European trip in 1922. Mannes, bubbling over with excitement, described his research in color photography, and managed somehow to infect his fellow passenger with the same enthusiasm. Mannes had forgotten the incident when, some months afterward, a young man named Lewis L. Strauss (who three decades later would be Chairman of the United States Atomic Energy Commission) appeared at the Mannes apartment and introduced himself as a Kuhn, Loeb representative. Strauss said that his firm might be willing to invest a modest amount to further the researches of Mannes and Godowsky, and he asked to see samples of their color pictures. What followed was a scene that might have come out of a slapstick silent movie.

Working in Mannes' kitchen, the two young men showed Strauss some of their procedures. Then they made several exposures and began to process the demonstration pictures. During the tedious process of developing, Strauss was ushered into the living room, where Mannes' sister Marya (later a well-known author and critic) was detailed to entertain him. Usually, developing took no more than 30 minutes or so, but the apartment was unusually cold, and the developing solution would not act in the expected time. When 30 minutes had gone by there was no indication of images on the plates. Mannes and Godowsky hurried out to the parlor to assure their guest that the process would take but a short time longer. More minutes passed,

Two young amateur photographers, Leopold Mannes (left) and Leopold Godowsky Jr., musicians by profession, invented the first truly effective color process, Kodachrome, after years of research that began in their parents' bathrooms and ended in the Kodak Research Laboratories. This 1922 picture shows them in a makeshift lab they set up in a New York hotel.

and still no images appeared. Concerned that Strauss might become bored by the delay and walk out, the young men hurried into the living room again and again to try to reassure him. Finally they decided that something had to be done immediately to keep Strauss amused. Mannes and Godowsky left their darkroom-kitchen to play Beethoven sonatas for their important guest. Between movements they dashed back to the kitchen to check on the progress of their plates. Some several musical pieces later, the pictures were sufficiently developed to be shown. Strauss was impressed and persuaded his firm to put up $20,000 (one of the most profitable investments that astute company ever made).

The Kuhn, Loeb grubstake enabled the two musicians to establish a proper laboratory that, while hardly a match for the facilities at Eastman Kodak, was a considerable improvement over kitchens and bathrooms. At first it was set up in what had been a dentist's office, but the inventors later moved a block up Broadway to the Alamac Hotel, then a favorite lodging place for musicians. There, between experiments, Mannes and Godowsky joined fellow artists in performances of chamber music. A more practical advantage of the hotel was its cooperative staff, including bellboys who were eager volunteer lab assistants.

During these years of the mid-1920s, Mannes and Godowsky concentrated on developing their two-color subtractive system—a film with two emulsion layers, one to record green and blue-green and another for red—that had so impressed Mees. By 1924 they had made sufficient progress to receive a patent on their results and the following year they were delighted to find their work mentioned in a new treatise on the history of color photography by E. J. Wall. The Wall book, however, came to have another meaning for them, for it directed their attention to patents taken out just before World War I by the German chemist Rudolf Fischer, and to articles by Fischer and his one-time assistant Johann Wilhelm Siegrist.

Fischer and Siegrist proposed a radical change from the methods previously used for generating the color in pictures made by the subtractive process. Standard dyes had been used. They were introduced into the images after the black-and-white positives had been made from the original negatives and fully developed; each dye had to replace each black-and-white image, forming a color image in its stead. Mannes and Godowsky had done this by controlling the rate at which each dye diffused through layers of their film—a process that is tricky to manage for a two-layer film and even trickier for a three-layer one. As an alternative to this method, Fischer and Siegrist suggested using chemicals called dye couplers, or color formers. These complex substances can be incorporated into an emulsion with the light-sensitive silver compounds, but they have no effect until acted upon by

the developer; then they turn into dyes, generating colors as development of the silver black-and-white images proceeds. In this way the colors are automatically controlled by the progress of the black-and-white development, and processing is greatly simplified.

The two Europeans never applied their idea to a multiple-layer film, but its significance was not lost upon chemists at Kodak in Rochester and Agfa in Germany, who began research into dye couplers—nor upon Mannes and Godowsky. After reading Wall's book, the two young men abandoned the methods they had been using previously and began a long search for dye couplers that could be adapted for use in multi-layer film. It was a very difficult effort, for such couplers as they experimented with shared a common and crucial failing: they wandered from one layer of the emulsion to the next, spoiling the quality of the tones.

By 1930 Kodak researchers had perfected black-and-white emulsions that seemed particularly suited to adaptation for color film. Mees, who realized that this discovery could aid his amateur protégés, invited them to come to Rochester and join forces with the Kodak staff.

For Mannes and Godowsky, the move to Rochester was a mixed blessing. Now, of course, they had up-to-date research facilities, and instead of bellhops as helpers they could call upon the assistance of talented physicists and chemists. And somewhat to their surprise, they found themselves at home in the small city of Rochester. It is the home of the Eastman School of Music, and fellow artists there welcomed the two young chemists who dropped in of an evening to join in their music. Godowsky, in fact, was soon playing host to well-attended chamber music sessions at his own house, and once when his father arrived on a visit, assembled a small orchestra in his living room to provide a proper greeting for the senior Godowsky.

But now the two young men also felt constrained to produce something salable; the economic depression of the 1930s was deepening; and as Godowsky put it many years later, "The Kodak Company may not have wished to continue the luxury of two musicians chasing the rainbow in esoteric darkrooms." And they could sense that their most enthusiastic supporter, Mees, was under considerable pressure from the company directors to turn out a marketable product—or fire them.

By 1933 Mannes and Godowsky, with the help of the Kodak research staff, had come up with a color film for home movies. It used only two primaries, but gave reasonably good colors and was much easier to use than amateur color-movie processes then in use (additive types that required specially equipped cameras and projectors). Mees was so impressed that he wished to market the two-color process right away, and despite appeals from Mannes and Godowsky for delay, he ordered final tests prior to public an-

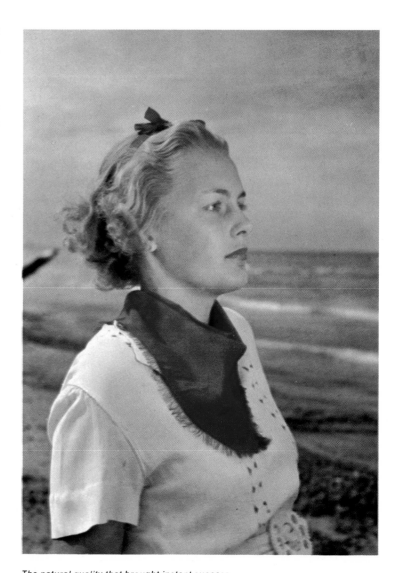

*The natural quality that brought instant success to the first modern color film, Kodachrome, is still evident in a beach scene taken in 1936 by Kodak photographer Albert Wittmer. Although most of the early Kodachromes have faded over the years, the colors shown here still accurately duplicate those of the original. They are reproduced from a color print that was made soon after the transparency was processed. Over the years, the print was carefully preserved to keep the color from becoming faded.*

nouncement. Mannes and Godowsky were opposed to these moves because they were confident that within a relatively short period of time they would be able to produce a film employing three primaries and therefore providing much more realistic colors.

Mannes and Godowsky determined to perfect a three-color process before the two-color film was placed on sale. Working at a frantic pace, the two young men sought to solve what had become the most difficult problem remaining—that of developing the pictures. Fischer and Siegrist had suggested that the dye couplers, which would ultimately color the images, be included in the layers of emulsion, but Mannes and Godowsky were unable, at that time, to find a method by which these color formers could be properly controlled while they remained an integral part of the film. Now they suggested that this problem be sidestepped for the moment, and that the couplers instead be added to the developing solution and controlled by the diffusion method they had used years before. This required such complex control of the processing operation that it could only be carried out in an elaborately equipped laboratory; photographers would have to send their film back to Rochester for processing—just as, 42 years earlier, the first amateurs using George Eastman's Kodak No. 1 had done with their black-and-white films. (Since this color film was for home movies, which had always been returned to the factory for processing, this system would not seem a strange one to the customers.)

On April 15, 1935, Eastman Kodak placed on sale the film called Kodachrome, largely the product of the genius of the two musicians. The year after its introduction in amateur movie-camera size it was offered in 35mm rolls for still cameras. With the limiting factor that inexpensive paper prints could not yet be made from Kodachrome—like all preceding color films, it produced a positive transparency—the century-old goal of a practical form of color photography was achieved. At first Kodak executives doubted that still photographers would want tiny transparencies that had to be held up to a light to be seen. Then, in a farsighted move, the company decided to return each transparency mounted in a frame of two-by-two-inch cardboard so that it could be inserted in a slide projector and shown on a screen. And the slide show, almost forgotten since the Victorian craze for magic lantern exhibitions, was reborn in a new guise.

Meanwhile, Mannes and Godowsky, together with the Kodak research staff, continued to work on several new variants of the three-color, dye-coupler subtractive color process. From these efforts came Ektachrome, a film with the couplers included in the emulsion so that it could be developed in any well-equipped darkroom, and Kodacolor, a negative-color film from which contact prints and enlargements could be made. But in the race to find

a way to include the couplers in the emulsion, Kodak was outstripped by the German firm, Agfa, for within months of the announcement of Kodachrome, Agfa began marketing its own color film, Agfacolor, which included the color formers in the film itself. Toward the end of World War II, United States troops seized the Agfa plant at Wolfen, near Leipzig, Germany and "liberated" the closely guarded technical details of the method of making Agfacolor; the patent rights were seized as war indemnity, becoming public property, and the formulas were soon distributed to film manufacturers around the world. Agfacolor thus became the basis for a variety of color processes, and by the mid-1950s many companies scattered from Italy to Japan were producing high-quality, easy-to-use color film for the amateur as well as the professional.

By this time, Mannes and Godowsky, their pioneering completed and their futures made secure by patent interests, had cut their ties with Eastman Kodak. Mannes returned fulltime to his first love, music. He became the pianist in a noted chamber music trio and joined his father at the Mannes School of Music in New York City, eventually taking over its management. Godowsky performed only occasionally as a professional violinist, but continued to take an active interest in all forms of color photography and engaged in research in color television as well.

With the perfection of various forms of dye-based color films, a new era opened for both amateur and professional photographers. So easy was color film to use and so pleasing were the results that by the mid-1950s hundreds of thousands of camera enthusiasts had abandoned black-and-white photography altogether. By 1964 American amateur photographers were taking more pictures in color than in black and white. But ease of use was not matched by ease of processing. While some films could be developed at home *(Chapter 6),* the operation was more involved than that required for black-and-white pictures. It was all the more astonishing then, when Edwin H. Land, president of the Polaroid Corporation of Cambridge, Massachusetts, announced in late 1962 that his picture-in-a-minute black-and-white process had been adapted to produce color photographs with a film called Polacolor. After snapping the shutter, the photographer simply pulled on the film tab at one end of the camera and 50 seconds later had in his hands a finished print in natural hues.

Although processing Polacolor is simplicity itself, the chemistry on which the film is based is extremely complex. Like all modern color films it is a subtractive type in which dyes lay down three primaries, but in Polacolor all chemicals—for automatic processing as well as coloring—must be included in a roll of film thin enough to fit inside a small camera. Contained within the .002-inch negative part of the film—about half the thickness of a human hair

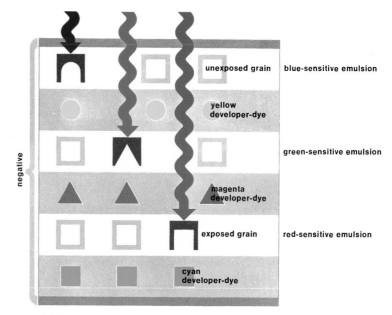

*A Polacolor negative consists of three double-tiered sections, each one divided into an emulsion layer of silver halide grains (gray-bordered squares) and a layer of developer-dye. Each emulsion layer is sensitive to one of the primary colors. Where blue light strikes, grains in the blue-sensitive layer are exposed (black symbols), setting up molecular traps for the yellow color dye chemicals nearby. Green light exposes the emulsion in the green-sensitive layer, passing through the blue section without affecting it. Similarly, red light passes harmlessly through the blue and green layers to expose the red-sensitive grains.*

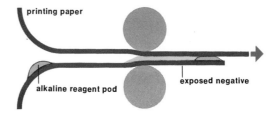

*Development of an exposed Polacolor picture begins after the tab on the camera is pulled. Attached to the film is a pod filled with an alkaline reagent. As the negative and positive are squeezed through rollers, the pod breaks, releasing the reagent to trigger development.*

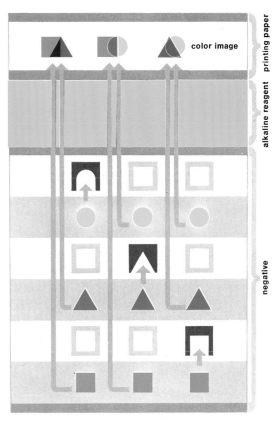

color image

printing paper

alkaline reagent

negative

*The alkaline reagent in Polacolor film, spread between the negative and positive, quickly works its way through the negative layers, releasing the special developer-dye molecules. These then spread (arrows) through the negative layers upward toward the printing paper. Wherever a developer-dye molecule touches an exposed grain of silver halide (black symbol), the molecule reacts with the grain, developing it and becoming trapped there. Because all developer-dye molecules start moving almost at once, they get a chance to react only with grains in the first emulsion layer they reach. Thus the yellow developer-dye reacts with—and is trapped by—exposed grains only in the blue-sensitive emulsion layer. The magenta and cyan in that part of the negative, encountering no traps as they spread, pass through that layer and reach the printing paper, where they mix to create blue. Similarly, exposed grains in other emulsion layers trap one color, and permit the other two to pass. All this takes 60 seconds. By that time the alkaline reagent has reached acid in the printing paper; the reaction between the acid and alkali stops all chemical action and binds the dyes into an image of luminous color.*

—are six distinct layers (plus a base and two spacers) required to create the negative image. There are three layers of emulsion, each layer being sensitive to only one primary color (no filters are needed). Next to each of these is a layer that contains specially designed molecules of developer-dye. In addition, there are four other layers that form the positive and one layer that contains a pod of alkaline chemical, known by its creators as goo, which triggers the processing.

When the user pulls the film tab, the film moves between two rollers that break the pod and release the alkaline solution. This solution seeps through all layers and activates the other chemicals to start the developing process. When the alkaline solution activates the developer-dye molecules, they move to the associated emulsion layer, developing a negative image and anchoring dye in each negative image area. Elsewhere—outside the negative image—developer dye is free to move to the paper to form a positive dye image. Thus yellow, for example, dyes the negative image in the blue-sensitive emulsion. Since the yellow dye was stopped at the blue negative image, only the other two dyes—magenta and cyan—get past that part of the negative image and move on to the positive, where their blending produces various shades of blue. The same principle applies to the other two color-sensitive emulsion layers and their associated layers of dye and developer. In this way all three dyes can find their way to the proper positive layer where they mix and produce all the hues of nature. Fixing occurs in the final seconds of the process when a small amount of the alkaline solution reaches acid molecules in one of the positive layers. The combination of acid and alkali generates water, which washes the remaining alkali from the positive image, halting the process. The dye molecules then can move closer together, forming a permanent bond to seal the picture.

With the introduction of Polacolor, photographers had a wide variety of color processes to choose from. No longer are equipment and methods usually associated with the chemist's laboratory needed to produce colorful pictures. The majority of the films can be used in any camera, from the cheapest to the most expensive, without special accessories. They take pictures readily in dim as well as bright light, almost matching the speed of black-and-white films. One type—Polacolor—produces a finished print on the spot, while some of the other kinds of film can be processed in an ordinary darkroom by techniques quite similar to those used for black-and-white films. All can reproduce the hues of the world with astonishing reality (or, at the photographer's option, with surprisingly effective unreality). And yet each reproduces tones in a slightly different way—one limpidly soft and romantic, another lush and rich, another brilliant and sharp—allowing every photographer to choose a film that presents his private vision of color. □

# The Color of the Past

Charming color pictures were being taken as long ago as the first decade of the 20th Century. The procedures that were used were cumbersome by modern standards, but the results were remarkably good, as the pictures on the following pages show. These examples were all made by the first practical color process, Autochrome, which was invented by the brothers Auguste and Louis Lumière of Lyons, France.

The Lumières built up the photographic supply business founded by their father (it still bears the family name and is today one of the largest film manufacturers in France). The two brothers were also pioneers in motion pictures; in 1895 they invented one of the first projection machines, a very ingenious combination of camera-projector-processing unit—all in one portable box—and sent crews out to take movies of far-off lands. Their firm produced more than 1,800 short films within a few years, but the brothers were less interested in entertainment than in experimental work (medical research occupied Auguste for much of the latter half of his 92-year lifetime).

Near the turn of the century the Lumières turned their talents to color photography and by 1907 had perfected the Autochrome process. Like other techniques of the time, it employed the additive method *(pages 14-15, 56-57 and 60-61)*, recording a scene as separate black-and-white images representing red, green and blue, and then reconstituting color with the help of filters. To do this on a single plate, the Lumières dusted it with millions of microscopic, transparent grains of potato starch that they had dyed red, green and blue. Then they applied pressure to the plate to squash the grains flat and fill the plate more evenly. The interstices between the starch grains were filled with carbon black, and the plate was covered with a thin coating of black-and-white emulsion. Exposure was made with the glass side of the plate facing the lens so that the grains acted as tiny color filters, each passing along light of its own hue; they thus broke the image up into dots representing the primary colors. After the plate was processed into a positive transparency, light passing through the grains gave each dot in the image its color.

Autochrome produced color more reliably than earlier processes, but it did have its own defects—principally the color spots that are noticeable in some pictures. These spots are not individual grains of colored starch—the diameter of each grain averaged .0005 inch, much too small to be visible in a reproduction. The spots appear because the tiny starch grains could not be uniformly mixed, and some stuck together in like-colored clumps, which are big enough to see.

In spite of its shortcomings, Autochrome quickly found wide use, and by 1913 the Lumière plant at Monplaisir, on the outskirts of Lyons, was turning out 6,000 plates a day. Autochrome plates continued to be produced until 1932—only three years before the introduction of the first modern color film. In that quarter century, they were used by amateurs and professionals in many countries to take informal family pictures as well as formal studio portraits. But seldom were the results any more delightful than in those Autochromes photographed, like the one on the opposite page, by Louis Lumière himself.

LOUIS LUMIÈRE: *On the Road to La Ciotat,* 1907

*Along a country road in the south of France,
members of the Winckler family of Lyons
—relatives of the Lumières—pose for a picture
by Louis Lumière. The Wincklers, traveling in an
elegant 1907 Peugeot Phaeton, were on their
way to the Lumière summer home in the resort
of La Ciotat. The subdued colors probably result
from the diffusion of light by the thick foliage.*

LOUIS LUMIÈRE: *Mme. Antoine Lumière and Granddaughter*, c. 1915

*Andrée, Auguste Lumière's eldest daughter,
shows her embroidery to her grandmother in a
portrait taken by her Uncle Louis. An indoor
Autochrome such as this required patience on
the part of the subjects; the plates were so slow
a pose had to be held for about 90 seconds.*

LOUIS LUMIÈRE: *Young Lady with an Umbrella,* 1907

JEAN TOURNASSOU: *French Soldiers in the Field*, c. 1915

*Vividly uniformed French infantrymen on bivouac near a shallow stream were recorded by Commander Jean Tournassou, head of photographic services for the French Army. The brilliant red of the breeches and deep blue of the tunics indicate the pure color that Autochrome plates could reproduce.*

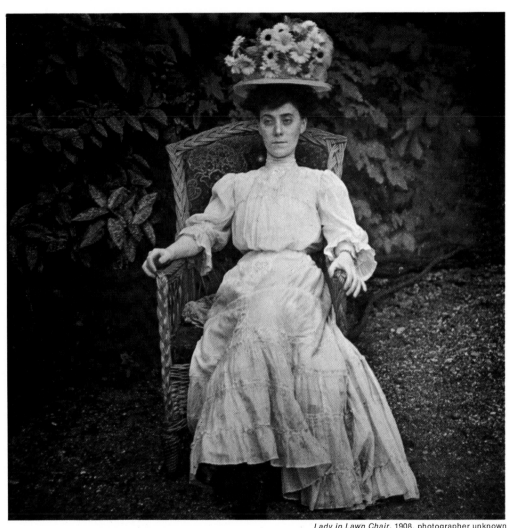

*Lady in Lawn Chair*, 1908, photographer unknown

A proper gentlewoman, an ornate chapeau of
daisies and net perched on her head, poses in a
garden in 1908 for an English amateur
photographer. Precise, easy-to-follow directions
for making color pictures were printed on
every box of Lumière Autochrome plates, and
they were used by some amateurs.

*Portrait of an Actress*, c.1912, photographer unknown

MRS. G. A. BARTON: *Harvest Bounties*, 1919

An English actress, her name now lost, strikes a theatrical pose for a 1912 color portrait in London's Dover Street Studios. The studio gave such pictures its own trade name—Dovertypes —but the plates were actually Autochromes, which were sold around the world.

This harvest fantasy was photographed in 1919 in England by an amateur, Mrs. G. A. Barton, whose skill made the most of Autochrome's capacity for recording the true colors of fruit, flowers, foliage—and that most difficult. of color subjects, the human complexion.

**Shooting Color Early or Late, Rain or Shine** 80

**Color from Dawn to Dusk** 82

**The Warm Glow of Early Morning** 84

**The Brilliance of Midday** 86

**The Richness of Late Afternoon** 88

**The Pale Hush of Twilight** 91

**Color and the Weather** 92

**Strange Hues from a Dark Sky** 94

**The Many Effects of Rain** 97

**The Color Extremes of Snow** 98

DOUGLAS FAULKNER: *Cotton-Candy Vendor in Twilight Colors, Mexico*, 1969

# Shooting Color Early or Late, Rain or Shine

The rules for beginners say: for natural-looking colors, take pictures in the middle of the day in sunlight or open shade. And the first time a photographer breaks the rules—risking a shot in rain or twilight—he may be astonished at what comes out of his camera. The colors he gets will indeed be different from those of a sunny day. Unnatural perhaps, but effective certainly—if he understands how color qualities are introduced into light by time of day and weather. For some of the most beautiful color photographs are those that ignore the rules and take advantage of the infinite variations of hue provided by natural light.

Sunlight, from a cloudless sky at midday, seems to be without any special color cast of its own—it is white light—and the human brain tends to accept midday colors as standard. The blues and greens and reds we see under those conditions are what blue and green and red *should* look like. Once we get those relationships fixed in our minds, we tend to carry them along with us, no matter what the actual light conditions may be. For example, we have learned, through years of looking, that the house on the hillside across the way is white and the trees around it green. Whenever we glance at them, we still think of them as being white and green—even though, in the glow of sunset, the house may have turned pink and the trees bluish or purplish black.

Although the human brain may be fooled, the camera is not. Color film reproduces what it sees, and this fact can be put to valuable use in getting varied and subtle pictures. Daylight follows a predictable cycle:

**Before sunrise**
In the earliest hours of the day the world is essentially black and white. The light has a cool, shadowless quality. Colors are muted. They grow in intensity slowly, gradually differentiating themselves. But right up to the moment of sunrise they remain pearly and flat.

**Early morning**
The instant the sun comes up, the light changes dramatically. Because of the great amount of atmosphere that the low-lying sun must penetrate, the light that gets through is much warmer in color than it will be later in the day—i.e., more on the red or orange side because the colder blue hues are filtered out by the air. Shadows, by contrast, look blue, because of their lack of gold sunlight and also because of the blue they reflect from the sky.

**Midday**
The higher the sun climbs in the sky, the greater the contrast between colors will be. At noon, particularly in the summer, this contrast is at its peak. Since there is no color in the white light coming from the noonday sun, there will be

no distortion of the relationships between colored objects. Each stands out strongly in its own true hue. Shadows at noon are black.

## Late afternoon

As the sun goes down, the light will begin to warm up again. This occurs so gradually that the photographer must train himself to detect it; otherwise the steady increase of red in the low light will do things to his film that he does not expect. Luckily, these usually turn out to be beautiful things. If the evening is a clear one and the sun remains visible right down to the horizon, objects will begin to take on an unearthly glow. Shadows lengthen and become blue. Surfaces become strongly textured and interesting.

## Evening

After sunset there is a good deal of light left in the sky, more often than not reflected in sunset colors coming from the clouds. This light can be used, with longer and longer exposures, almost up to the point of darkness, and it sometimes produces pinkish- or even greenish-violet effects that are delicate and lovely beyond imagining. Just as before sunrise, there are no shadows and the contrast between colors lessens. Finally, just before night, with the tinted glow gone from the sky, all colors disappear; the world once again becomes a pattern of black and gray.

## Weather

There is no such thing as bad weather for color pictures, for anything that obscures sunlight alters colors in useful ways. Fog gives pearly, muted tones, much like those recorded before sunrise. Stormy weather adds drama and richness to the deeper hues. And rain can dim some colors and enrich others, while creating shining surfaces with startling reflections.

Rain and fog also bring problems. One is a diminution in light intensity, requiring long exposures. Long exposures change the behavior of the color elements in the film. Green may not respond as fast as red, for example, giving a reddish cast and black where greens belong. This is one result of what is known as reciprocity failure, and it can be corrected somewhat by filters. Or it can be ignored if the imbalance is unimportant—or desirable.

For what is "good" color depends on the photographer's intent. As the great photographer Andreas Feininger has pointed out, color can achieve one of three goals. It can be *natural,* i.e., the color in the transparency can match the color of the object viewed in white light. It can be *accurate,* in which case it may not look natural. It can be *effective,* esthetically satisfying, regardless of accuracy or naturalness. These goals can be achieved by exploiting the ways in which light changes with time of day and weather.   □

# Color from Dawn to Dusk

The first light of day is a magical time. The world is wet and still, and dew lies on the grass. Delicate wisps of fog often blur and blot the landscape. In the earliest hours, before the light is strong enough to see well, there is little point in trying to make color pictures, even at long exposures. Everything is seen—by eye as well as film—in shades of black and gray, with perhaps a tinge of blue.

But as the light strengthens, colors begin to emerge; as soon as any of these can be differentiated, the photographer can go to work. In the picture at right, faint hints of green and blue are already appearing in the water. The grassy bank is definitely green, a single positive note of color in what is otherwise a mysterious and luminous near-monochrome. All of these qualities will change markedly as the time passes and the light intensifies. Many photographers take advantage of the shifting and strengthening of tones that the day brings by looking for one good subject and then shooting it over and over as its values alter.

A tripod is often required for early-morning work because exposures may be long. Check the meter reading frequently; the light increases faster than seems possible. And bracket the shots: half a stop up for a transparent bright effect (as in this misty lake scene by Jean-Max Fontaine), half a stop down for a stronger, richer picture.

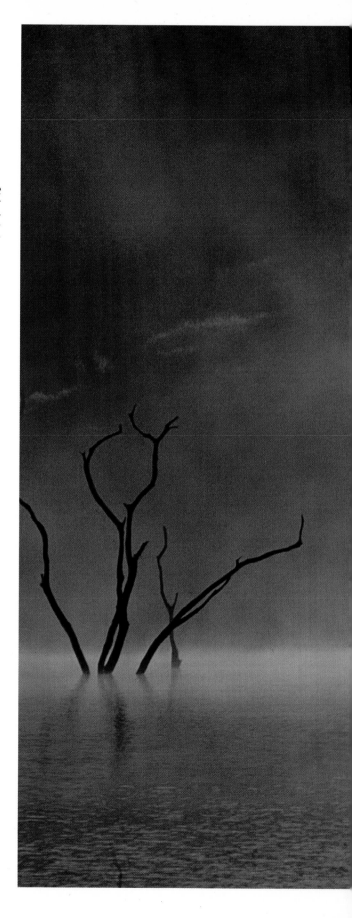

*By rising even before the animals that frequent this waterhole, French freelancer Jean-Max Fontaine was able to record an eerily pale early-day view of India's Periyar Lake. His Nikon's long-focal-length lens (200mm) added to the effect of unreality by distorting the relative sizes of the trees. There was ample light—Fontaine made this exposure at 1/125 second and f/8.*

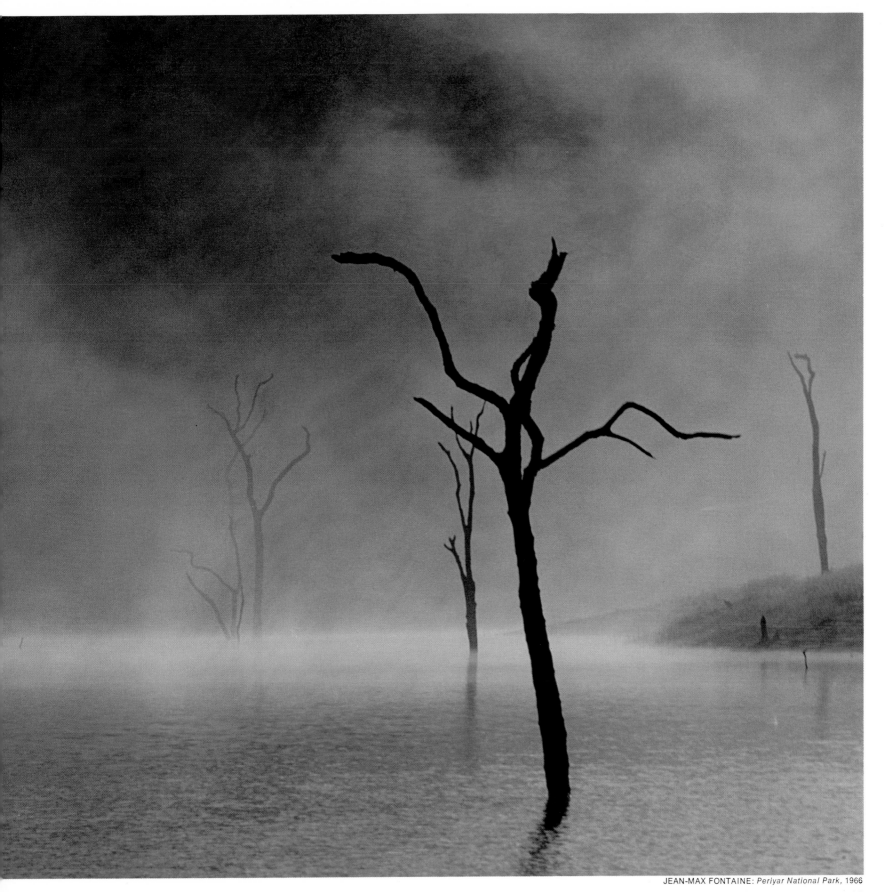

JEAN-MAX FONTAINE: *Periyar National Park*, 1966

# The Warm Glow of Early Morning

The sun is now up, but still very low on the horizon. The light is warm enough to make the bricks of these houses glow. At midday they will be just as red, but their relationship to the other tones in the picture will be different, and that warmth of brick will be lost among the hard colors and black shadows that surround it. Here the areas that are not hit directly by the sun are touched with blue. The large shadow at far right has blue in it. The white storefront at the far left has become blue. Even the windows swim with blue reflections.

It is these elements—these subtle color imbalances—that make of this picture not just any street, but a special, after-sunrise, empty street, silent still, but about to erupt into the roar and clutter of the day. The picture was taken by Bill Binzen from his own apartment window. He had watched the early-morning light creep across the street many times and finally decided to photograph it because it reminded him of a painting by the 20th Century American artist Edward Hopper—an almost identical view of a row of almost identical brick apartments that conveys the same sense of silence, of waiting for the day's work to begin.

Another aspect of the early-morning light that the photographer can exploit is the beautiful shadows cast by the low sun. Here the fire escapes announce themselves with stripes elegantly slanted across the building fronts. At noon this effect would be lost; the shadows would fall straight down and disappear among the slats of the fire escapes.

*Early light of a September morning gives a warm glow to the buildings along a still quiet New York street. Using a wide-angle lens (20mm) to include four buildings only a street's width away, Bill Binzen exposed for 1/125 second at f/6.3.*

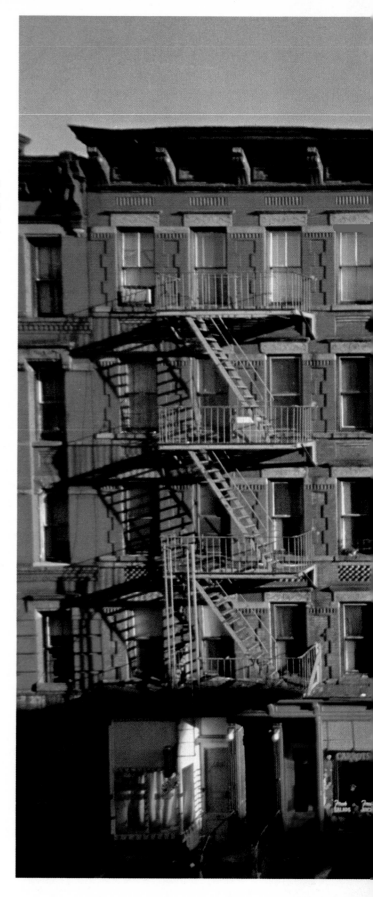

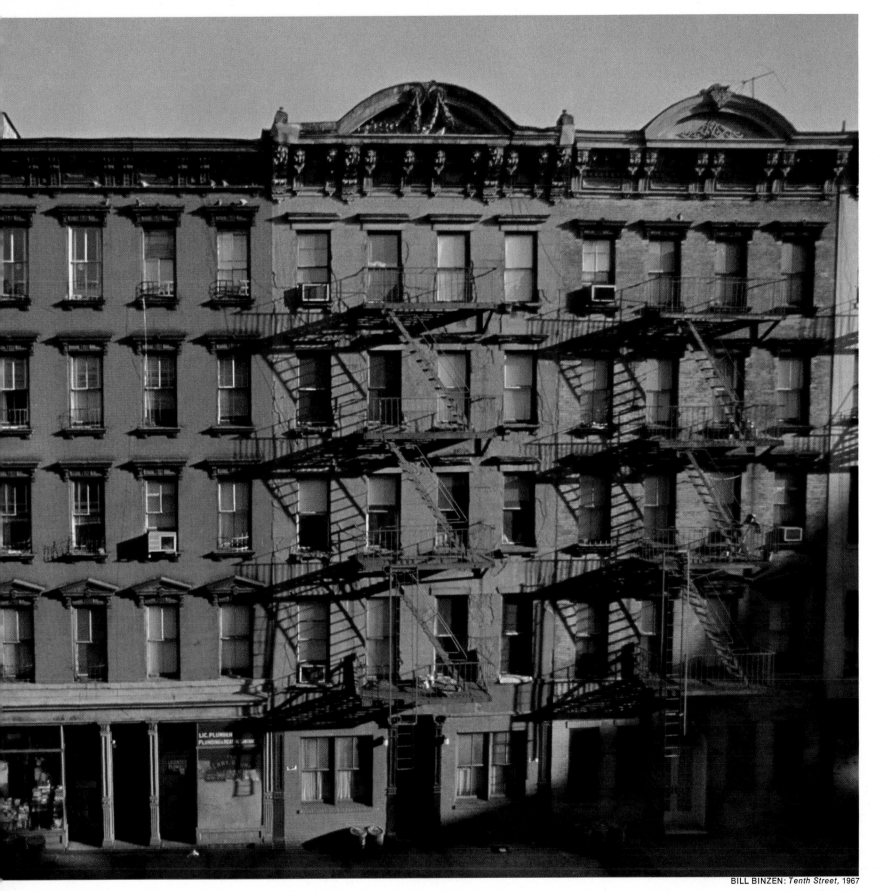

BILL BINZEN: *Tenth Street*, 1967

# The Brilliance of Midday

With the sun at its zenith, the light is now the closest to pure white that it will ever be, and the contrast between all colors is at its strongest. The result is a very bright picture. In the example at right the sky is a strong blue, the water even stronger. The boats are bright orange rimmed with green, the boatman's slicker bright yellow. These clashing colors, found only in a photograph taken at the blaze of noon, make the heat strongly felt. The viewer is tempted to escape by crawling into one of those puddles of shade under the boats.

But for all the brilliant colors, this is not a really "colorful" picture. The very strength of the different tones tends to be self-defeating; they cancel each other out. What is left is a powerful assault on the eye, to convey a sense of heat and light pounding down on a tropical beach at midday.

By their very brightness, and by the accent on form that results from the sharp contrasts between dark shadows and hard highlighted surfaces, pictures made at midday tend to become abstractions. It is not a good time to photograph people. There are 10 persons in this picture, but none—with the possible exception of the two children —comes alive as an individual. Their faces are hidden in the shadows cast by their hats, and they are merely decorative figures in a landscape.

*As the midday sun scorched the sands of one of the West Indies islands called Les Saintes, inhabited by fishermen of Breton descent, Bill Binzen attached a 28mm lens to his Leica to get this vivid photograph at 1/250 second and f/8. The wide angle of view provided by the short-focal-length lens enabled him to include not only the small boat anchored just offshore but also the beached rowboats in the foreground.*

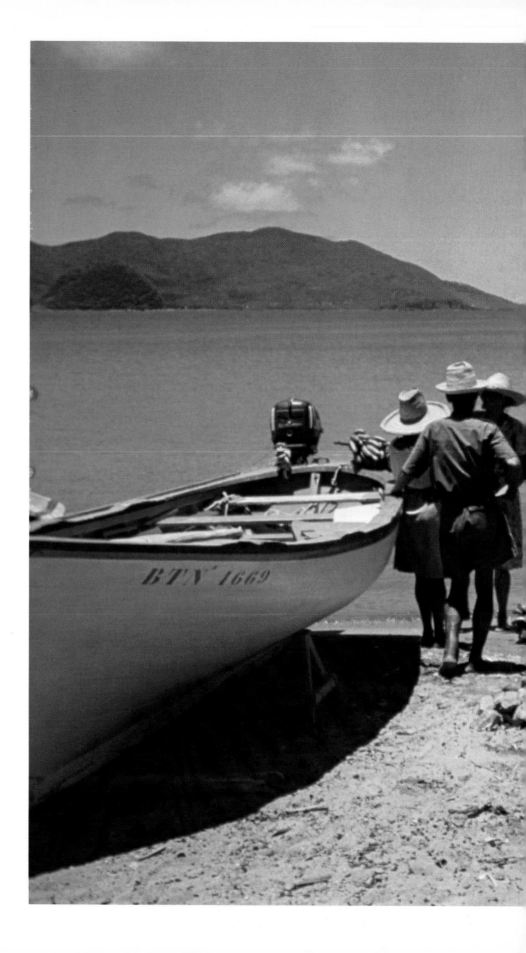

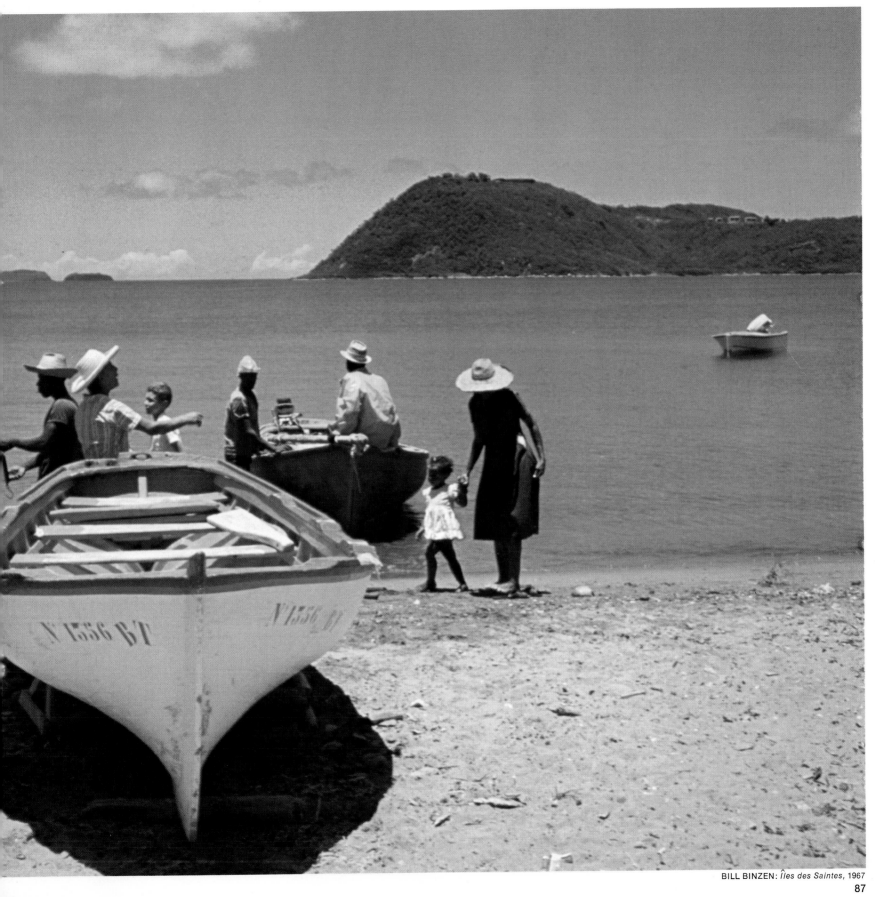

BILL BINZEN: *Îles des Saintes,* 1967

# The Richness of Late Afternoon

This is generally considered the most rewarding time of day for photography, and for a good reason. As in the early morning, the elements of low, warm light and long shadow are present, but unlike the situation in the morning this is not a vanishing condition—it grows stronger and more dramatic as sunset approaches. The photographer finds himself working faster and faster to keep up with the wonderful enrichment of the scene that develops before his eyes. Once again, he should pay close attention to his exposure meter; the light at this time dims fast and longer exposure times are needed every few minutes. If he can bring himself to stay in one place, he should do so. He should also try to anticipate what will happen to specific objects. They may be cut off from the sun by an intervening hill or building before the peak light condition is reached. Many photographers walk around and watch what happens to a scene as the sun goes down, then come back the next day and put their observations to work.

The picture at right is a superb example of the use of warm light and long shadow. The trees are golden on one side, greenish-black on the other. The whole graveyard stands out, more unreal than real, thanks to the shadowed hill behind it. The angle of view is perfect—if the photographer had stood farther to the right, he would have seen too much of the sunny sides of the tombs. Here he has caught only their edges; enough to give them form, enough to do justice to the pale colors of their shaded sides, yet not enough to overpower the glints of light on the smaller headstones, or even the shoes of the people walking across the field.

*A combination of late afternoon lighting and a long-focal-length lens give the impression of a Mexican metropolis until the tombs and the tiny, dark figures of the walkers reveal it as a cemetery. Douglas Faulkner shot the picture with a 105mm lens on his Nikon F, and underexposed slightly—1/125 second at f/4 —to emphasize the deep, rich colors.*

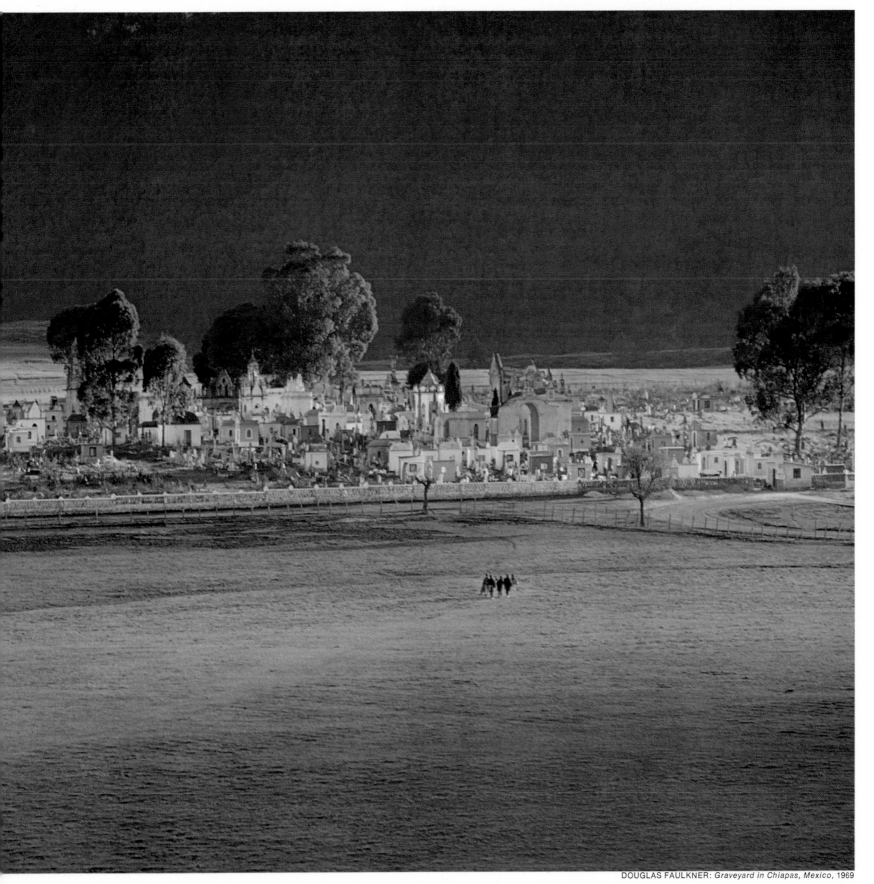

DOUGLAS FAULKNER: *Graveyard in Chiapas, Mexico,* 1969

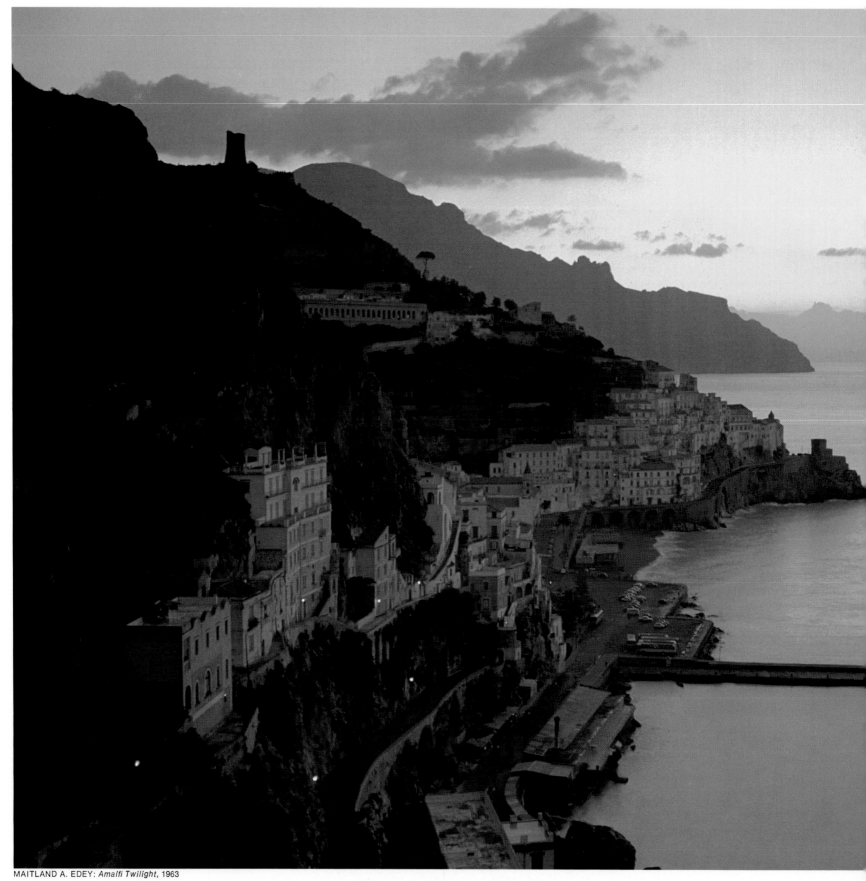

MAITLAND A. EDEY: *Amalfi Twilight,* 1963

# The Pale Hush of Twilight

*The normally bright-blue color of Italy's Gulf of Salerno becomes purple while the houses of Amalfi take on a cool glow in the last light of day as the sun disappears below the horizon.*

The high point of the evening's special quality comes and passes quickly. Too early, and the hush of twilight is not there; too late, and the differences in colors disappear, exposure times get too long and the picture becomes distorted or too dark.

The example at left has caught the lucky moment. Traces of a fine sunset linger in the sky and are reflected from the sea. These two light sources produce a bath of blue-violet that suffuses the mountainous Italian coast. It is getting dark down in the streets of Amalfi, a few lights wink on, a last faint wave washes up on the beach. But the facades of the houses perched on the cliffs are still aglow with just enough light to show that one is white, another pink. In minutes these differences will be lost; the violet will engulf them.

Evening pictures require long exposures and a rock-still camera, so a tripod or clamp is a must. And because the illumination is so difficult to gauge, extensive bracketing is required. This photograph was made by an amateur who took five different exposures: at the correct aperture indicated by the meter reading, at half an f-stop wider, at half an f-stop smaller, at a full stop wider and at a full stop smaller. As it turned out, the shot that was a full stop over the indicated setting produced the best picture. The great amount of light in the sky and sea had weighted the meter reading, and the other shots were all too dark.

# Color and the Weather

As if the photographer were not challenged enough by the different angles and colors of light at different times of day, his options are even further expanded by the weather. Just because it is raining or snowing there is no reason to stay indoors; pictures can be found that are unlike anything one can make in clear weather. (One caution, however: cameras must be carefully protected against moisture.)

Fog is a great challenge in any form, from the thin wisps that cling to the ground at sunup to heavy pea soup that seems to blanket everything from view. Even impenetrable fog is useful if the photographer can find some vantage point—perhaps a hill or skyscraper —from which he can shoot down at trees or other buildings whose tops have broken through into the clear colors of the open air. Or he can find rich colors in strong-shaped foreground subjects like archways or street corners, allowing them to loom through the murk while everything else disappears.

Ground fog offers many more opportunities. It is often not solid and if the photographer can find a subject with strong receding elements in it—like the dead trees on pages 82-83—then he can exploit their progressively paler forms to convey a sense of space, almost of infinity. Here again, a powerful foreground shape helps.

Overall light mist *(right)* can produce pictures of unusual delicacy. Their colors will be muted, often to the faintest of pastel tones. Details will be blurred (it is best to avoid subjects for which good definition is important). Scenes also tend to flatten themselves out into two dimensions; do not count on shadows to provide contrast or modeling —there will not be any.

Exposure in mist is flexible; it depends on the effect desired. But be careful not to overexpose: there is more light than there seems to be in that pearly air. In order to obtain rich, saturated colors, deliberately underexpose at least one f-stop.

*LIFE photographer Alfred Eisenstaedt waited two hours for the fog-diffused light to create a balance of colors at Connecticut's Mystic Seaport—the grayness of still water matching the mist-filled atmosphere and the red roof at right faintly brighter than its reflection.*

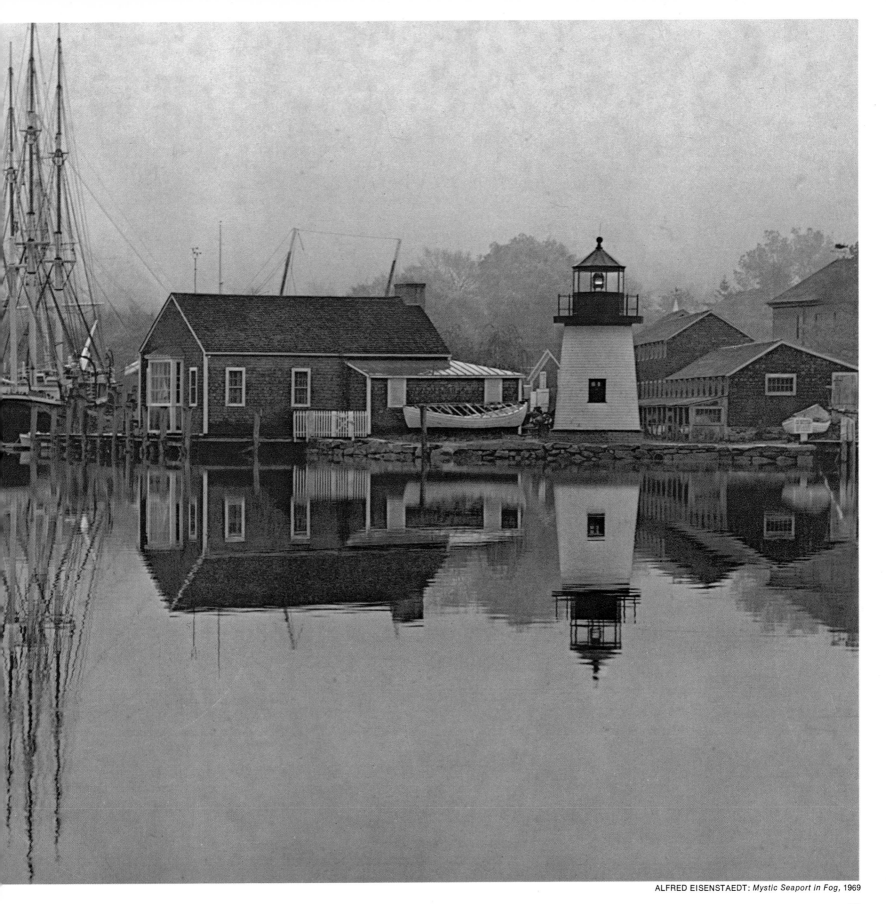

ALFRED EISENSTAEDT: *Mystic Seaport in Fog,* 1969

# Strange Hues from a Dark Sky

FARRELL GREHAN: *Martha's Vineyard,* 1963

Some of the most interesting pictures are often found during the moments before a storm, when the sky darkens and colors are strangely transformed. In the picture above, taken shortly before a thunderstorm broke, reflected light has thrown green shadows into the porch but created strong blue accents in the windows. These unexpected colors provide a startling backdrop for the rich, natural hues of the flowers.

In the picture opposite another storm gathers and the children scuttle for cover, their shirts bright under the lowering clouds, the side of the church darkened by a rich green shadow. In bright sunlight this would have been just another routine snapshot.

The twin spires of a steeple and a fir tree direct the viewer's eye to the gray clouds of an approaching storm—an ominous backdrop for the bright colors of children on the lawn—in Bill Binzen's photograph of the Pearson Point Baptist Church on Washington's Puget Sound. It was shot at f/5.6 with a 28mm lens.

◄ Without showing the darkening skies that loomed over a summer house on Martha's Vineyard, Farrell Grehan conveyed the gloomy weather by catching the distorted background colors, which contrast sharply with the rich orange and pink of the flowers along the porch.

BILL BINZEN: *Puget Sound*, 1967

DON HINKLE: *Wet Motorcycle,* 1970

LEIF-ERIK NYGARDS: *Washington Square Park*, 1967

*Swedish freelancer Leif-Erik Nygards used a shutter speed of 1/60 second with an aperture of f/4 on his 90mm lens to shoot the waterlogged scene above. The soft shades of green are only briefly interrupted by the muted yellow of the refreshment stand's awning and by the action of the youth sloshing his way through the park.*

◄ *After a spring rain, Don Hinkle went out on New York City's streets with his Nikon and a 35mm lens. Fascinated by the glistening colors of a parked motorcycle, he managed to mirror the similar fascination of a rain-drenched youngster. Hinkle used a relatively long exposure time— 1/15 second at f/2—but he was still able to get a sharp picture with his hand-held camera.*

Rain is interesting to the photographer for several reasons. The first reason is what it does to the atmosphere and to overall color balance. The second is the challenge of photographing the rain itself. The third is what it does to surfaces and their colors.

Overall, falling rain has a dimming and blurring effect. Color contrasts are lessened, details are lost. In the picture above the whole scene is a soft, sopping green. It is wet in the pools rapidly gathering on the ground, in the hunched figure of the man with his clothes plastered to him, in the slanting streaks of the raindrops themselves.

The color of things is heightened by water. Wet rocks, otherwise a grimy gray, become interesting shades of brown, green and purple. Shiny surfaces like the motorcycle opposite glow with silver and blue droplets. And puddles provide dramatic color accents like the red of the traffic light.

97

# The Color Extremes of Snow

NORMAN ROTHSCHILD: *New York Snowstorm,* 1968

Snow is a problem. During snowstorms colors are very subdued, and detail disappears. To avoid total monochrome, it is necessary to find a tinted light source somewhere. That is what Norman Rothschild did with the neon sign in the picture above. He also was able to pick up a subtler and fainter glow in the farthest shop window.

The opposite problem is posed by sunlit snow. Contrasts of light and dark are extreme and very difficult to handle because the light reflected from the snow on the ground, added to that from the sky, is overpowering. It also gives too-high meter readings, which lead to underexposed pictures.

By far the best time to photograph sunlit snow is late in the day. Then it takes on lavender or golden tints, and its surface texture begins to show. And if the angle is properly chosen the low sun vibrates in a million points of light reflected from the snow crystals. ☐

*Pausing at a corridor window on the 17th floor of his apartment building, Norman Rothschild was struck by the orange glow of the restaurant's neon sign blazing through a New York City snowstorm. He attached an 85mm lens to his Konica and made this picture on high-speed Ektachrome, exposing a full second at f/1.4.*

**Getting the Most from Color** 102

**The Natural Beauty of People** 104
**Delicate Tones in Indirect Light 106**
**Bold Uses of Direct Light 108**
**A Gentle Aura from Backlighting 110**
**Fill Lighting for Indoor Shots 112**
**Matching Artificial Light to the Setting 114**
**The Pitfall of Unwanted Color 116**

**Capturing the Hues of Man's Possessions** 118
**Colorful Surroundings for Animal Portraits 120**
**Diffuse Colors for Appealing Still Lifes 122**
**The Essence of Flower Colors 124**
**The Fine Art of Copying Fine Art 126**

EVELYN HOFER: *Portrait in Windowlight*, 1969

# Getting the Most from Color

Most people, most of the time, photograph subjects they cherish: their families, their friends, their pets, houses and gardens. Color is what often makes images of these subjects especially memorable. A color photograph of a human face can capture the most intricate and subtle play of tints; a still life of apples can suggest the very essence of deliciousness; a fine color picture of a dog all but re-creates the bark. The techniques for getting good color pictures are the same as those for black-and-white pictures—but they are a little more demanding, for color film cannot tolerate nearly as much error in exposure, nor is it particularly good at revealing detail in both the very dark and the very light portions of a scene.

The most common subject of color pictures is, of course, people, and justifiably so. The human face is the most interesting and—when successfully shot—the most rewarding image to capture on film. But the colors in the human skin are extraordinarily complex, and deserve to be approached with all the care and respect that the photographer can muster.

Paradoxically, it is the studio portrait taken under controlled-light conditions that can turn out to be the trickiest, for unless the photographer knows exactly what he is doing he can get into all kinds of trouble. His strong studio lights will bring out with pitiless clarity every flaw and blemish in the face, along with whatever sallow or mottled tones the skin may have. The more lights he uses to "control" the situation, the greater his problems. A light used to reduce a shadow in one part of the face may create shadows in another part. He may even find himself with overlapping shadows, and wind up with a totally unreal and artistically disastrous result.

Natural light is usually simpler to handle, although it puts limits on what a photographer can do. A masterful solution to a natural-light problem is shown in the photograph on the previous page, depicting a girl standing close to a window. It is nearly midday. The sunlight is sharply angled and pitilessly hard, but it is striking a counter and wall that are predominantly white. This throws so much reflected light around the small room that overall contrast is reduced. The critical decision in this picture was in the placing of the girl. The photographer put her in front of the sunlight, which now acts as a hard backdrop for a figure that can be reproduced much more tenderly and in greater detail by the reflected light bouncing off the white surfaces of the room. Although it is not actually doing so, the light seems to be pouring through the window directly onto the girl, leaving half her face in shadow and giving a wonderfully sculptured effect to her body, picking out the smallest wrinkles in her shirt in a way that only a combination of direct and reflected light could do.

Out-of-doors, the direct rays of the sun may pose some rather more awkward problems. This is particularly true if the sun is high, near midday, when

it gets in people's eyes and casts shadows below the nose and lower lip. Yet there are solutions to these difficulties. Sunglasses and hat brims can keep the subject from squinting. Faces shot in profile may not be as harshly shadowed as front views *(pages 108-109).* And using the direct rays of the sun for backlighting yields some of the most arrestingly beautiful pictures of all *(pages 110-111).*

Open shade or a cloudy sky offers much more kindly illumination outdoors. The most delicate colors show up under soft and diffused light, and shadows will be absent or merely suggested. Indirect light can impart extraordinary luminosity to the human face, although the photographer's eye cannot see this as well as color film can. There is one major pitfall, however: faces shot under foliage may carry a faint greenish glow from the leaves; those shot in the shadow of buildings, particularly white ones, may become faintly bluish from the reflection of the sky. These shade-induced tints, like all the subtle tonal imbalances encountered in color photography, can be exploited to advantage, or they can be balanced out by filters.

The esthetic options—and cautions—involved in taking color pictures of people apply also to color pictures of things. Each kind of photograph brings its own special set of conditions that may handicap or help the photographer. But there are techniques that make it fairly easy to master even the most difficult subject—the complex hues of a painting, for example, or the colors of both the outdoors and the indoors in a shot that includes both. The marvel of modern color film is that, despite the bewildering lights and hues of the world, it can meet nearly any challenge. □

# The Natural Beauty of People

Some of the most charming color pictures of people are those shot indoors by the natural light that enters through windows or doors. These two examples by Humphrey Sutton have in common the strong modeling and interest supplied by a highly directional light source, but beyond that they are entirely different. The one on this page was made in direct sunlight and the one opposite in the diffuse light of a cloudy day, its soft illumination surrounding the face of a man relaxing with his drink in an Irish pub.

The picture of the mother and children presented greater problems. The sun bearing directly on the two figures would have made the contrasts between light and dark unmanageable except for the time of day and the way in which the subjects are posed.

Arms and legs are positioned so that they catch the light and provide essential contours. And the light itself is that of late afternoon. In this cozy kitchen at day's end, the chrome bucket gleams, the two faces are aglow, and the face of another child can be seen unexpectedly emerging from the shadows.

*The photographer's problem in making this picture was to bring up the boy's face to the point where it could be seen without overexposing the brightly lit wall and, most importantly, the faces of his sister and mother. He did it by waiting until late afternoon, when the direct sunlight was at its softest, and by counting on a little reflected light from the back wall to give the boy just the emphasis needed.*

HUMPHREY SUTTON: *Mother and Children in the Aran Islands,* 1966

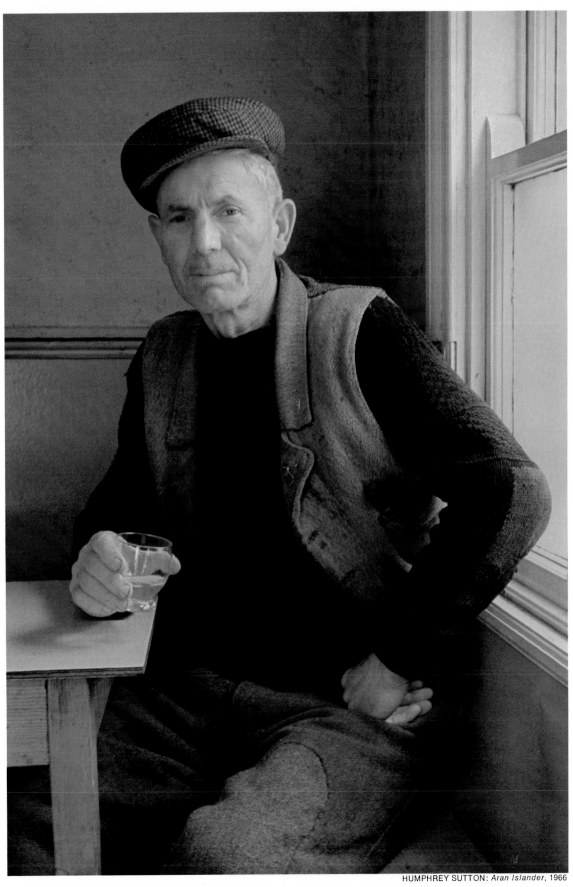

This picture was shot on an overcast Irish day, and the light filtering through that large window is as soft and diffuse as a cloud. The light side of the face is set against the shadowed corner of the room, the dark side silhouetted against the light wall, their colors superbly balanced. We know this quiet drinker, the emphasis first on his patient cynical face, second on the glass in his hand. The patterns of his pullover and cap add just the right touches; everything else in the picture is dark and unobtrusive.

HUMPHREY SUTTON: *Aran Islander*, 1966

# Delicate Tones in Indirect Light

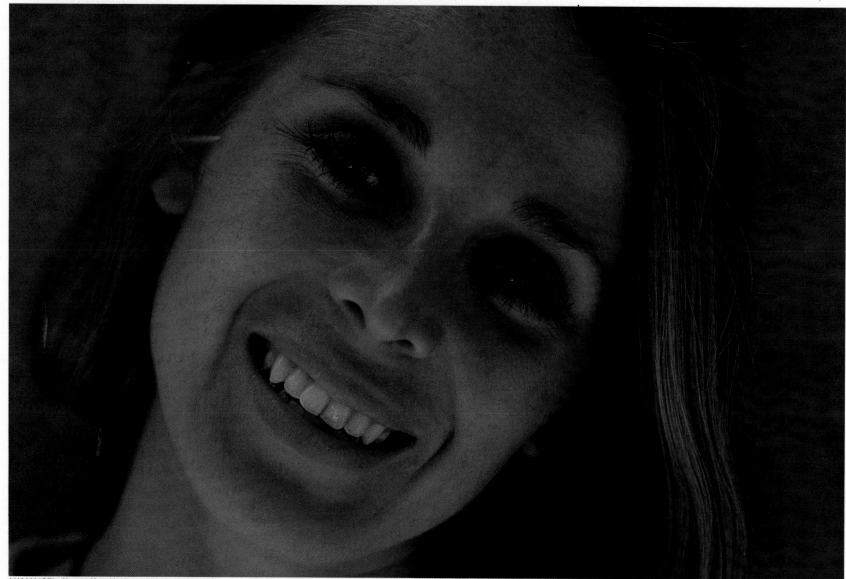

JAY MAISEL: *Young New Yorker*, 1964

The diffuse quality of reflected light is kind to the human face, giving it subtle tones and a soft glow that are always complimentary. Opportunities for exploiting such indirect light outdoors are ever present. For the two pictures on these pages, the photographers utilized sunlight that was bouncing off the walls of nearby buildings. One caution: make sure the wall is a warm or neutral color—otherwise the face may gain an unexpected (and undesired) hue due to the subtraction of certain wavelengths from the light *(pages 116-117).*

*Standing in shade and illuminated by late-afternoon sunlight reflected by a white wall, a girl radiates youthful health. Jay Maisel took the picture with a 90mm macro lens, which can focus on very near objects, at 1/250 second and f/4.*

Modulated pink tones distinguish Humphrey Sutton's shot of a sleepy-eyed Irish lad sitting in open shade in the town square of Galway. Light from the early-morning sun was reflected onto the boy's face from a building across the street.

HUMPHREY SUTTON: *Galway Boy*, 1966

*The Natural Beauty of People: continued*

# Bold Uses of Direct Light

JOHN DOMINIS: *Mexican Schoolgirl*, 1968

Strong, direct sunlight is usually the worst possible illumination for pictures of people. It may draw dark shadows across a face or cause the subject to squint—but it can perform magic as well. In the shot of the Mexican child on her way to a school ceremony, the direct rays of the morning sun evoke a very special mood, a lovely mix of little-girl happiness and modesty that is expressed by her luminous, averted face. And the low-lying sun casts no facial shadows. John Dominis could have shot from another angle to emphasize the brilliance of her costume, but he wisely kept the dress in shadow. Her face alone, lighted up as if by excitement, conveys the special meaning of the festive moment.

Since the girl's face was turned away from the camera, the photographer did not have to worry about her squinting. Vernon Merritt's picture on the opposite page shows another solution to this problem: the girl was able to look toward the bright sky with open eyes because she was wearing sunglasses. Here, direct lighting is used to suggest the outdoor nature of the girl. Deeply tanned, with a spark of light leaping from the rim of her stylish glasses, she truly looks like a sun worshiper.

*John Dominis caught this candid shot with a 35mm lens on his Nikon, set at 1/100 second and f/5.6. The exposure was set to capture the shadowed colors of the girl's fiesta dress.*

Vernon Merritt used a wide-angle 28mm lens for his picture of a girl viewing New York from a car. The lens makes her chin seem large but emphasizes the skyward tilt of her face.

VERNON MERRITT III: *View on Park Avenue*, 1969

109

# A Gentle Aura from Backlighting

SAM ZAREMBER: *Flower Vendor*, 1968

One way of defeating the hardness of direct sunlight with its ugly nose and lip shadows is to turn the subject away from the sun so that his whole face is shaded. This technique can result in pictures of great originality and beauty. Care must be taken to keep the direct sun off the lens: use a lens hood, or shade it with a hand or piece of cardboard. The picture at left was shot early in the afternoon with the sun coming in high over the woman's right shoulder. It made a magnificent nimbus of her hair, which succeeded in lighting up the right side of her face, and even sent a glow around front to fill in her features.

The later the hour, the harder it is to keep the sun out of the lens when shooting toward it. Try to put the sun behind something, or above the picture frame *(right)*. In these situations accurate exposure is a guess. As Sam Zarember said of the photograph at right: "I started by making a black picture and ended with a white one. Somewhere in between I knew I would get what I wanted."

*The focus in this picture was on the woman's eyeglasses; it was kept deliberately shallow to blur the strong colors in the foreground. As a result, everything else appears to be a fuzzy blaze of light. The gleaming crescent at the bottom of the left eyeglass pulls the whole picture together and is a lucky accident.*

*The light for this picture had to be very low to ▶ shine through the petals of the jonquils—and to penetrate the girl's dress to indicate her pregnancy (right). It was shot almost directly into the sun, which would have burned out the girl's face if a lock of hair had not been there to soak up the rays and reveal her profile.*

SAM ZAREMBER: *Indications of Motherhood*, 1969

# Fill Lighting for Indoor Shots

With artificial light, a photographer can orchestrate his pictures almost like a musical conductor, adding shadows to emphasize the shape of a face, creating highlights, employing diffused illumination for a subdued mood or otherwise modulating the lighting devices at his disposal. However, in color photography—as in music—a slight misstep can do a considerable amount of esthetic damage. Freelance photographer Peggy Barnett purposely demonstrates a common error in the portrait of her 89-year-old grandmother at right.

Light was provided by two electronic flash units to the left of the subject, and a diffusing screen of tracing paper was used to soften the illumination. But, as the picture shows, the shadowed side of the woman's face has gone almost completely black even though it was receiving some illumination. The contrast range of color film—its ability to show detail in both the light and dark areas of a scene—is much less than that of black-and-white film.

To reduce the contrast in the face and reveal a natural-looking amount of detail in the shadowed area, the photographer set up a "fill" board, which bounced light from the flash units back into the shadow. (Posing her grandmother near a white wall would have done the job just as well.) The outcome of this simple addition to her lighting arrangement is the excellent portrait shown on the opposite page.

*Even though the picture at right was shot in very diffused lighting, there was still not enough illumination striking the right side of the subject's face; the result is a black shadow. If the photographer had exposed for the shadows, the highlights would have been overexposed.*

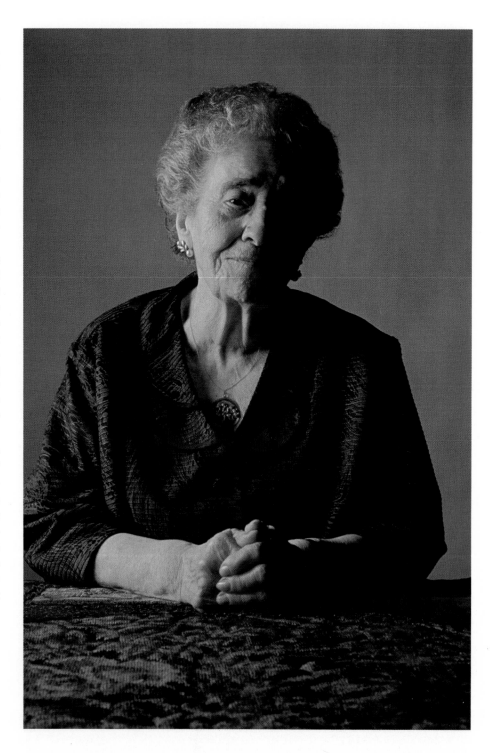

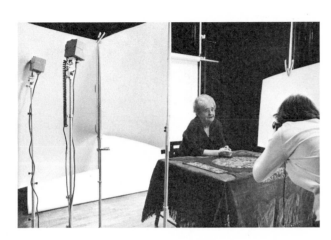

Two electronic flash units plus a reflecting fill board set up as shown above illuminated the portrait at right. Two flash units are set about four feet from the subject, behind a sheet of ordinary tracing paper, which softens and spreads their light. A sheet of cardboard perpendicular to the diffusing paper prevents light from spilling onto the background. On the other side of the table another sheet of white cardboard reflects light onto the shadowed side of the subject. Peggy Barnett does not use a tripod when shooting portraits because she wants maximum freedom to vary her angle.

Here the shadow is preserved, but enough light is reflected from the fill board to show detail in the subject's face. To catch this animated expression, Peggy Barnett had her grandmother recite poetry during the shooting session.

# Matching Artificial Light to the Setting

Pictures that depict people in their everyday surroundings possess an extra dimension of naturalness that studio portraits cannot match. To preserve the authenticity of the setting, the light ordinarily used in the room is ideal for picture taking, but it may well turn out to be inadequate for the exposure requirements of color film.

Faced with a need for artificial illumination in such situations, many photographers deploy lights or reflector boards just as they would in a studio, striving for good detail and modeling. However, in the pictures shown on these pages, freelance Evelyn Hofer took a different tack: she tried to recreate the normal light of the settings with her artificial lights.

The aproned man at right owns a small Italian delicatessen that is normally illuminated by two bare bulbs. Miss Hofer retained the lighting milieu by setting up a single electronic flash unit beside the nearest bulb. Although it cast deep shadows that might have been unacceptable in a studio portrait, this harsh, angled light evokes the cramped atmosphere of a neighborhood store with great success.

The subject of the portrait on the opposite page is an artist who works in a barnlike loft that is ordinarily illuminated by fluorescent lights on the ceiling. These could not be used, since fluorescent light gives a green cast to color pictures unless special filters are employed. Instead, Miss Hofer matched the original illumination by aiming two electronic flash units at the ceiling. The bright light, cascading from above and bouncing off the walls and floor, dispelled all shadows—but it showed the artist in her natural environment.

For a picture of artist Kiki Kogelnick in her studio, Evelyn Hofer directs two electronic flash units straight up at the ceiling (above). Although the subject is drenched with light from overhead, her face is clearly visible under the brim of her hat because of the high degree of reflection from the white walls. A black outfit isolates her from the blaring colors in the background. The picture was shot with a 120mm lens on a 4 x 5 Linhof view camera.

To mimic the light cast by dangling, bare bulbs in a New York delicatessen, Miss Hofer set an electronic flash unit eight feet high and aimed it downward at a 30° angle (below). Her unit contained a modeling light—a nonflashing light turned on by a switch—so that she could check how the shadows would fall before triggering the flash. The final picture (left) was shot with a wide-angle lens to gather in a sizable view of the grocer's shelves.

# The Pitfall of Unwanted Color

Practically every photographer has, at one time or another, fallen into the trap demonstrated in the two pictures at right, in which a subject takes on the colors cast by the walls he is leaning against. This unwanted tinting is not the fault of the photographer's equipment. Quite the contrary; the film has honestly recorded the fact that the subject is being illuminated by colored light reflected from the walls.

Portraits shot beneath trees offer the most familiar example of this problem. A pretty girl photographed under such seemingly flattering conditions is likely to appear a seasick green, since the sunlight that reaches her is filtered and reflected by the green foliage. Too late, the photographer remembers that the eye tends to perceive almost every scene as if it were being illuminated by white light, whereas color film detects the true spectral make-up of light.

With experience, a photographer will learn how surroundings affect the colors of a subject. Once he has learned to see—or at least anticipate—true colors, the pitfall of color reflections can become an asset. He may, for example, create a lovely and unusual portrait by showing the color that is cast by a flower held close to a child's face.

*The reddish cast that is given to hair, skin and even the blue in the young man's jeans is solely the consequence of red light reflected off the brilliant wall of this corridor. Indoor color film, appropriate to the light produced by bulbs along the corridor, was used, and the exposure—a long 12 seconds because of the dimness of the corridor—was correct.*

*A similar color contamination occurs when the student leans against a green wall. The reflected color makes one side of his shirt appear to be painted green. But the colors of his skin and jeans are more natural because they are farther away from the wall and are also illuminated by light reflected from the red ceiling and the blue wall on the other side of the corridor.*

# Capturing the Hues of Man's Possessions

As much as color adds to pictures of people, it becomes still more an asset —even a necessity—in photographs of such still-life subjects as flowers, fruit or room furnishings. To get a pleasing, accurately colored appearance in pictures of this kind, professional photographers have developed a number of specialized techniques.

John Zimmerman, who has photographed many houses on assignments for LIFE and other magazines, wanted to show both the outdoors and indoors in a single shot of the long, window-walled living-and-dining room opposite. Since he was using daylight film to record the exterior colors, he could not illuminate the interior with ordinary flood lamps, lest the room appear to have an unnatural yellowish cast. Zimmerman was able to circumvent this difficulty by inserting blue "daylight" bulbs in his floods and also in the recessed light fixtures in the ceiling of the room. He also put a blue-tinted light-balancing filter (82B) on his Nikon.

An accurate reading of both the indoor and the outdoor light was indispensable in this difficult situation. To make sure that he balanced the colors properly, Zimmerman made his first exposure in mid-afternoon when his light meter indicated an aperture one-half f-stop higher than that for indoors. He continued shooting for about 20 minutes until the outdoor reading indicated a setting one-half f-stop lower. This bracketing of exposures ensured that he would get at least one photograph in which the exterior and interior light were correctly balanced.

*John Zimmerman's lighting set-up for his study of a modern interior included four blue flood lamps—three near the camera end of the room (top), the fourth between the ceiling beams (bottom left) close to the fireplace to hide the flood from the camera. Cardboard deflectors were taped in front of the upper parts of each flood in order to preserve the shadows in the beamed ceiling. Zimmerman inserted blue bulbs in the room's light fixtures (bottom right).*

Sun-dappled trees, blond wood and white interior walls all retain their true colors in Zimmerman's carefully balanced light. The final picture, taken with a 20mm lens, was a two-second exposure at f/8. This lens and aperture yielded excellent depth of field—everything from foreground to outdoor background is sharp.

# Colorful Surroundings for Animal Portraits

Nina Leen has a way with animals (she talks to them while she is photographing them), but it is her careful arrangement of background colors as much as her relationship with her subjects that makes her animal pictures outstanding. Woodsy surroundings are particularly suited to the shaggy black and white Old English sheepdog at right, but the features of this purebred could easily have been lost if it had been posed in front of the woodpile: the color and texture of the bark on the logs echo the dark portion of the dog's coat. Placing the dog atop the woodpile solved the problem, particularly after the lens was adjusted to blur the lawn and trees in the background.

Miss Leen likes to photograph pets outdoors in cloudy weather. Not only does this produce soft, even colors, but it also averts the difficulties of hot floodlights that may cause animals to pant and become restless. Although the picture of a whippet against a tapestry looks like a studio shot, it actually was taken outdoors. Miss Leen went to the trouble of arranging this unusual backdrop because she recalled that whippets were often depicted in medieval tapestries of hunting scenes; not only does the embroidered foliage suggest the aristocratic lineage of the sleek hunting hound, but the russet color serves as a subtle counterpoint to its light-brown markings.

*Using a 105mm lens on her Nikon, Nina Leen photographed this champion sheepdog, Fezziwig Ceiling Zero, at 1/250 second and f/5.6. The large aperture and moderately long focal length yielded an out-of-focus background that is recognizably wooded but does not distract from the shaggy presence of the dog.*

NINA LEEN: *Sheepdog, 1964*

A champion whippet, *Courtney Fleetfoot of Pennyworth*, was taken with an 85mm lens at 1/125 second and f/8. The dog's ears are perked up because the photographer got its trainer, who was out of sight, to speak out just before the picture was taken (Miss Leen felt that the dog would have resembled a too-perfect porcelain statue without this alert expression).

NINA LEEN: *Whippet*, 1964

121

# Diffuse Colors for Appealing Still Lifes

Lighting is the crucial consideration for still lifes. If the illumination is too diffuse, the subject will lack the modeling that suggests its three-dimensional qualities; if the light is not diffuse enough, awkward double shadows will be cast, and colors in the shadows will look artificially different from those in the highlighted areas.

A perfect balance was struck by freelance photographer Dick Meek in his striking picture of red and golden apples. He used an electronic flash unit as a single light source, directing it from above at a 45° angle. He also set up a sheet of white cardboard to reflect light back onto the apples for soft, fluid lighting. The camera was aimed through a hole cut in the reflector sheet, and it was positioned so that no direct light fell on the lens.

When flash is used for still lifes, it is advisable to judge the lighting in advance by setting up a small floodlight close to the position of the flash unit and noting how the shadows will fall in the final picture. The arrangement of lighting and subject should be made on the basis of what is seen through the camera's viewfinder—not what is seen by the naked eye. If the still life contains a very shiny object, its glare can be subdued by moving it to the back of the arrangement and focusing on the foreground objects—thus throwing the spots of reflection out of focus.

*In setting up this picture the photographer determined his f-stop by measuring the distance from the light source to the subject (top) and then used this figure to compute exposure after checking the suggestions supplied with his electronic flash unit. After arriving at the best arrangement of fruit by examining the apples through his viewfinder (bottom), he snapped the picture with a cable release to avoid any jarring of the camera that might cause blurring —and got the clear, natural still life opposite.*

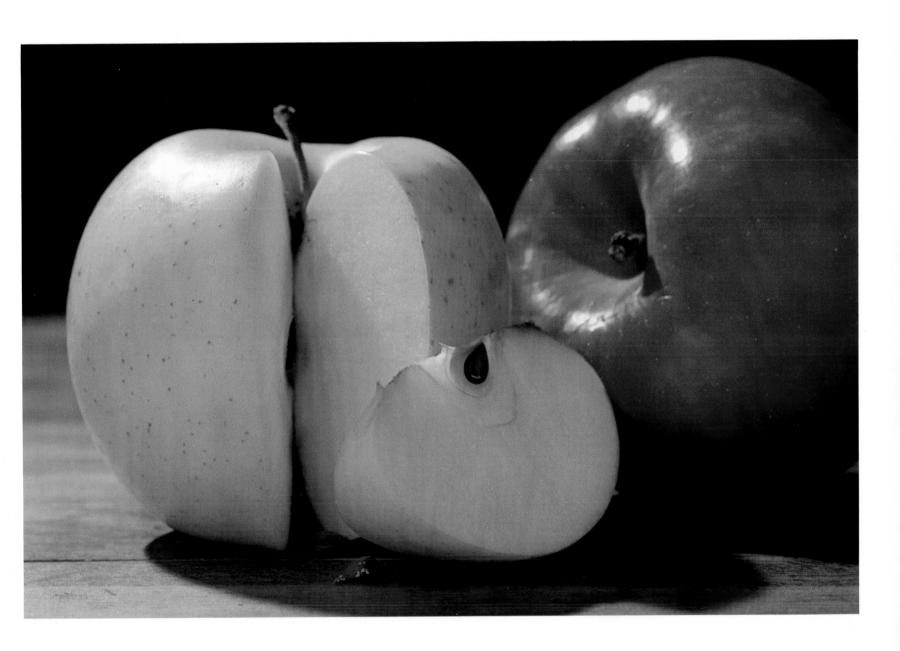

# The Essence of Flower Colors

*The beauty of a trout lily is lost in a clutter of colors and light because the background, while out of focus, is still too clear. A very small aperture, f/22, counterbalanced the depth-of-field limitations of a long lens—180mm.*

*When the photographer opened his aperture to f/4, the background became more flatteringly blurred. Grehan also shaded the lily with an umbrella, thus further isolating it from the brighter background, which is in full sunlight.*

*A third version, taken in full sunlight, shows the lily at its most colorful. Farrell Grehan shifted his angle of view slightly to silhouette the flower against a dark rock and retained the f/4 setting to keep the background out of focus.*

Photographing flowers is a meticulous business in which small adjustments can make a big difference. Farrell Grehan, noted for his floral photography, spends a great deal of time studying a flower through his viewfinder, moving his Miranda camera a few inches to one side or the other to select background colors that will suit his subject. The three pictures of a trout lily above demonstrate how crucial a few simple shifts of lighting and background can be to the final photograph.

Grehan usually shoots from "flower level," resting his camera on an equipment case or on the ground to get the picture. As a rule, he sets his shutter speed at no less than 1/100 second, since flowers will tremble in even the slightest breeze. He frequently tries to show the whole plant: "I'm interested in its leaves, its petals, how it comes out of the ground and what its surroundings are like." Certain subjects, however, require selection of only one or a few elements for emphasis. This was his approach to the flowering deerhorn cactus on the opposite page, which he shot from directly overhead in a manner that greatly limited the depth of field and entirely isolated the lovely red blossoms from their stems.

Shooting from directly overhead, Grehan created a lovely composition of cactus blossoms, enhanced by the presence of a feasting bee. To prevent the brilliant desert light from overwhelming the subtle colors of the flowers, he shaded the cactus with an umbrella, and to focus attention on the blossoms, he restricted the picture's depth of field with a long lens (105mm) and a large aperture (f/4).

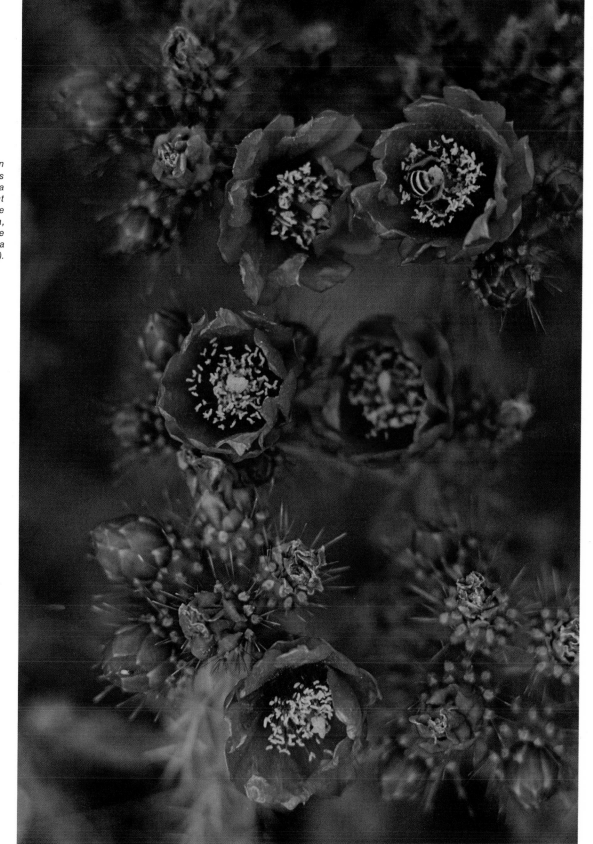

FARRELL GREHAN: *Cactus for a Bee,* 1968

# The Fine Art of Copying Fine Art

To gauge color, scales of standardized gray and color-control patches are attached to the frame. The best shot can be selected by comparing the scales with their photographic images.

The angle of the painting is measured by ► holding a level against the frame. Since hung paintings are rarely perfectly vertical, this measurement helps to prevent focusing errors.

The angle of the film plane is made parallel to that of the painting by holding the level against the back of the camera and tilting the camera until it matches the painting's tilt.

The amateur who tries to make a souvenir picture of a museum painting or prepare a slide from a treasured family portrait may be disappointed the first time. Producing an accurate copy of fine art requires special techniques. On these pages Lee Boltin shows how to copy paintings. Copies for books are made on 4 x 5 film, but the procedures used apply to smaller sizes as well. If they are painstakingly followed, an accurately colored, distortion-free copy results. Achieving faithful reproduction of the painting's colors is trickiest. As a guide, Boltin sets two comparison scales on the frame, as shown above. One is a gray scale and is marked with 10 squares printed in tones ranging from pure white to solid black. The other is a color-control scale marked in nine squares of standardized colors (both scales are sold by photo stores).

By comparing the reproduction of these scales in the photograph with the actual scales, Boltin can tell how accurate his copy is. This enables him to choose the best of several exposures, or if a print is to be made, to compensate for color distortions.

But Boltin also takes other precautions. He makes sure the available voltage is that specified for his lights. He uses an inexpensive photographic level to make sure that the plane of his film is parallel to the plane of the painting; he thus guarantees perfect focusing for every part of the picture. After blocking out all other light, he checks the evenness of his two light sources by comparing shadows cast by a pen. And he gauges the exposure on a gray test-card to get a reading unaffected by color. The result of all this care by Boltin is shown on page 128.

Two floodlights, each at the height of the painting's center, give even illumination. They are equidistant from the painting and angled so no glare is reflected to the camera.

To balance the light, Boltin holds a white ▶ card in the middle of the painting. When equally dense shadows are cast on either side of a pen, the lights are correctly positioned.

◀ Metering the light, the photographer takes a reading from a standard gray test-card instead of the painting itself. This card matches the reflection of an "average" indoor subject.

To avoid blurring caused by camera movement, Boltin snaps his picture with a cable release. He bracketed his exposures widely to be sure of reproducing the colors accurately.

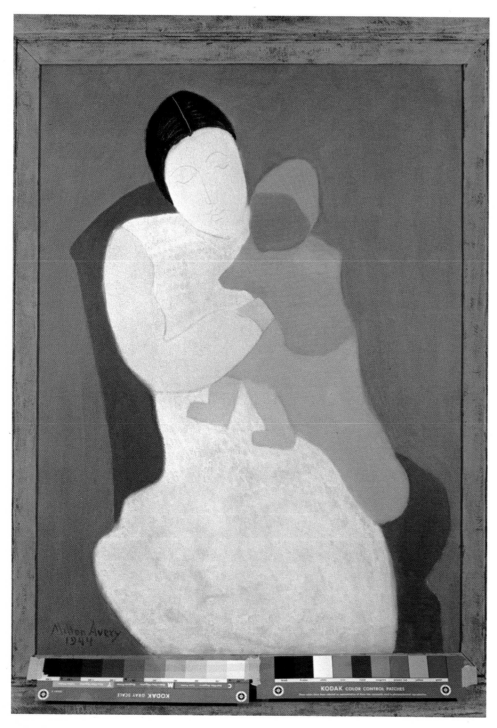

The photographic copy of Milton Avery's painting, "Woman and Child," retains the original's appeal by capturing its subtle modulations of color—such as the difference between the mother's arm and the child's leg. These unsaturated colors are the reason so much care must be taken in copying, for they are the most difficult to reproduce faithfully.

## Ernst Haas's Colorful World 132

**The Dazzle of New York 134**

**The Tranquil World of Venice 140**

**Color in Motion 145**

**The Stark Hues of the West 148**

**Nature's Close-up Colors 156**

**The Everyday Transformed 162**

*Brooklyn Bridge,* 1952

# Ernst Haas's Colorful World

When Ernst Haas loaded his Leica with color film in 1952 to shoot the sights of New York streets, he was already one of the world's foremost photographers, famed for his versatility, but he had never made a color picture. This very first venture into color photography produced such vivid evocations of the city that LIFE magazine published 24 pages of pictures in a two-part essay —the longest color story the magazine had ever run. And from that point, color became a medium peculiarly Haas's.

His approaches to color—there are several—have helped to influence the way many photographers now look at color in a scene. In his views of the outdoors—nature and rugged open country as well as cities as diverse as New York and Venice—he switches from style to style to communicate the essence of the subject in unusually powerful ways. Compositions like the one opposite, partly made of reflections from the corner of a glass-walled skyscraper, speak straight to the highly charged atmosphere of the modern metropolis. A later study of Venice *(pages 140-143)* employs a different photographic language just as eloquently, showing the enchantment of that city in dreamlike images and elusive colors.

Haas's treatment of motion has been even more influential. His photographs of action are almost never frozen images of arrested movement; he deliberately blurs his scenes in a variety of ways *(pages 135, 138-139, 142-147, 162)*, so that the swirls of color that trace the action merely suggest motion while the color itself becomes the subject of the photograph. He hit upon this approach because he was forced into it by the slow speed of the color film he was then using. Attempting to photograph a bullfight in the fading light of late afternoon, he had to use a slow shutter speed to avoid underexposure. This, of course, made it impossible to stop the action in the ordinary way, and Haas "panned" his camera, turning it to follow the charge of the bull so that a fairly clear image would remain on the film. The background was blurred, but the effect of the smeared color so entranced Haas that he applied it in later pictures in a variety of forms. In some shots he blurs the subject, in others the background and in still others he jiggles the camera to create a complex combination of color tracery.

Haas, a painter turned photographer, is an innovator with a quixotic streak of conservatism. He began taking color pictures with the first modern color film, Eastman Kodak's Kodachrome I, and he clung to its strong rendition of hues despite its very slow speed (ASA 12). When the twice as fast—and thus much more versatile—Kodachrome II replaced it, Haas at first resisted using the newer, softly toned film. He complained so bitterly to a Kodak representative about the unavailability of Kodachrome I that the company sent him the remnants of its stock—enough 35mm rolls to fill a refrigerator. Haas gratefully used them, but soon found in the newer emulsions fresh ways to make colors delight the eye.

*Reflections,* 1965

# The Dazzle of New York

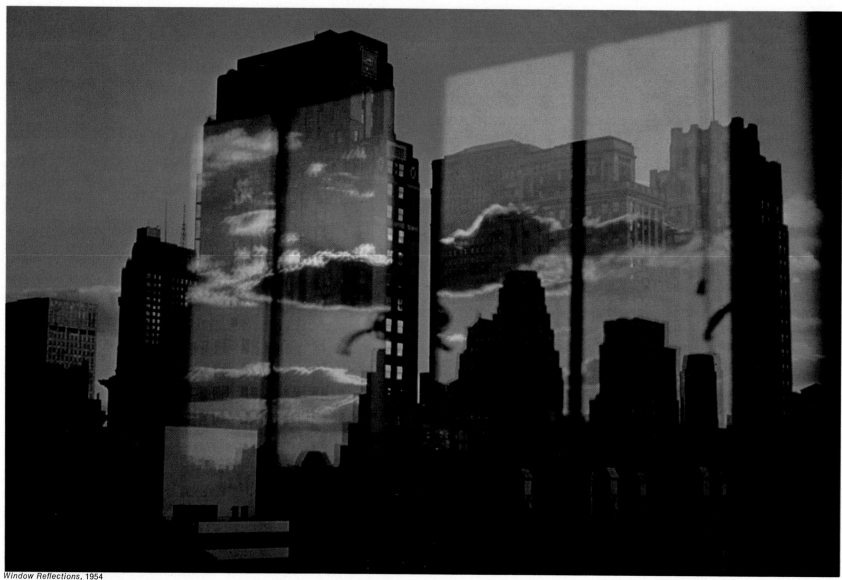

*Window Reflections,* 1954

Ernst Haas sees New York as the quintessential modern metropolis—glittering, tense, all startling patterns and contrasts. In his vision, the crowded architecture of Manhattan seems to be cities within a city, to multiply existing buildings. He shot the picture above through a window, placing artificial skyscrapers on real ones by including rectangular reflections of another window behind him. To provide a contrast for the synthetic angularity of the skyscrapers, the warm tones of sunset reflected from the rear are superimposed on the cold blue directly ahead. This same feeling for jarring juxtapositions appears in the quite different picture of New York opposite in which a dark, straight sweep of traffic contrasts with the clear white rising spiral of the Guggenheim Museum.

*Guggenheim Museum*, 1965

*Oil Spot,* 1952

*Poster Painter, Times Square, 1952*

In his photographic studies of New York, Haas often uses abstract designs. The exploding rainbow opposite is a drop of oil spreading over wet asphalt —a scene that can be viewed two ways. It first appears an abstraction, but is also a realistic recording of the city, for Haas has indicated both the scale of the oil film and its everyday nature with the shadow of an oblivious business-man hurrying past.

The sweep of lavender and gold above was created by a man painting a poster of a comet for an ad in Times Square, but Haas made it an appealing pattern by snapping his shutter at just the right moment. He waited until the man bent over to mix his paints. The eye of the viewer follows the upsweep-ing lines but is held in the pic-ture by the platform and the figure.

To communicate the dynamism of the modern metropolis, Haas emphasizes contrasts of many kinds. Sometimes he opposes blurred pictorial elements to sharp ones, dark blues and blacks to vivid reds and white. In his photograph of Times Square in the rain, the black silhouettes of the human figures in the background are sharply focused so that the eye has something to hold on to, but the flickering reflections of red neon lights shining on the asphalt are left out of focus, shimmering around a strange rectangle of blue.

A like counterpoint suggests the energetic movement of traffic in the picture opposite. Haas made a long exposure, so the moving cars became a blur. However, the pavement arrows are perfectly sharp—their motion is symbolic rather than actual.

*Rainy Night, Times Square, 1952*

*Rushing Traffic*, 1964

# The Tranquil World of Venice

*Gondolas at San Marco, 1955*

*Serenading Gondoliers*, 1955

Turning from the tense spirit of New York, Haas photographed Venice in 1955 as a city of quiet mystery. His colors are subdued. To get these muted shades, he visited the city in autumn, when the weather alternated between fogs and soft sunshine. It is fog that conveys the atmosphere in the picture of moored gondolas on the opposite page. Rising high on the crest of a wave, they are silhouetted against the Doges' palace, its delicate architecture veiled by the silvery mist. To combine all these elements in his picture Haas hunched low in another gondola and angled his camera upward; he was able to use a 1/200-second shutter setting to stop all the motion because the illumination made possible a short exposure—a surprising amount of light penetrated the fog.

A dreamlike sensation is evoked by the subdued light in the picture above of two gondoliers, sitting under an arcade as they while away the hours with the music of a guitar. The soft shadow and the dusky color of the wall add to the impression that the city of Venice has hardly been changed by the passage of centuries.

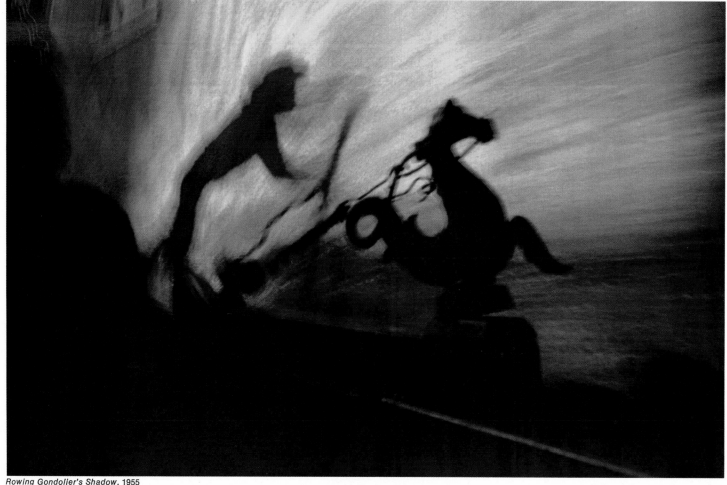

*Rowing Gondolier's Shadow*, 1955

Some of Haas's images of Venice convert reality into fantasy. In the picture above, he made the shadow of a gondolier cast on a sunny wall into an eerie echo of a decorative brass seahorse mounted on the side of the gondola. Haas heightened the resemblance between the images by his choice of lens: its short focal length—35mm—exaggerates the size of nearby objects, making the seahorse seem about as big as the background shadow.

No technical trick but Haas's sense of timing made something special of the most trite subject in Venice—the Piazza San Marco pigeons that are snapped by almost every tourist. Haas set his shutter at 1/5 second so that motion would blur and adjusted his aperture for slight underexposure to mute the colors to browns and greys. Then at just the right moment he shot, catching some pigeons sharp, others blurred—a balance of the real and the ghostly.

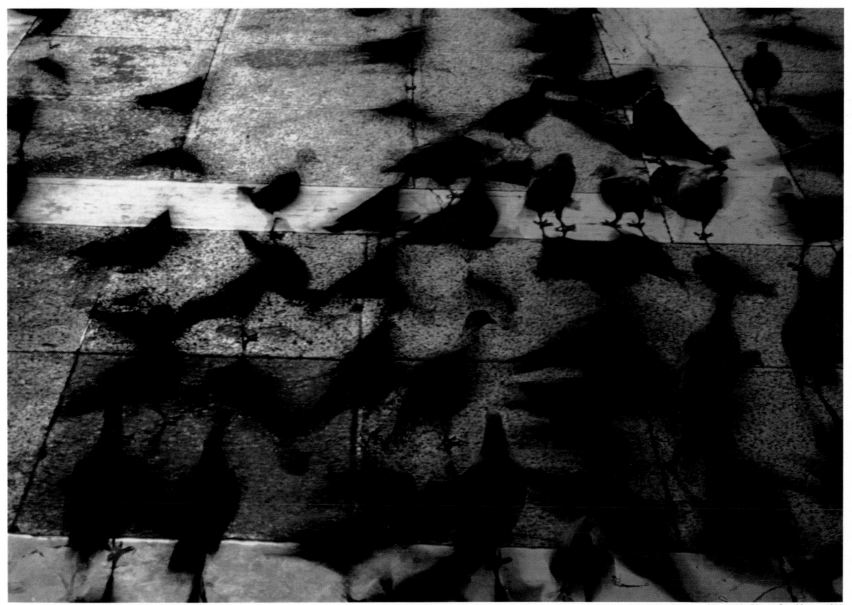

*Pigeons in Piazza San Marco*, 1955

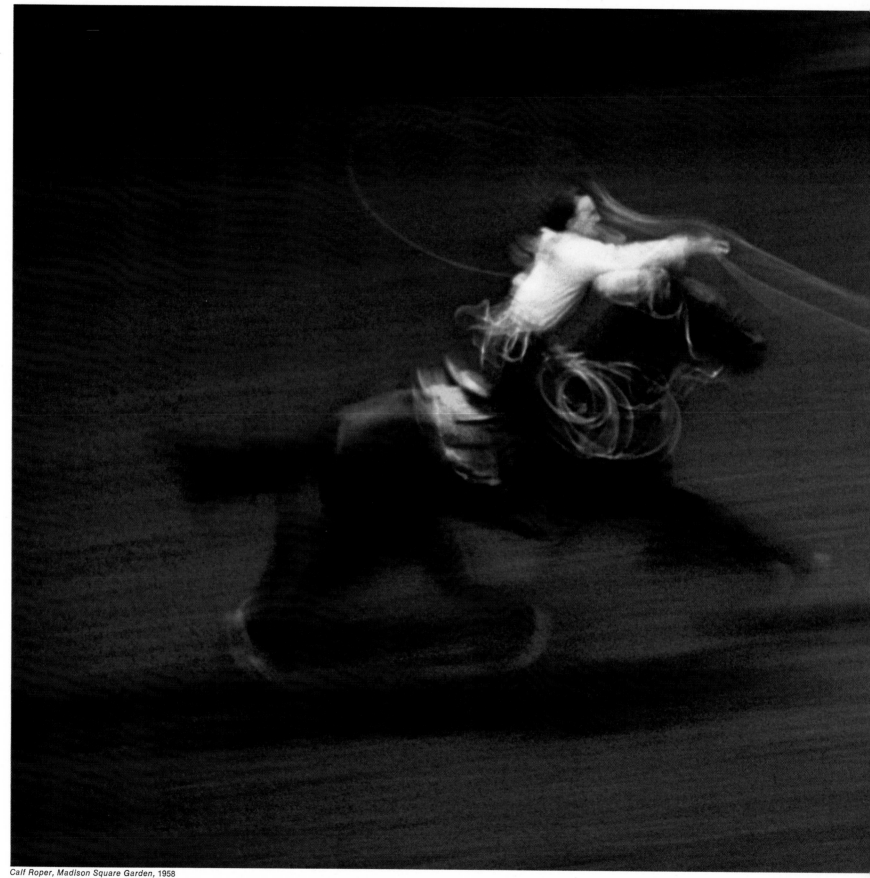

*Calf Roper, Madison Square Garden,* 1958

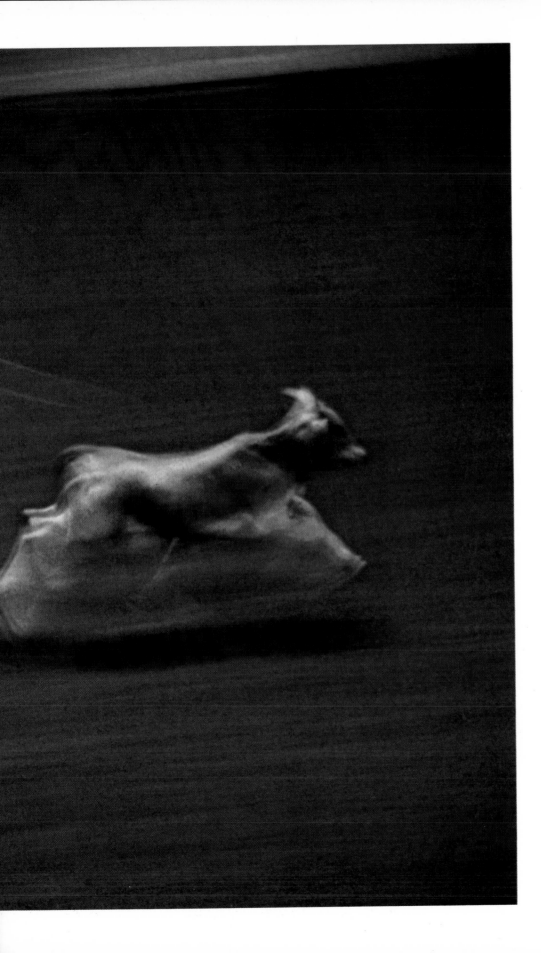

# Color in Motion

The secret of Ernst Haas's evocative action pictures seems simple: The color moves. How it moves is what makes the picture, and achieving that motion is seldom simple. Haas made the picture at left, showing a calf-roping event at a rodeo in Madison Square Garden, by panning his camera. Throughout the ½-second exposure, Haas kept the horse and calf in his viewfinder as they charged across the arena. Because the camera followed the chase and held the calf, lasso and horse stationary relative to the film, they appear fairly sharp. But the turf and the legs of the animals were not stationary relative to the film. They blurred, creating the moving color that not only signals action but, more important, contributes drama to the picture.

Haas works subtle variations on this technique. He may turn the camera faster or slower than the moving subject, or he may jiggle the camera to suggest rhythmic or erratic motion. By thus permitting all sorts of movement in the eye of the beholder—the camera—he gains great esthetic control over the motion of the real world.

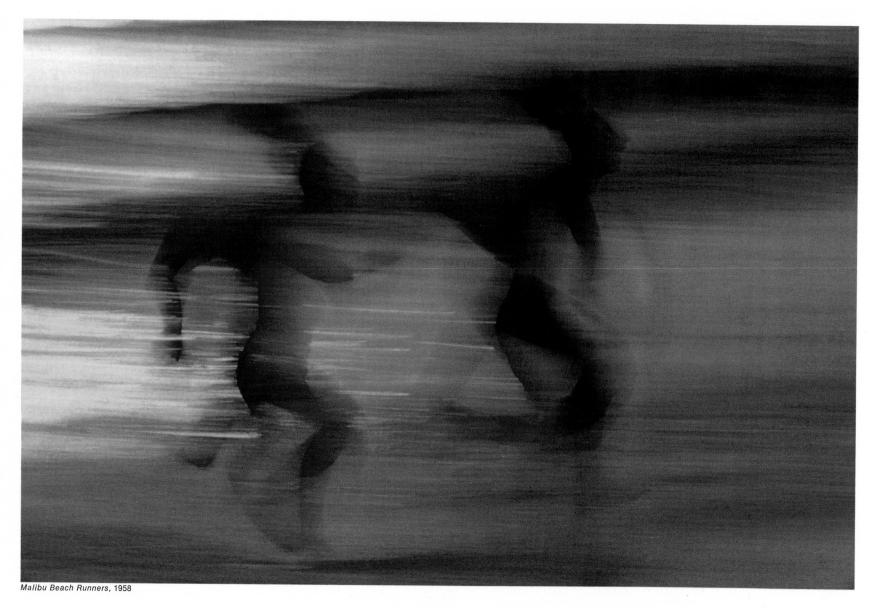

*Malibu Beach Runners, 1958*

"Color fades in motion and becomes transparent," says Haas. "I take this to be a real visual advantage." Its image smears on the film, like paint streaked by a finger, to a thin veil over the background. Haas deliberately emphasized this effect in both pictures on these pages. He followed the runners sprinting along a California beach with his camera while making a time exposure. The movement—abetted by underexposure of the figures to favor the glare of the ocean behind them—dimmed the runners to a subtle gray surrounded by the dark-green streaks of the sea.

For the bullfight picture at right, Haas held the camera still during a 1/5 second exposure. The resulting swirl of transparent crimson conveys his conception of a bullfight as "a spectacle of motion, the perfection of motion."

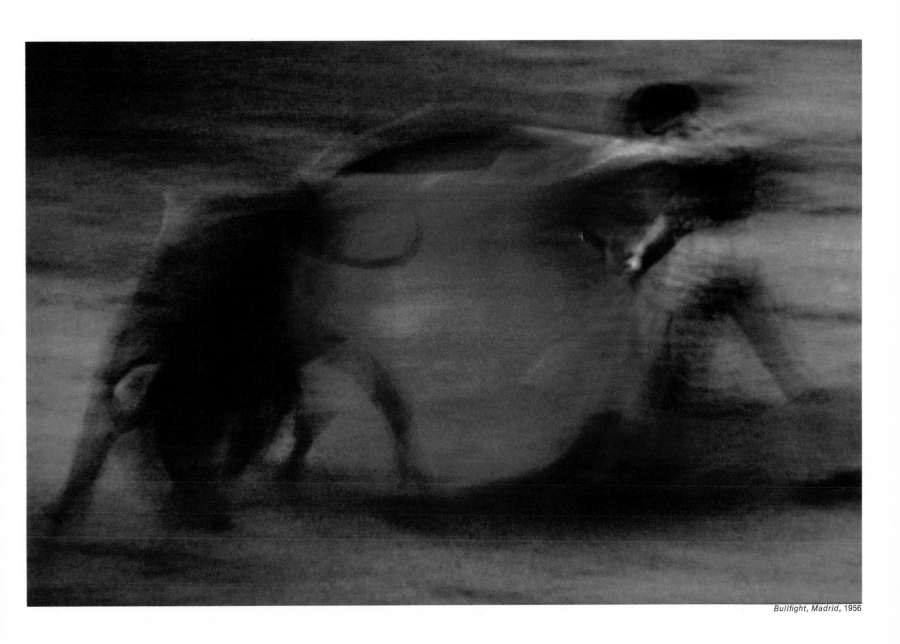

*Bullfight, Madrid*, 1956

147

# The Stark Hues of the West

Almost immediately after arriving in the United States, Haas traveled to the West—and he has never gotten over his fascination with picture-making in this rugged country. He has returned to it many times to record its lonely spaces. Even here, where everything seems so still, his results gain distinction from the same sense of timing that sets apart his studies of motion and cities. For example, this picture of Monument Valley in Arizona, made on a trip in 1967, captures a moment of ephemeral beauty that came immediately after a rare rain had soaked the sandy soil and red sandstone cliffs, intensifying their colors. Haas knew that he had to catch one precise instant—after the air had cleared but before the earth had dried and faded. Aloft in a small plane, he insisted on flying through the bumpy atmosphere—paying no attention to the pleas of a violently airsick companion —until the envisioned scene appeared. He arrived over Monument Valley just as the sky was clearing, made a quick pass—and headed home with a view of color such as might never again appear in the desert country.

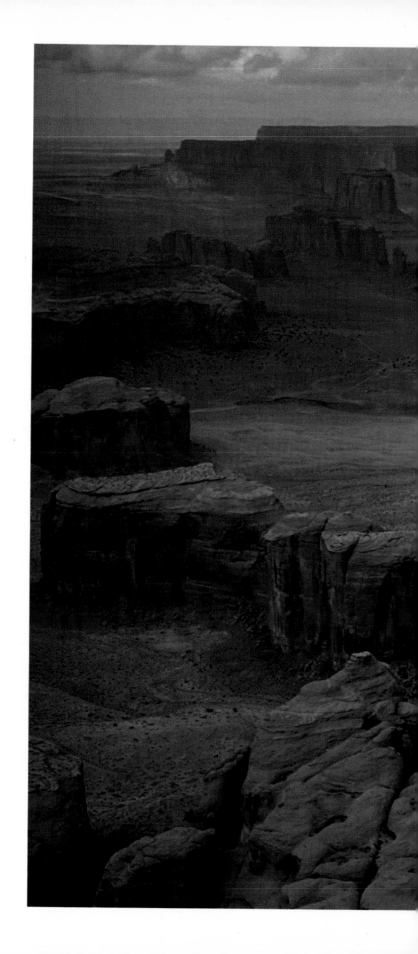

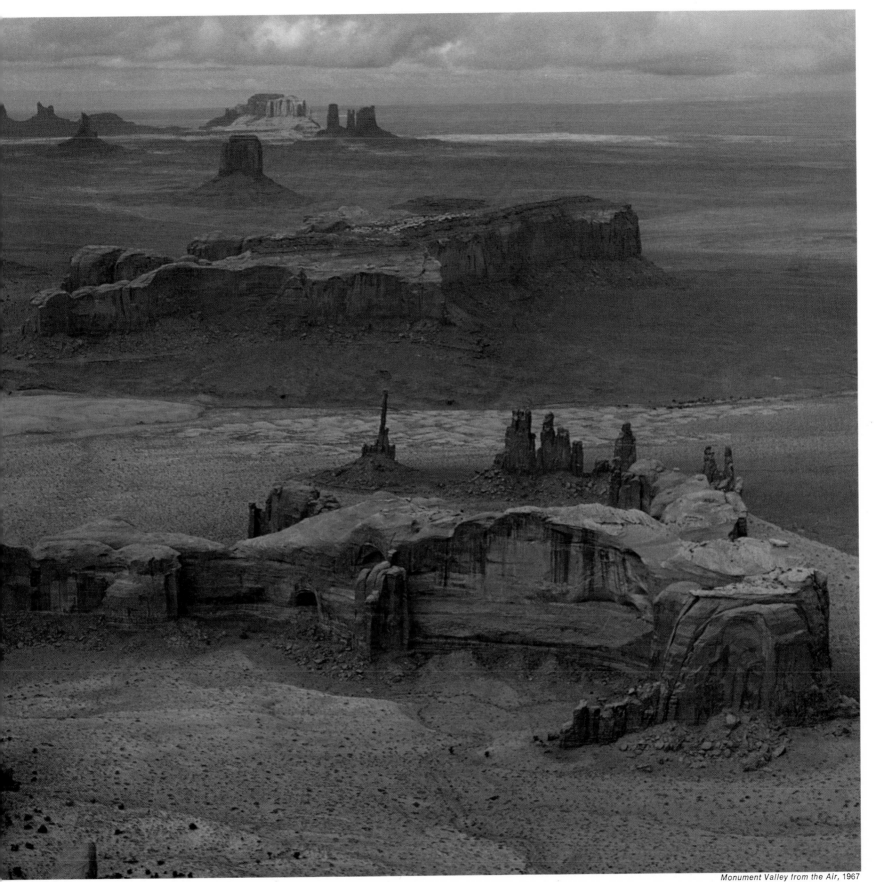

*Monument Valley from the Air,* 1967

149

Memories of an earlier West are re-awakened by Haas's picture of cowboys riding beside a road across the hills of California. But, like many of his photographs, it contains a paradox. The men were indeed authentic ranchhands, but they were straddling two eras when the photograph was made —for they were returning home after a day's work as extras on the set of a Western movie. Haas, who had been taking pictures of the movie makers on an assignment, made the photograph through a lucky accident. While driving from the movie setting back to town in a truck, he had a flat tire. Seeing the cowboys on the horizon, he forgot about repairing the tire and stood on the roof of the truck, patiently waiting until they came close enough to form this nostalgic composition.

*Western Homecoming,* 1958

Haas was traveling along a highway from Utah to Las Vegas when he saw the scene at right—an old road and a line of telephone poles that looked to him as if they were rising up into heaven. These two parallel lines, slicing across the purple-hazed cloud shadows on the desert ahead, offered Haas an unusual opportunity to express the great distances of the American West. What makes the picture work so well is the apparent perspective produced by Haas's choice of lens. He rarely uses anything but a normal 50mm lens, but it would have made the telephone poles in the foreground seem massive and widely spaced when compared to those farther away. Instead, he switched to a longer focal length, 135mm, which changed the angle of view so that the nearer poles all seem to be almost the same size, making their separations appear less than is actually the case. With this seeming alteration each individual pole loses its identity and becomes part of a simplified line that, like the road, pulls the viewer into the ever-receding space of the West.

*Highway to Las Vegas,* 1960

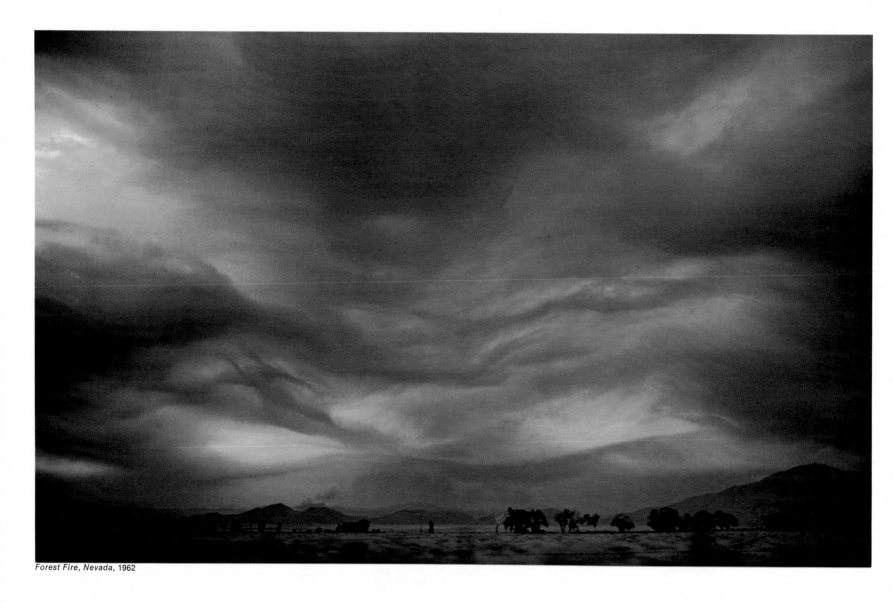

*Forest Fire, Nevada, 1962*

The West as photographed by Haas is a country of fierce, roiling energies as well as silence and solitude. In the picture above, the world seems threatened by the heat and fury of primeval storm. This is, in fact, a photograph of a natural disaster—a forest fire. Great waves of wind-driven smoke were roll-ing off the mountains of Nevada and darkening the sky. The smoke, mixed with clouds, scattered enough sunlight to produce the ominous colors, even though it was only half past four in the afternoon.

In the picture opposite, taken at Point Lobos, California, Haas recorded the destructive power of the Pacific Ocean. Viewed through the frame of a gnarled and weather-beaten tree trunk—which has already fallen victim to the white-frothed sea—a jagged section of the continent's coastline has been isolated by the waves and is slowly being re-duced to rubble.

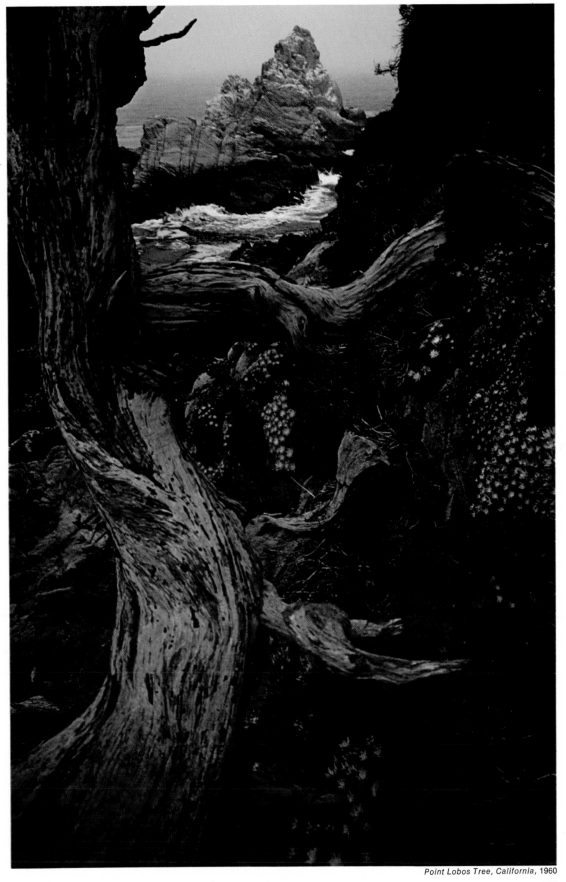

*Point Lobos Tree, California, 1960*

# Nature's Close-up Colors

In recent years, Haas has made color a subject in itself by isolating it in extreme close-ups of nature. "Like many good things," he says, "this came out of a frustration." Pictures taken at any appreciable distance often resulted in a clutter of colors; by homing in on a subject, he found that he could capitalize on pure color values.

His close-peering camera discovered a magical beauty in perfectly ordinary subjects that could be seen on any walk through the woods. An autumn leaf *(right)* becomes a golden filter for the backlighting of the sun. Bubbles and pine needles trapped in the thin ice of a brook *(opposite, top)* create a composition of pale, icy tones. Nature even provides her own lenses to bring the veins of a leaf into still closer view *(opposite, bottom)*, obscuring its green. The lenses are actually droplets of water that appeared on the leaf in the cool mists of September.

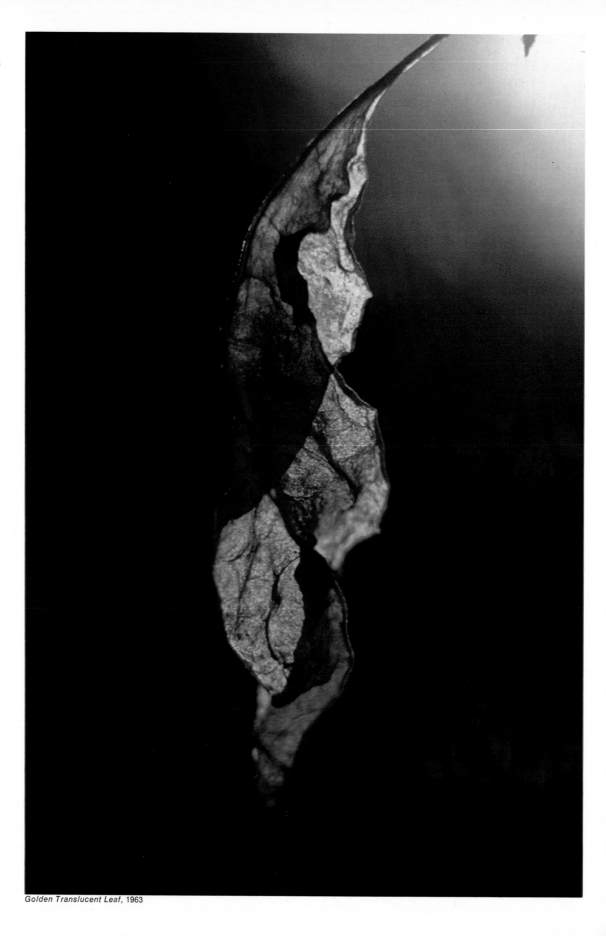

*Golden Translucent Leaf,* 1963

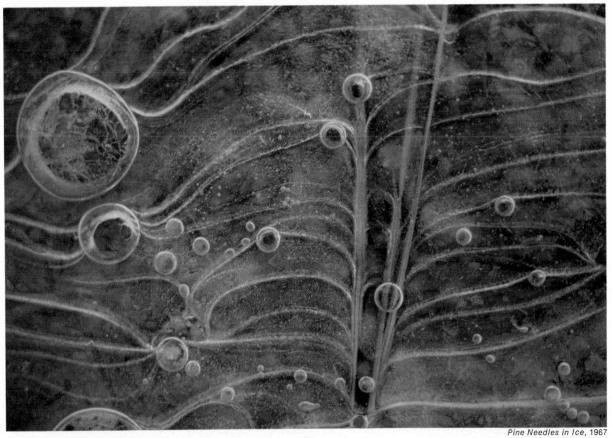

*Pine Needles in Ice,* 1967

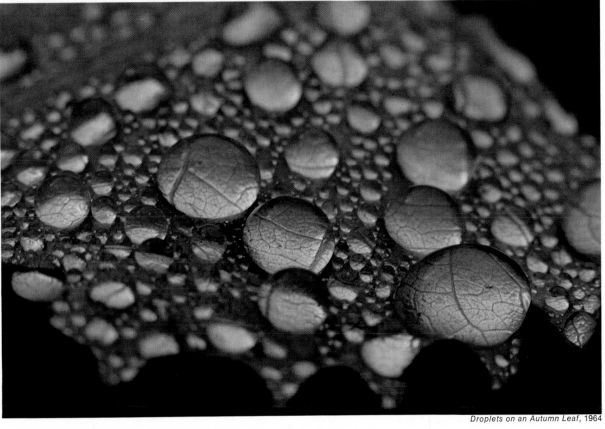

*Droplets on an Autumn Leaf,* 1964

Haas created a fantasy in the picture at right, turning leaves into trees looming over a rain forest. The two leaves in the foreground—one is behind the other—are impressively big in reality. They grow on South American *Xanthosoma mafaffa* plants rising about six feet high on thick stems rooted directly in the soil, and natives of Ecuador use them for umbrellas. These particular leaves, however, came to resemble trees because they were attacked by voracious caterpillars that left only traceries of stems and veins behind.

Haas took the picture early in the morning, when fog provided a luminous background against which the intricate skeletons of the leaves could clearly be seen. By using a lens of short focal length, 35mm, which makes the nearby leaves disproportionately large compared to the real background, he transformed them into lords of the tropics.

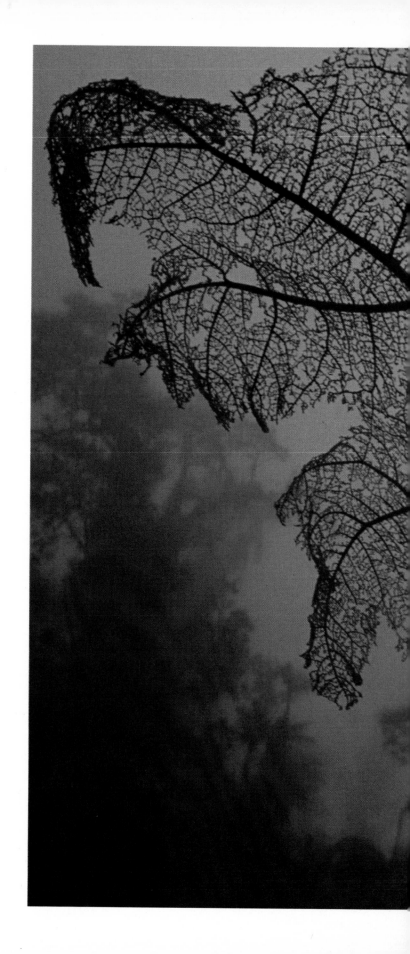

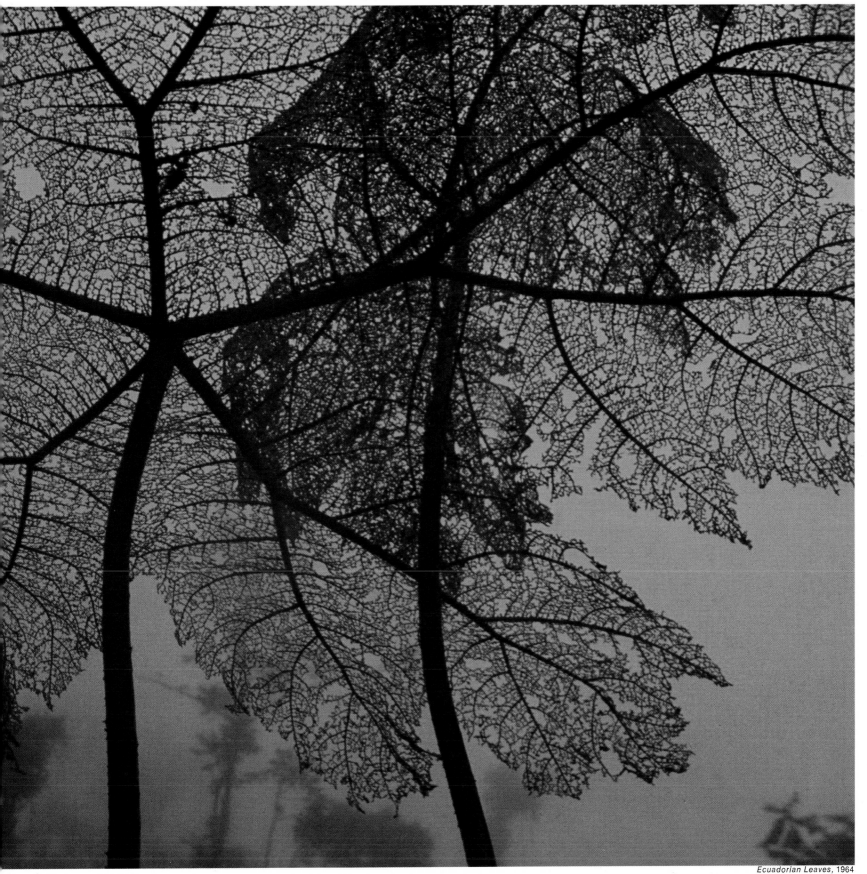

*Ecuadorian Leaves*, 1964

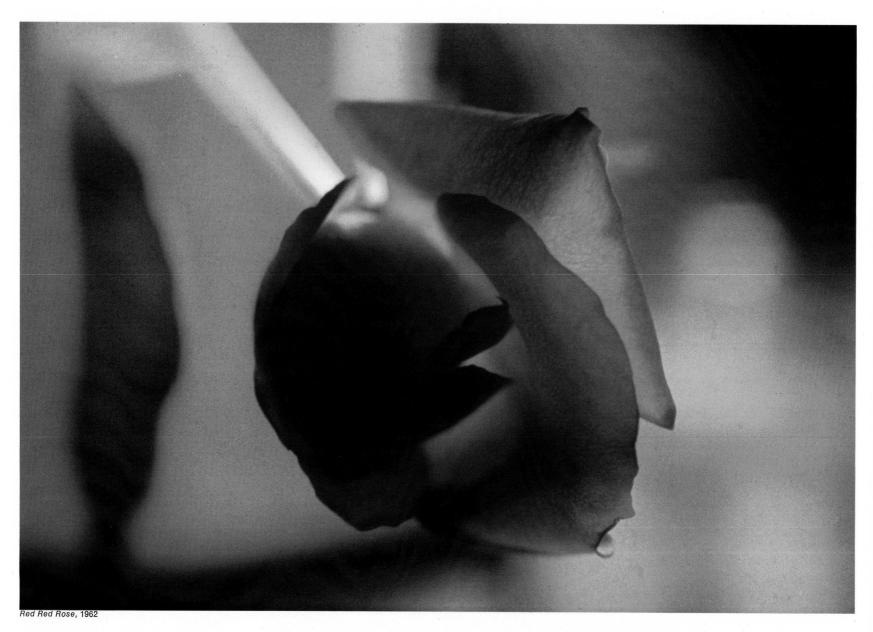

*Red Red Rose, 1962*

"Beauty pains," says Haas, "and when it pains most, I shoot." When he saw a red rose hanging close to a red wall in his apartment *(above),* he shot—although he almost never photographs indoors. He created a similar sort of colorplay in his close-up of a single blade of grass curling in front of a knothole in an old board *(opposite, left).* The soft glow of the grass, photographed on an overcast day, is caused by light coming from two directions —through the knothole and also from the open sky. In the picture at far right, two leaves of a Mexican cactus—one dying, the other one a healthy green —formed an irresistible composition because of their thin red edges.

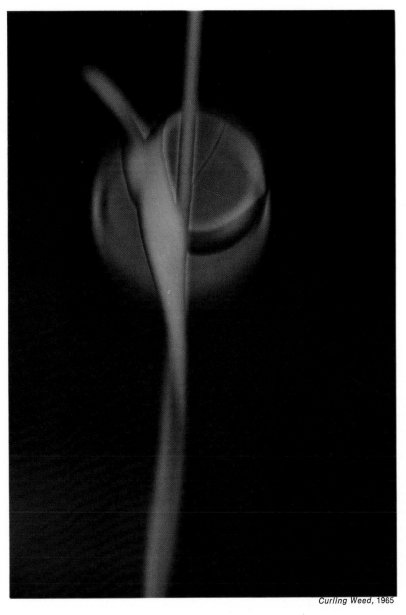

*Curling Weed*, 1965

*Growing and Wilting Cactus Leaves*, 1963

# The Everyday Transformed

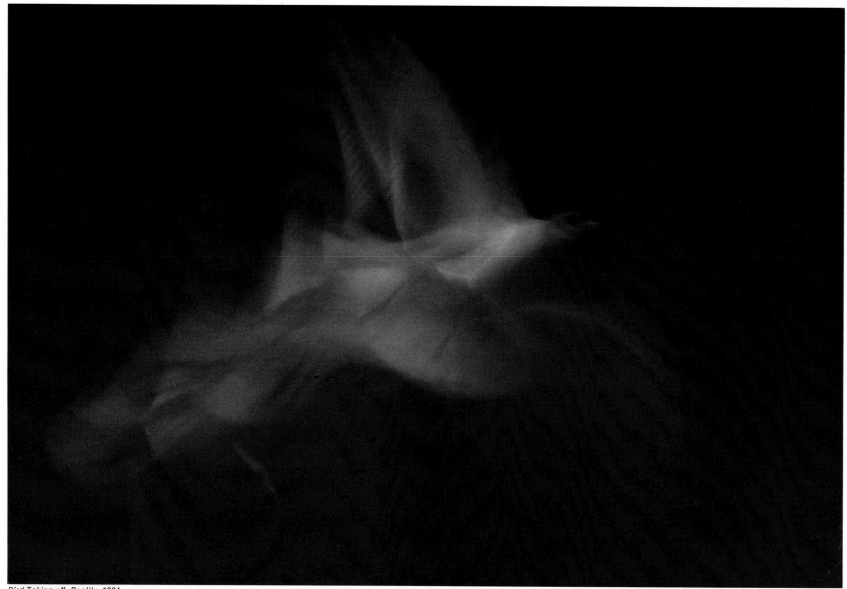

*Bird Taking off, Reality, 1964*

The "found" subject is given fresh meaning by Haas's emphasis on color pattern. "I tried to show the concepts of both *bird* and *flying* at the same time," he says of this picture. He made a 1½ second exposure of a seagull in flight, holding the camera still for half that time, then panning so that a blurred but strong white image was recorded. Deliberate underexposure turned the water behind the gull into an almost black backdrop for the white flurry of wings.

*Bird Taking off, Peeled Poster,* 1969

Another startling evocation of a bird in flight is not really a bird at all. Haas photographed a ripped poster that he had spotted one day while walking through the streets of Los Angeles. The horizontal bands of red and black sug-gest motion, the ragged white of the underlying paper looks like out-stretched wings, and there is even an uncannily appropriate dot of black for an eye. "I have always wondered how it was torn that way," Haas says.

Some of Haas's most striking images have been created out of the discarded and decaying materials of civilization. In a ghost town in Nevada, he found a rusted tin pot that had once been used for target practice. A close-up that he made of this unprepossessing object *(right)* shows the round hole of a bullet's entry and the strangely graceful cruciform of its exit.

On another occasion he became fascinated by peeling white paint on the wall of an abandoned hut. Seeing one curled piece of a red underlayer that reminded him of lipstick, he composed a picture *(opposite)* that looks like a jagged version of a human face.

*Bullet Holes in Rusted Pot, 1962*

*Face in Peeling Wall Paint*, 1961

165

"For me," says Haas, "the final stage of photography is transforming an object from what it is into what you want it to be." In the photograph at right, he created a human figure out of a squashed beer can he saw on a New York street. Countless cars passing over the can had endowed it with surrealistic features as they crushed it into asphalt softened by the summer heat. There it was transformed by the camera into what Haas sees as a depiction of Buddha. □

*Squashed Beer-Can Buddha, 1963*

## For the Best Color, Home Processing 170

**Mixing Developer Chemicals 172**

**Developing the Film 175**

**Materials for Printmaking 180**

**Equipment for Printmaking 184**

**Balancing the Enlarger for Color 186**

**Making Prints from Transparencies 194**

**A Print in True Colors 196**

**Guidance from a Contact Sheet 198**

## A Master of the Color Print 199

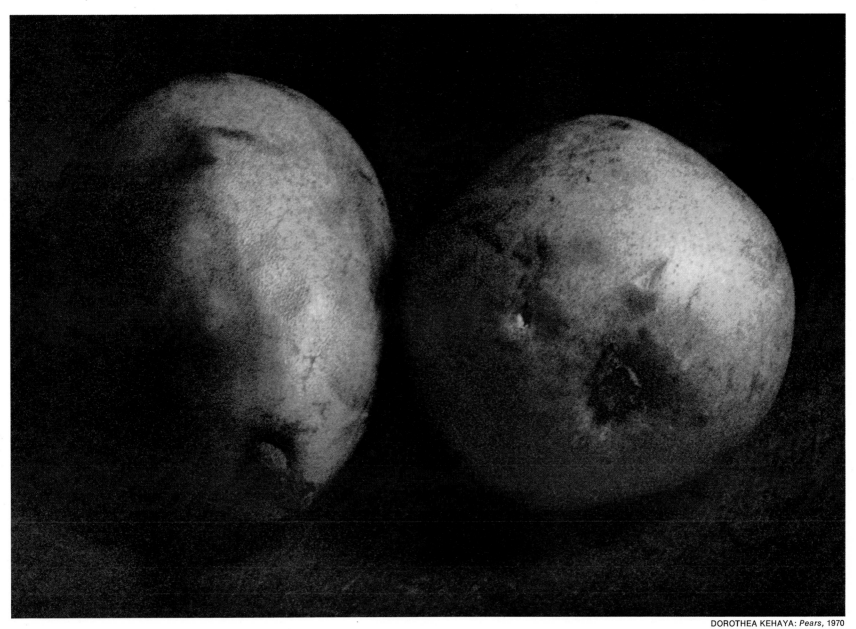

DOROTHEA KEHAYA: *Pears*, 1970

# For the Best Color, Home Processing

There is one good reason for processing color pictures in a home darkroom instead of relying on a commercial laboratory: control. The photographer who develops the film himself can maintain his own standards of quality and fit them to the special requirements of the individual photograph, ensuring that all the influences on the picture—time, temperature, chemical concentrations—meet the rather strict rules for good color. And he can do this fairly easily thanks to greatly simplified procedures and prepackaged kits that contain all the necessary chemicals. Some of the equipment needed and the techniques involved differ from those used in processing black-and-white pictures, but the differences are easy to adjust to.

The basic advantages of home processing apply to all kinds of color materials—negatives, prints and transparencies. Most amateurs leave the processing of transparencies to commercial laboratories. A considerable number of steps are involved and small variations in conditions can have a severe effect on the results. With transparencies it is also necessary to depart from the routine processing procedure if colors are to be manipulated.

The real payoff comes to the photographer who makes prints from his own color negatives or from his transparencies. For in making prints, much more than in the processing of slides (a comparatively cut-and-dried procedure), the photographer has full creative control over the final picture. He can make a picture lighter or darker to compensate for incorrect exposure in the camera; correct colors or change them for an artistic effect; crop out unwanted sections of the negative, and vary the printing time of specific parts of the picture by dodging or burning in portions that are too dark or too light. Thus the photographer's creative contribution need not cease as soon as the shutter snaps; he can continue to shape the content, the size and the colors of a picture right through the final moments of processing.

Although some brands of both types of color film—reversal, for slides, and negative, for prints—can be processed at home, not all brands can be. The most popular and readily available reversal films are Agfa Agfachrome, GAF Color Slide Film and Kodak Ektachrome. Among the color negative films that the amateur can develop are GAF Color Print Film, Kodak Kodacolor and Kodak Ektacolor.

Special processing chemicals made specifically for each of the three brands of reversal film that are listed above are available in photo supply stores, and these should be used. For developing color negative film several kits are on the market. The most widely used of them is the Kodak Process C-41 *(page 172),* which is capable of developing not only the Kodak negative films but also GAF Color Print Film. (The well-known Kodak C-22 kit,

which preceded the C-41 and is still available, can be used to develop such reversal films as High Speed Ektachrome and to produce from them negatives instead of positive transparencies—a useful trick because this high-speed reversal emulsion is much faster than ordinary negative emulsions. The unusual picture on page 214 by Norman Rothschild, in which a red firehose connection comes out a bright green, was produced in this way.)

A second set of chemicals is needed to develop prints from these color negatives. Several kits are on the market but the most widely used is the Ektaprint 3 kit made by Kodak *(page 181)*. It is also possible to make prints directly from transparencies instead of from negatives. A set of chemicals called Ektaprint R-500, developed by Kodak, is used here to illustrate the technique *(pages 194-195)*.

The darkroom equipment needed for color processing need not be elaborate nor overly expensive. A photographer who has processed black-and-white film will already own everything he needs for developing color films, both negative and reversal types. For making prints he will need only a couple of extra items that are on the expensive side: a set of color filters (about $20 to $25, depending on type) and perhaps a voltage regulator (ranging in price from $50 to $180), which may be required to compensate for household current variations that can affect the color and the intensity of the light from the enlarger lamp *(page 184)*. Any good enlarger having an incandescent lamp and properly color-corrected lenses can be used, though it should be modified with a heat-absorbing glass that is usually placed above the condenser lens—an easy job to install in most cases. One inexpensive but important item needed for both developing and printing is a pair of rubber or plastic gloves. Chemicals that are used for color processing are more potent than those used for black-and-white films, and they must be handled with extra care.

The following pages show the complete step-by-step procedure for producing color prints from color negative film and transparencies. Both negative and reversal film offer great opportunities for creative control of the result during processing at home. However, more color negative film is used by amateurs than reversal film, and a strong trend in this direction continues. In any event, many of the steps shown apply to both processes; in particular the sections on mixing chemicals and developing negative film can serve as guidelines for reversal processing.

The techniques shown have been carefully supervised by Herbert Orth of the TIME-LIFE Photo Lab. They should assure the home photographer of properly developed color film as well as creative rewards.

# Mixing Developer Chemicals

*Chemicals for processing color negative film, supplied in a kit (box at top), are shown in order of use (left to right): developer (six bottles), bleach (one packet, two bottles), fixer (one bottle), and stabilizer (one bottle).*

*Implements needed to mix the chemicals are: plastic graduate, four labeled brown bottles, plastic stirring rod, scissors, rubber or plastic gloves, a thermometer and a plastic funnel.*

Mixing color-processing chemicals is an apparently complicated procedure that quickly becomes easy and routine for anyone who has done it the right way at least once. In approaching the procedure, the best guide is the experience of darkroom experts who have discovered, sometimes the hard way, what things can—or cannot—be done to save time and effort. The home-processing technique shown comes from the know-how of Herbert Orth of the TIME-LIFE Photo Lab, combined with the specific directions in the pamphlets that come with the chemical kits. This technique is followed on these pages step by step, from mixing the first chemicals to developing film and making prints. Included in the procedures are some bits of practical advice, such as a shortcut method of adjusting water temperature *(step 1 on the opposite page),* and a method of making nine test prints on only three sheets of paper *(page 187).* The chemicals used here are contained in Kodak's C-41 processing kit in the one-pint size *(left),* which provides materials for developing at least six 36-exposure rolls of 35mm film. After the first two rolls, developing time is increased in accordance with the instructions. The solutions can be stored six to eight weeks after mixing. For uniform results, the amounts of water used in mixing should be measured carefully and the temperature of the water should be kept 80° to 90°F. for the developer and bleach, and at 70° to 80°F. for stabilizer and fixer. Cleanliness is also imperative. After each chemical is mixed, the table and implements—funnel, stirring rod, graduate, thermometer—must be washed to prevent contamination.

### 1 | adjust the water temperature

Place the stem of the thermometer under the faucet and adjust the taps until the temperature of the water is 80° to 90°F. Gloves should be worn while mixing solutions.

### 2 | mix the "A" developer

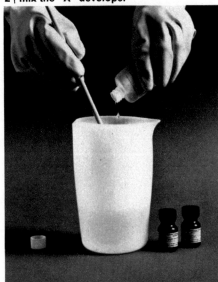

Into the graduate pour 11 ounces of water at 80° to 90°F. and slowly add the contents of one of the two bottles of part "A" of the developer. Stir solution until it looks uniform.

### 3 | add the "B" developer

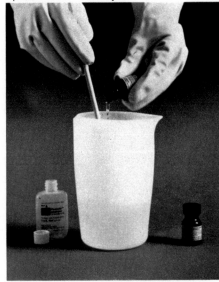

Empty one of the two bottles of part "B" of the developer into the graduate and stir mixture until uniform. For proper chemical reaction, developers must be added in this order.

### 4 | add the "C" developer

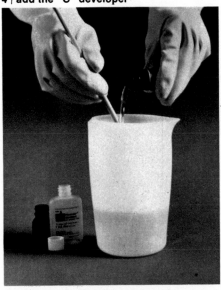

Empty a bottle of "C" developer into the graduate, into which parts "A" and "B" of the developer have already been added. Again, stir solution to make certain it is well mixed.

### 5 | add water

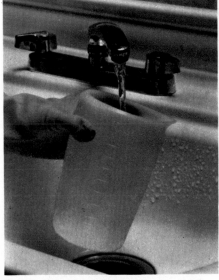

Partially fill another container with water at 80° to 90°F. The water in this container will then be added to the developer solution in order to provide a total volume of 16 ounces.

### 6 | store the mixed developer

Holding the funnel steady, fill the pint bottle marked "C-41 Developer" with the freshly mixed solution, pouring slowly to allow air within the bottle to escape. Cap the bottle and put it aside.

### 7 | wash contaminated implements

*The graduate, funnel, stirring rod, thermometer and table must be washed thoroughly: all have been exposed to the developer. Washing must be done after each solution is mixed.*

### 8 | open the bleach packet

*Pour 11 ounces of water at 80° to 90°F. into the graduate. Cut the bleach packet without squeezing it. Keep the end away from the face. The powder can harm eyes and nasal passages.*

### 9 | prepare the bleach

*Pour the powder into the graduate and stir. Then add the "B" and "C" bottles of bleach. Mix well; add water for a total of 16 ounces. Pour into its bottle. Wash equipment.*

### 10 | prepare the fixer

*Pour 11 ounces of water at 70° to 80°F. into the graduate. Empty the bottle of fixer. Add water to make a total of 16 ounces. Store the fixer. Wash equipment.*

### 11 | prepare the stabilizer

*Again pour 11 ounces of 70° to 80°F. water into the graduate; empty the bottle of stabilizer. Add water for a total of 16 ounces. Stir until the chemicals are dissolved. Store.*

### 12 | put the bottles into a water bath

*Place the four bottles of solutions in a deep tray filled halfway with water at 100.5°F. This bath stabilizes the temperature of the chemicals near the level required for proper development.*

1 | negative-processing chemicals
2 | temperature control water bath
3 | color negative film
4 | film-cassette opener
5 | scissors
6 | developing tank reels
7 | developing tank
8 | photographic thermometer
9 | funnel
10 | plastic graduate
11 | timer

With the chemicals mixed and in their water bath *(top left, above)* the rest of the equipment for developing the color negatives can be assembled. This equipment is the same as that used for developing black-and-white film. Because tolerances used in color work are more demanding, however, equipment should be of good quality. For example, the developer temperature must not vary more than one fourth of one degree, so an accurate thermometer is essential. The type shown will meet that tolerance and also register any change of temperature almost at once—a handy feature when adjusting temperatures. An accurate timer is also a necessity. Since the same timer can be used for controlling the enlarger and for timing development, it makes sense to invest in one good instrument rather than two of lesser quality.

### 1 | open the film

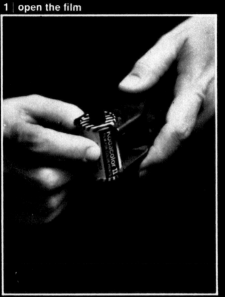

In total darkness, open the film container, popping off the end of a 35mm cassette with an opener. With other film types, remove the cartridge side or unroll the paper backing.

### 2 | cut the film end

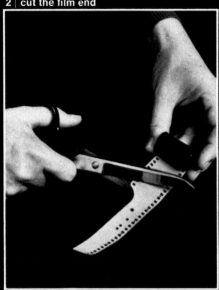

After removing the spool from its protective covering, use the scissors to square the end of the film if necessary. Put the scissors out of the way to avoid scratching the film.

### 3 | thread the reel

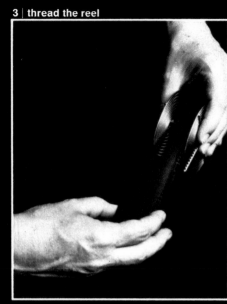

Holding the spool so that the film unwinds off the top, insert the end into the reel core. Make sure the reel is held so that the outer ends of its spirals are at top and face the film.

### 4 | wind the film

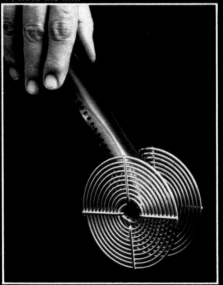

With thumb and forefinger, bow the film to let it slide onto the reel without scraping the sides. Slowly push the film so that the reel rolls forward, drawing the film into the grooves.

### 5 | put the reel into the tank

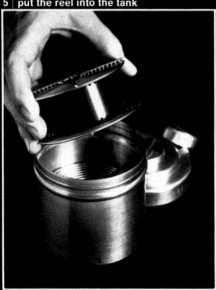

Put the loaded reel in the tank after making sure the film is on properly—each coil in its own groove. If developing one reel, use a blank spacer reel to hold the loaded reel in place.

### 6 | cover the tank

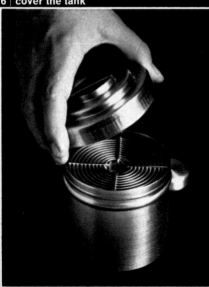

Place the light-tight cover on the tank. Lights may now be turned on. Put on the gloves.

### 7 | adjust the developer temperature

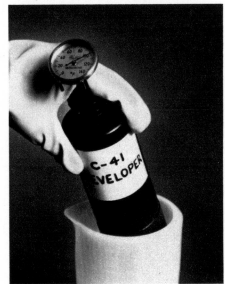

To get the developer to exactly 100°±¼ °F.
—this temperature must be held within one
fourth of a degree—put the bottle, with the
thermometer in it, into warm or cool water.

### 8 | fill the tank with developer

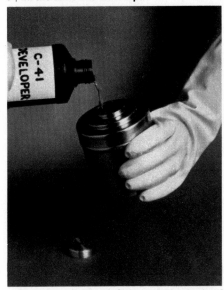

With developer at 100°±¼ °F., slowly pour into
the tank through the light-tight filler opening,
holding the tank at a slight angle to let air
escape and avoid splashing. Fill to overflowing.

### 9 | start the timer; dislodge air bubbles

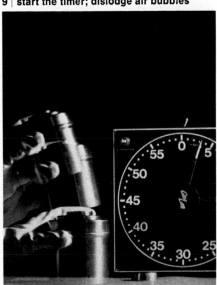

Start the timer, preset to three and a quarter
minutes, the developing time. Bang the tank
against the table a few times to dislodge air
bubbles that could cause uneven development.

### 10 | cap the tank

Place the cap on the cover's light-tight filler
opening so that developer cannot spill out of the
tank during the following step of agitation.

### 11 | agitate the tank

Use a gentle inversion motion to agitate the tank for 30 seconds. This keeps fresh solution in contact with the film, ensuring even development. Do one cycle per second.

### 12 | maintain 100.5°F.

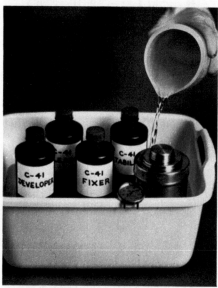

After the first agitation, put the tank in a 100.5°F. water bath for 13 seconds, then agitate again for 2 seconds. Add warm or cold water to the tray as needed to maintain the bath temperature.

### 13 | empty the tank

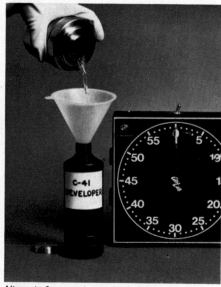

Alternate 2-second agitations with 13-second water baths until the end of developing time. With 10 seconds left, pour the developer back and return it to the bath. Wash the funnel.

### 14 | bleach the film

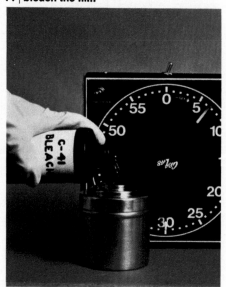

Fill the tank with bleach and start the timer that has been preset to six and a half minutes. Repeat procedures for agitation, and stabilize the temperature at 100°F.±5°F.

### 15 | empty the tank

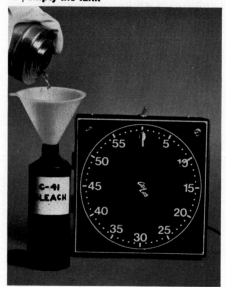

With 10 seconds left on the timer, pour the bleach back into its brown plastic bottle. Replace the cap on the bottle and put it back in the water bath. Wash the funnel.

### 16 | wash the film

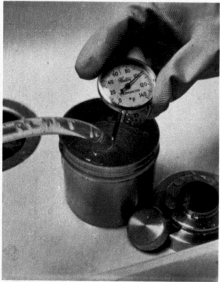

Open the tank and direct water from a hose into the center of the reel; water temperature should be 100°F.±5°F. Continue for three and a quarter minutes. Wash the cover, lid and funnel.

### 17 | add fixer

Fill the tank with fixer and start the timer, which is preset to six and a half minutes. Procedures for dislodging air bubbles, temperature control and agitation are the same as for bleaching.

### 18 | final wash

Wash the film for three and a quarter minutes, following the procedure used in step 16. It is important to continue to maintain the temperature. Shake the tank gently.

### 19 | add the stabilizer

Fill the tank with stabilizer and start the timer, which is preset for one and a half minutes. Pour the stabilizer back into its brown bottle. Cap the bottle and put it back into the water bath.

### 20 | dry the negatives

After opening the tank, direct water from a hose into the center of the reel. The water temperature should be 73° to 77°F. Continue for four minutes. Wash the cover, lid and funnel.

### tips for processing color

To adjust the temperature of a small bottle of solution, insert the thermometer and then hold the bottle under the hot or cold water faucet. For quick adjustment of the temperature of liquid in a tray, place a clean glass of hot water or ice water—whichever is needed—in the tray, and move it slowly through the solution, constantly checking the temperature until the desired level is reached.

Check the instructions that come with the processing chemicals for the drain time each step requires. For the C-41 process, for example, drain time is consistently 10 seconds.

The most common cause of streaked color film is incorrect agitation. Follow the rule for agitation exactly (step 11, page 178), taking care not to overdo.

To cover tiny scratches in the emulsion of a negative, rub a dab of petroleum jelly—Vaseline—lightly over the emulsion. The jelly will prevent the scratch from showing up in the print.

If regular darkroom gloves or household gloves are too heavy to allow as much dexterity as you need—particularly in making prints—try the thin gloves that surgeons wear. They cost about the same and are available at drug stores.

Luminous tape, sold in photo supply stores, affords a handy way to mark small objects you need to find in the dark: a timer switch, a cassette opener, a filter holder, a tray. Its glow is visible to the eye but too dim to harm photographic materials if used sparingly.

A plastic sheet, such as an old shower curtain, makes a liquid-proof, easily stored protective cover for the "wet table" in an improvised darkroom. It is easy to wipe clean—an essential consideration for color processing.

# Materials for Printmaking

The first step in preparing to make a color print is an odd one: take the printing paper out of the refrigerator. The paper has three delicate layers of gelatin emulsion that can be affected by heat, and it must be stored in the refrigerator at 50°F. or less. If there is room, it should be kept in the freezer compartment. The paper should be taken out, however, at least one hour before it is to be used so that its temperature can rise to room level. Then the sheets that are needed may be removed—in a darkroom—from the original package and placed in a separate container *(right)*. Before the package is returned to the refrigerator with the unused sheets. the excess air should be pressed out of the moisture-proof bag and it should be carefully resealed.

The time to take the paper out of the refrigerator is just before processing chemicals *(opposite)* are mixed; the mixing. plus setting up the equipment *(pages 184-185),* takes about two hours.

Although the number of containers of processing chemicals provided in the one-gallon Ektaprint 3 processing kit, on which the following procedures are based, may seem formidable at first glance, there are only three different solutions that have to be mixed. Some require more than one chemical. which accounts for the additional bottles. The chemicals are not hard to mix, but it is important to follow the proper order —as shown in the step-by-step sequences overleaf—for mixing solutions that have more than one ingredient. Like other color-processing chemicals. these must be handled with caution. Some are caustic. Heed warnings on the package, wear gloves and work in a well-ventilated room.

*Color printing paper can be removed (in darkness) from its moisture-proof foil wrapper after it has had time to warm up—the supply is kept in a refrigerator to prevent spoilage.*

*The sheets to be used are placed in a light-proof container until they are needed. An empty paper box—one marked "Unexposed" in large letters—can serve this purpose well.*

The chemicals from Kodak's one-gallon Ektaprint 3 processing kit, used to process the Ektacolor 37 RC paper selected, should be assembled on the wet side of the work table. In order of use (left to right) they are: three bottles of developer, two bottles of bleach-fix and a bottle of stabilizer.

The implements required to mix the chemicals include: a two-gallon plastic pail; two brown gallon bottles marked "bleach-fix" and "stabilizer"; two pint-sized bottles and three quart-sized bottles marked "developer"; a plastic graduate; a plastic stirring rod; a plastic funnel; waterproof gloves; a photographic thermometer; a viscose sponge.

**1 | pour water into the pail**

Wearing gloves, use the graduate to fill the mixing pail with three quarts of water at 80° to 90°F. Then fill the graduate with about 32 ounces of water and set it aside.

**2 | add the "A" developer**

After shaking the bottle of part "A" of the developer, empty it into the pail. Now rinse the bottle with water from the graduate and empty into the pail. Stir until uniform.

**3 | add the "B" developer**

Pour in the contents of the "B" developer bottle. Rinse the bottle well as in step 2 to be sure that all of the solution is used. Then stir the solution thoroughly until it becomes clear.

**4 | add the "C" developer**

Add the "C" developer, then pour in enough water to bring the total volume to one gallon. Stir thoroughly until the solution is uniform. It may have a somewhat hazy appearance.

**5 | fill the developer bottles**

Fill each of the five bottles to capacity. Since the pail may be heavy, dip the graduate into the pail for the first few bottles, and then pour as shown. Cap each bottle immediately.

**6 | finish filling the developer bottles**

To fill the last bottles, developer can easily be poured directly from the pail into the graduate as shown. Wash off the pail, graduate, funnel, stirring rod; sponge the surface of the table.

### 7 | mix the "A" bleach-fix

Fill the pail with two quarts of water at 80° to 90°F. and then add the "A" bottle of bleach-fix. Again, rinse the bottle well as in step 2. Mix the solution thoroughly.

### 8 | add the "B" bleach-fix

Add the "B" bleach-fix to the pail while stirring, and then once again pour in sufficient water to bring the solution up to a total volume of one full gallon. Stir until thoroughly mixed.

### precautions

1) The instructions and warnings that come with individual chemicals and appear on direction sheets should be read carefully before the chemicals are opened. Some people are allergic to the chemicals, which may irritate the skin or the eyes. And many of the chemicals are poisonous if swallowed or inhaled. If a solution spills onto the skin, wash the area immediately with an acid-type hand cleaner and rinse well with water. Gloves—rubber or plastic —should be worn, especially for mixing and pouring solutions and for cleaning the darkroom. Before removing gloves after each use, wash them with acid hand cleaner and water.

2) Keep all working surfaces, trays, tanks and other containers clean.

3) The quality and life of the processing solutions depend on their remaining free of contamination.

4) Do not mix chemicals in printing and processing areas: they can spot prints.

### 9 | fill the bleach-fix bottle

Pour the bleach-fix into its gallon bottle and wash the implements. (To assure smooth flow of the liquid, a stirring rod may be placed in the bottle neck with the funnel so air can escape.)

### 10 | mix the stabilizer

Pour three and a half quarts of water at 80° to 90°F. into the pail. Pour the stabilizer into the water. Add water to make one gallon. Stir until uniform. Pour the mixture into its bottle.

# Making the Print: Equipment

With the preliminaries out of the way—negatives developed, the chemicals mixed and paper removed from the refrigerator—the darkroom can be arranged for making color prints. All the necessary items (plus a couple of highly desirable accessories such as an antistatic brush, and a focusing magnifier) are shown on the opposite page. Clustered to the right are "wet side" materials—chemicals and the things that are needed to work with them; these should be laid out near the sink. "Dry side" items, around the enlarger, should be kept far enough away to prevent contamination by the chemicals. The timer, set between the two groups, will be used both for controlling the enlarger and later for timing development of the prints.

Only two pieces of equipment are extras not required for black-and-white processing but needed for color work: a piece of heat-absorbing glass for the enlarger and a set of color filters.

The heat-absorbing glass is necessary because color negatives and color filters can be damaged by even small amounts of heat. The light beams of many enlargers give off enough warmth to cause harm unless a heat-absorbing glass is used. A pale green, the glass also provides some color correction. It is installed in the enlarger used in this demonstration by lifting up the lamp housing and simply laying the glass on top of the condenser lens.

A voltage regulator is sometimes a necessity because most household current varies a bit in voltage from time to time. A deviation of five volts will cause a change in the color of the enlarger light—and a discernible error in the color of the print being made. The voltage regulator is an electrical device that compensates for such deviations. The regulator is plugged into the wall outlet; then the enlarger is plugged into it and the regulator keeps the current close to the desired voltage.

The type of color filters needed depends on the enlarger. If the enlarger is like the one shown and has a built-in drawer for holding filters between the lamp and negative, the relatively inexpensive acetate type (called "Color Printing" or "CP" filters) can be used. Any number of filters can be combined to create the color balance desired.

If the enlarger, like most older models, does not have a filter drawer, however, it must be fitted with a filter holder attached below the lens. In this position, acetate filters cause optical distortions. Gelatin filters, optically corrected to avoid distortions, must be used. They are called "Color Compensating" or "CC" filters, and are slightly more expensive. Not more than three or four of these "CC" filters should be used at one time.

But use as few filters as possible to obtain the color desired. Each piece of gelatin, regardless of its density, cuts down exposure by about ten per cent. In addition, each filter collects dust, thereby causing a loss of sharpness, and interfilter reflections can cause flare. Therefore, the filters should be kept clean and flat.

The use of filters is the only thing that really sets color printing apart from black and white. The chemical processing is much the same, although there are several more steps, some of which demand a great deal of exactitude.

1 | **color-print paper and containers**

2 | **enlarger**

3 | **timer**

4 | **print-developing chemicals**

5 | **plastic funnel**

6 | **viscose sponge**

7 | **plastic graduate**

8 | **waterproof gloves**

9 | **photographic thermometer**

10 | **two 8 x 10 trays and one 11 x 14 tray**

11 | **color negatives in glassine envelopes**

12 | **test-wedge masking card**

13 | **enlarging easel**

14 | **focusing magnifier**

15 | **heat-absorbing glass**

16 | **antistatic brush**

17 | **color filters**

18 | **scissors**

19 | **contact printing frame**

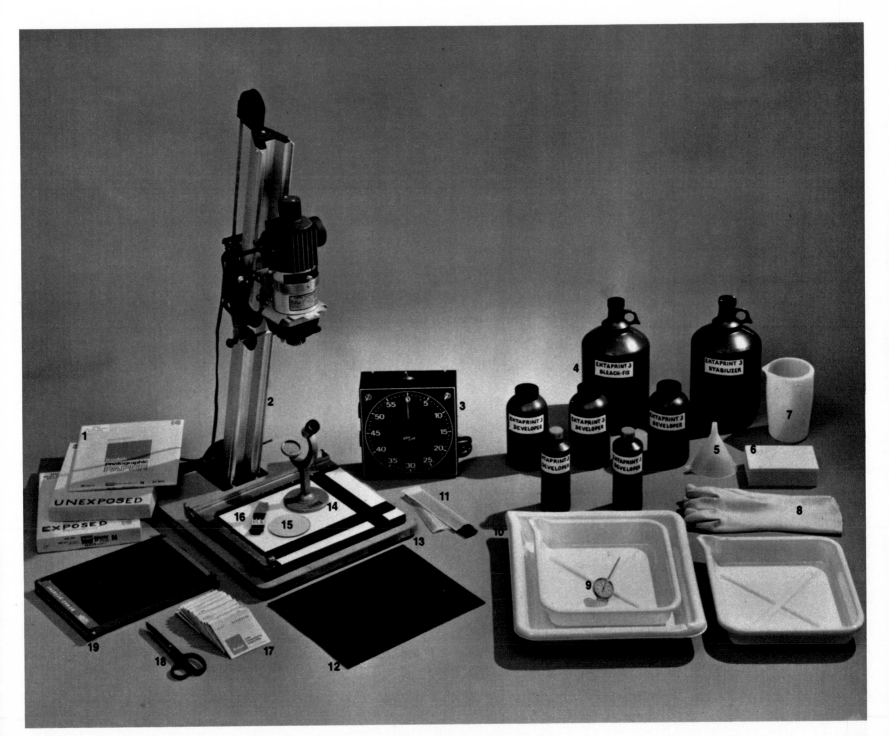

# Balancing the Enlarger for Color

Once everything else is ready, it may be tempting to start right in making the first print, or to make a contact sheet of the newly developed negatives. To get off on the right foot, however, preliminary test prints are essential. The main purpose of the tests is to adjust the color of the light from the enlarger. This is necessary because the enlarger light is one of three basic elements—the others being the negative and the paper—that determine the final colors in the print. Both the film and the paper are made with standardized dye chemicals, and therefore the color of the enlarger light must be balanced to work properly with them. This balancing is done by placing colored filters in the enlarger's light beam. To find the right filters for a particular enlarger (even two enlargers of the same model rarely give off exactly the same color of light) at least three different combinations of filters, or filter packs, should be tried.

With the system devised for this book, nine test strips can be made in the time it usually takes to develop one print. These test strips, called test-wedges, will give information on basic exposure times as well as on filters (see diagrams on the opposite page). If none of the three combinations suggested gives satisfactory colors, variations of them may have to be tried, using the first round of results as guides to new filter and exposure combinations. Once the basic filter pack has been established only slight changes—to correct variations in the negative or the paper—will be necessary in the future.

Only three kinds of color filters are generally needed. One, a 2B ultraviolet-absorbing filter, is part of any pack; it takes care of the color distortion that would be caused by the small amount of ultraviolet radiation generated by the lamp. The other two are yellow and magenta, which, if combined in the proper densities, make corrections in any of the primary colors. The strength of color in the yellow and magenta filters is one of the factors that must be determined by testing. This strength is designated by a density number—the higher the number, the stronger the filter. For example, 20M means a magenta filter with a density designated 20; it is four times denser than an 05M filter. Filters of the same color strengthen the density of that color: 20Y+20Y gives the same density of yellow (Y) as a 40Y filter. The filters used in the following tests, made with a Kodacolor II negative shot outdoors, were: 2B, 10M, 30M, 50M and 10Y, 30Y and 50Y. For the final correction in the case illustrated, an 05Y filter was also needed. For indoor pictures a slightly different pack would be used. For future work you probably will need at least an 05M as well as 20M, 50M, 20Y and 50Y filters.

To make these tests, it is necessary to use for them a negative of good density and of a familiar subject (so that colors can be judged). Close-ups of people provide useful test negatives because it is easy to tell when flesh tones look natural. Photo supply stores sell standardized negatives for color testing (professionals sometimes call such a negative a "Shirley" after the model who posed for the original one).

|  | | |
|---|---|---|
| WHITE | CC | -10 M |
| LIGHT | CC | 00 Y |
| DATA | Ex. Factor | 70 |

*Because the color response of color-printing paper often varies slightly from batch to batch, manufacturers test each batch and, on the label of the box or package, list the filters that are generally needed to compensate. This is usually called white light data (because the print is made with white light from the enlarger lamp). The corrections needed usually are slight; the only change called for in the label above is the subtraction of a magenta filter with a density of 10, designated by the notation —10M. The notation 00Y means that none of the yellow filters (if any) in the basic filter pack need to be changed. The Ex. Factor (Exposure Factor) is a figure that is used, according to a formula given in the manufacturer's instructions, for computing the new exposure time necessitated whenever the paper's sensitivity to light varies from the average. The white light data is needed only when switching to a new batch of paper. It is not used for the preliminary enlarger-balancing tests described on the following pages.*

### first filter pack: 90M+90Y+2B

12 sec.

18 sec.

24 sec.

### second filter pack: 80M+80Y+2B

10 sec.

15 sec.

20 sec.

### third filter pack: 70M+70Y+2B

8 sec.

12 sec.

16 sec.

A different filter pack is used in test-exposing each of the three sheets, as diagramed at left. The negative image is projected on the easel. A piece of cardboard is then used to mask it for three different exposure times (as shown above and in step 4 on page 188). Expose the right-hand third of the first print for six seconds. Move the card a third of the way to the left and expose again for six seconds. Finally remove the card and give a last exposure of 12 seconds. Thus the first wedge receives a total exposure of 24 seconds; the middle wedge 18 seconds and the last wedge 12 seconds. Proceed in the same way with the next two sheets. The reason for decreasing the exposure with each new print is that the filters decrease in density, increasing the amount of light that hits the paper. Note that these factors—exposure times and filter packs—will vary with the film. Here we used Kodacolor II.

## 1 | cut the filters to size

Holding each filter by the edge, cut pieces to fit the enlarger's filter drawer. Cut enough for three sets, remembering to include one 2B piece.

## 2 | insert the first filter pack

Put the first filter pack (90M+90Y+2B) in the filter drawer. The 2B (ultraviolet) filter is always used. Start with this pack, bracketing the one suggested for use with Ektacolor 37RC paper.

## 3 | clean the negative

Using an antistatic brush, clean all dust off the negative. Then wipe the negative carrier, place the negative in it, emulsion (dull) side toward the paper, and put the carrier in the enlarger.

## 4 | open lens wide

To focus, set the enlarger lens to its widest opening. Note how many clicks the lens makes as it is turned to the widest stop from f/5.6—it must be reset to f/5.6 for the exposure.

187

The initial steps in the making of prints consist of focusing the image and exposing the test wedges. One handy shortcut is an easy-to-find mark, which can be made by putting a piece of tape on the enlarger column, to show where the enlarger head should be positioned to produce prints of commonly used sizes, such as 8 x 10 and 11 x 14.

Sharpness and exact exposure times are essential if the test results are to be conclusive. The steps can be carried out quickly even though the room lights are turned on between steps, making it easier to change filter packs and reset the timer for the second and third test prints *(step 8)*. Before the lights are turned on, however, it is imperative that the exposed and unexposed sheets of paper be placed in their lightproof boxes.

### 1 | adjust image size

*With the enlarger turned on, raise or lower the head until the image is the desired size—here 8 x 10 inches. The image can be projected onto a white easel or a sheet of plain paper.*

### 2 | focus the image

*Looking through a focusing magnifier, adjust the focus control of the enlarger until the image is sharp. Then stop down the lens to f/5.6, the aperture used to make the test prints.*

### 3 | mark the enlarger head position

*Put tape on the enlarger to mark head position for future reference. Mark the filter pack (page 187) on the back of a sheet of paper. Place it on easel, emulsion side up. Set timer.*

### 4 | expose the test prints

*Hold the mask over two thirds of the paper and expose the first wedge. Reset the timer, move the card and expose the other two wedges. Repeat test for other filters and exposure times.*

### 5 | store the prints

*Place each test print in the light-tight container as soon as it is exposed. It may "rest" for half an hour, while the reactions induced in it by light stabilize, before it is developed.*

While the exposed prints stabilize, the wet side of the darkroom can be prepared. If the enlarger timer is going to be used also for developing prints, it should now be reconnected to an outlet near the processing trays.

The temperatures of the chemicals should now be adjusted. The temperature of the developer is critical. It must be within a half a degree of the prescribed 88°F. during the three-and-a-half-minute development procedure. Therefore, it should be adjusted immediately before processing begins. All other chemicals have more latitude and can be processed at anywhere from 86° to 90°F., whichever is convenient, bearing in mind that the higher the temperature, the less time required. In the winter it will probably be easier to stabilize at the lower temperatures.

### 1 | check the bleach-fix temperature

Wearing gloves, place the bottles in the sink and check the bleach-fix temperature. Run hot or cold water in the sink to bring the bleach-fix and other solutions to 88°F.±2°F.

### 2 | fill the bleach-fix tray

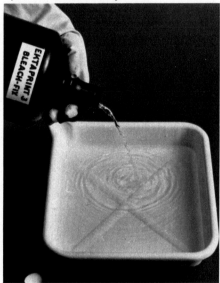

Pour the bleach-fix into one of the smaller trays —filling it about two-thirds full. Leave the other bottles in the sink with the water at 88°F.±2°F. Wash the thermometer and gloved hands.

### 3 | check developer temperature

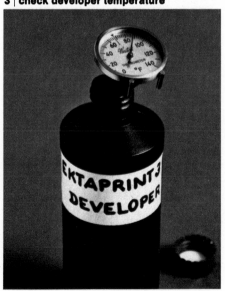

Dip the thermometer (be sure it is clean) into one of the developer bottles. If the temperature has fallen, raise it to 88°F.±½°F. by holding the bottle under a hot water faucet.

### 4 | fill the developer tray

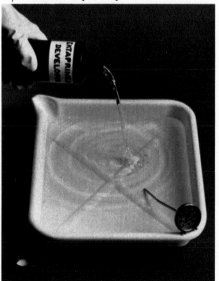

Pour the developer into the remaining small tray and check its temperature. Now, fill the largest tray half-full with water warm or cool enough to readjust the developer to 88°F.±½°F.

### 5 | put the developer tray in water

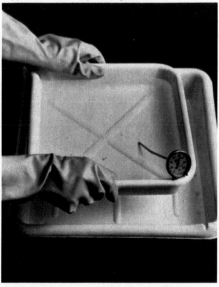

Gently set the tray of developer in the water of the large tray. Add more hot or cold water to the big tray if necessary to stabilize the developer at 88°F.±½°F. Wash the gloves.

The developer and bleach-fix should be used without delay, before the solution temperatures have a chance to change from the required levels. The two steps of developing and bleach-fixing take five minutes altogether and must be carried out with the room lights turned off. A number 13 (dark amber) safelight can be turned on for part of this time (three minutes maximum) if it is kept at least four feet from the paper. However, its illumination is so dim that it is of doubtful assistance. Since only two trays are used, and these are a few inches apart, working in total darkness should be no problem.

The only difficult procedure in the following steps is learning to interleave the three sheets of paper in the solutions while wearing gloves. But dexterity will come quickly with practice.

### 1 | snip a corner of the first sheet

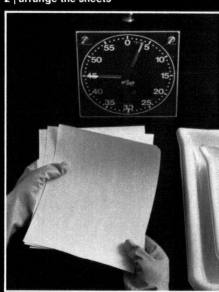

With lights out and clean gloves nearby, take out the test sheets and snip a corner off one. This marks it as the first sheet in; it must also be out first for uniform development.

### 2 | arrange the sheets

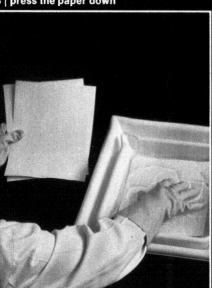

After putting the gloves on, arrange the three sheets like a fan, the clipped sheet on top and emulsion (glossy) sides facing up. Set the timer for three minutes, 45 seconds and start it.

### 3 | put clipped sheet in developer

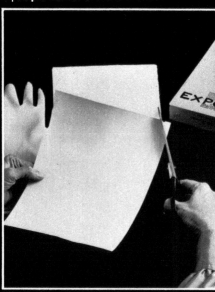

As the timer's second hand starts to move, take the top sheet (the clipped one) and in a sweeping motion turn it over and—as the hand hits 30—slip the sheet into the developer.

### 4 | press the paper down

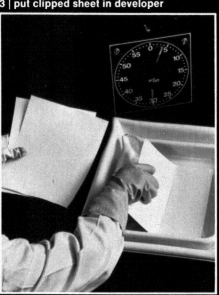

Press the sheet down so that it is completely covered by the developer. The emulsion side is now facing down and will remain this way during the rest of the developing and fixing cycle.

### 5 | agitate the paper in developer

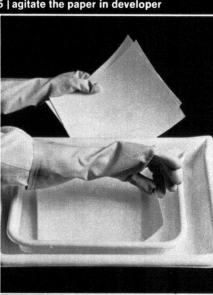

When the first sheet is immersed, gently grasp its top edge and agitate it back and forth for about five seconds. This and the previous step together should take about 20 seconds.

## 6 | immerse next two sheets

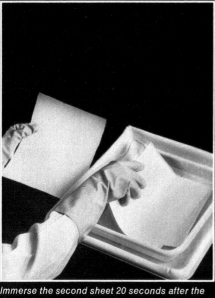

Immerse the second sheet 20 seconds after the first, agitating as before. After another 20 seconds, repeat with the last sheet. The sheets are now in order, the first one on the bottom.

## 7 | lift out the first sheet

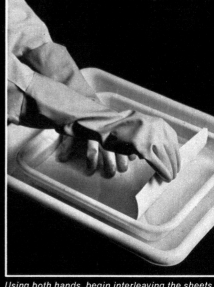

Using both hands, begin interleaving the sheets. To start, press down with one hand to prevent sliding. With the other hand grasp the bottom sheet by one edge and tug it out of the pile.

## 8 | put the first sheet on top

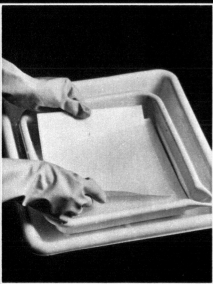

Holding the just-removed sheet lightly by opposite edges, reimmerse it, without draining, on top of the pile. If the sheets stick together, don't panic; take the time to coax them apart.

## 9 | press the reimmersed sheet

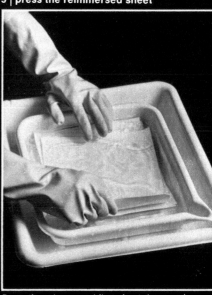

Press the reimmersed first sheet down and agitate (step 5). Then methodically interleave the other sheets, keeping track of the order by feeling the clipped corner of the first sheet.

## 10 | finish development

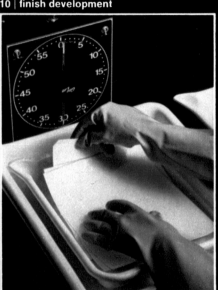

During the last 30 seconds of the three-and-a-half-minute development, find the clipped sheet. Continue interleaving so that this sheet is on the bottom as the time draws to a close.

## 11 | remove the first sheet

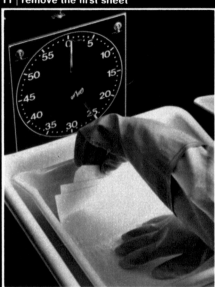

As the timer nears the end of the development period, pull the clipped sheet from the bottom of the pile with the left hand, using the right to steady the other sheets in the tray.

## 12 | drain the sheet

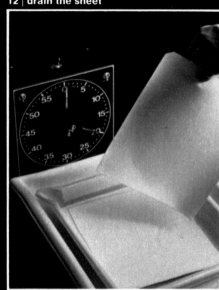

Start counting the seconds out loud to know when to remove the next two prints (i.e., at 20 and 40). Drain the clipped sheet into the tray for not more than 20 seconds.

## 13 | switch hands

Place the drained print in the right hand, close to the bleach-fix tray. Now confine the left hand to the developer, right hand to bleach-fix to avoid contamination of unfixed prints.

## 14 | bleach-fix the first sheet

Put the print into the bleach-fix tray. Repeat this hand-to-hand procedure, removing the second sheet from the developer after 20 seconds, and the third after 40 seconds.

## 15 | bleach-fix the other sheets

Bring both hands to the bleach-fix tray as soon as the third and last print has been transferred. Then set the timer for a minute and a half. interleave and agitate the prints as before.

As soon as the prints have had their one-and-a-half-minute treatment in the bleach-fix, the lights may be turned on for the rest of the processing. Unless the test exposures are completely out of line, images will already be apparent on the three sheets. Do not try to judge the colors at this point; they will still undergo some refinement in later solutions. Only the roughest estimate of exposure can now be made.

If the exposure is obviously and drastically wrong, discard the test prints, take fresh paper and start over with longer or shorter exposure times. Otherwise finish the tests and then decide what corrections should be made. The exposure times specified for these tests have been selected to cover as wide a range as possible and still give conclusive results.

The developer solution cannot be reused; it is poured down the drain after the processing is done. Each quart of developer develops three 8 x 10-inch prints before it is exhausted, so if prints or additional tests are to be made, a fresh bottle must be used each time. The other solutions last longer and are returned to their bottles for reuse. They process seven prints (8 x 10) before they are no longer usable.

### 16 | turn the prints over

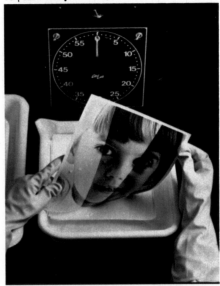

After the prints have been in the bleach-fix bath for one and a half minutes, turn them over, one at a time, so the now-visible image faces up. The room lights may now be turned on.

### 17 | empty the bleach-fix tray

Pour the bleach-fix solution back into its bottle, pressing the prints lightly to hold them in the tray. Cap the bottle and wash the funnel. Turn on water; adjust temperature to 88°F.±2°F.

### 18 | wash the prints

To wash away bleach-fix solution, run water into a corner of the tray for two minutes. Interleave the prints, draining the tray from time to time and allowing it to refill.

### 19 | pour in the stabilizer

Check the stabilizer temperature (88°F.±2°F.) and fill the tray about one-third full with it. Set the timer for one minute and interleave. Sponge and dry the print (as in steps 5 and 6, page 195).

# Making Prints from Transparencies

Chemicals for developing prints from transparencies, using Kodak's Ektaprint R-500 process, are shown in order of use (left to right): first developer, stop bath, color developer (three bottles), bleach-fix (two bottles), and stabilizer.

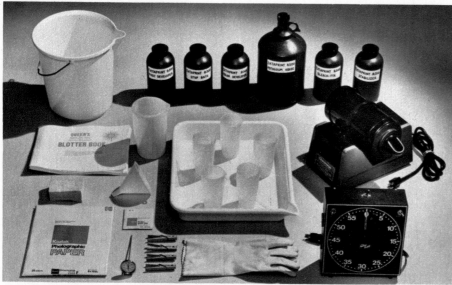

Implements needed for mixing the chemicals are: pail, five labeled brown gallon bottles, blotting paper, graduate, 11 x 14-inch tray, eight-ounce graduates, processing drum, agitator, sponge, funnel, Ektachrome RC paper type 1993, thermometer, clothes pins, gloves, timer.

Processing prints from transparencies at home has become increasingly popular because of new chemicals that need less developing time and higher temperatures. Even with a rudimentary darkroom, making prints from transparencies poses no real problem.

The most satisfactory method employs the Ektaprint R-500 chemicals developed by Kodak. Though trays can be used with the procedure shown with the Ektaprint 3 chemicals *(pages 182-183)*, making prints with the kind of drum shown here is more convenient. A drum permits working with room lights on immediately after insertion of the paper into the drum; it provides more even agitation; and it is both cleaner and less cumbersome. A motorized agitator further simplifies the process by leaving the hands free to adjust temperatures and prepare the chemicals for the next step. In order to cut down on expenses, however, the drum can be agitated by hand.

After gathering the chemicals *(top left)* and the implements *(bottom left)*, carefully mix the chemicals, applying both the general techniques illustrated in connection with the Ektaprint 3 process *(pages 182-183)* and the specific instructions included with the Ektaprint R-500 chemicals. Then pour the five solutions into the labeled brown bottles and set them in a water bath at 115°F. to allow for the cooling of the chemicals when they are poured into the tank. The correct temperature for processing is 110°F.

After balancing the enlarger for color *(pages 186-187)*, expose a sheet of color print paper *(page 188)* and insert the paper into the drum as shown in step 1 on page 195.

### 1 | load the drum

In the dark, remove the end-cap of the drum. Curl the exposed print, emulsion side facing inwards, and insert it along the paper guides. Replace the end-cap and turn on the lights.

### 2 | prewet the paper

Pour three ounces of 115°F. water into the spout of the drum that rests on the agitator. Set the timer for 30 seconds. Prewetting helps the developer flow over the paper.

### 3 | roll the drum

Plug the agitator cord directly into the timer. Turn the switch and let the drum roll until the timer shows 10 seconds. (All times of this process include a 10-second drain time.)

### 4 | empty the drum

Pour out the water. Following the 12 steps in the directions that come with the Ektachrome RC paper type 1993, repeat steps 2, 3 and 4 for all five chemical solutions (page 194) and washes.

### 5 | remove excess moisture

After rinsing off the stabilizer, put the print on an inverted tray and wipe both sides with a sponge. More moisture may be removed by placing the print between two blotting pads.

### 6 | dry the prints

Clip the print at the corners and hang it in a dust-free place. Depending on the humidity, drying may take from 20 minutes to an hour. A fan and heater can hasten the process.

# Making the Print: Achieving True Colors

With the 10M+10Y+2E filter pack, all three strips in this test print come out too blue. They, like the other tests, may be judged against the standardized reference strip below, which was prepared for this volume.

With 15M+15Y+2E filters the tests are closer. The center strip was judged the best of the nine, though still blue and too dark. A switch was made to 15M+20Y+2E and one second less exposure to make the final print (opposite).

With the 25M+25Y+2E filters the three test strips turn out to be on the reddish side. For the photographer who prefers the warmer skin tones in his pictures, this filter pack might be the choice for further adaptation.

*Too red: subtract magenta and yellow*

*Too green: add magenta*

*Too blue: add yellow*

*Too cyan: add magenta and yellow*

*Too magenta: subtract magenta*

*Too yellow: subtract yellow*

When making test prints *(top row, opposite)* first make sure they are completely dry. They then provide clues to aid in making a final print *(right)* that accurately reproduces the colors recorded by the negative.

Judge overall color balance by examining the sheets together in even light. In these tests, the sheet on the left came out obviously too blue, the one on the right too red. Compared with these, the middle sheet comes closest to pleasing, natural colors and its middle wedge appears to have the best color of all. It is so close, in fact, that further correction for final balancing of color may be hard to prescribe.

These last changes are best made by checking the best wedge with a group of pictures whose colors are distorted a known amount, such as the strip at the bottom of the opposite page. (This can be used as a reference for color balancing any enlarger.)

The reference strip's prescriptions show us the directions toward which filter corrections have to be made. We must add or subtract the color or colors of which we have too little or too much. The cure for a print that is too magenta, for example, is to decrease the magenta in the filter pack. More magenta in the light yields more magenta in the print. Similarly, the excess blue of the test wedge in the tests opposite is adjusted by darkening the filter that absorbs blue—the yellow filter.

The best test wedge is now used again to help find the correct exposure time. In the example used here, the best wedge was a little too dark, so the exposure was reduced by one second.

The final combination: 15M+20Y+2E with 15 seconds' exposure.

# Making the Print: A Contact Sheet

**1 | set the enlarger setting**

Check the tape on the enlarger (step 3, page 188) and raise the head slightly so the enlarger's light now covers the same area on the higher contact frame that it did on the enlarging easel. This change will not affect the exposure time.

**2 | process the contact sheet**

Follow the procedure for exposing and processing prints (pages 187-193). Since only one sheet is in the tray, agitation can be achieved by moving the paper back and forth every few seconds, at consistent intervals.

**3 | choose the best frames**

With a magnifier, go over each frame on the sheet and select those that appear likely to need the least correction for color and density. Identify them by circling their frame numbers with a crayon or with a grease pencil.

One of the best shortcuts to good color enlargements is the contact sheet, which shows all frames of a roll printed together. It provides a quick and economical means of selecting the negatives that will give the best results.

In black-and-white processing, making a contact sheet is the initial step. This cannot be done in color processing, for the enlarger must first be color balanced. The reason advance balancing is necessary becomes clear as soon as the first contact sheet is made. The sheet will, typically, contain pictures that were made at different times of different subjects, with different lighting and different colors. If the enlarger had not been balanced, even the pictures that had been correctly exposed in the camera would be off-color

on the contact sheet, and there would be no way of judging what kinds of color corrections each picture might need. Balancing solves this dilemma.

With the newly calculated basic filter pack, the enlarger will make a correct, or nearly correct, color enlargement from any negative that has good density and good color balance. Negatives that appear off-color in the contact sheet can be compared with their neighbors to determine what kind of color correcting they need.

With the basic filter pack and exposure time established, the procedure for making color contact sheets is exactly like that for making black-and-white ones. The negatives are placed in a contact printing frame with the color print paper. As always, the emulsions

—that of the print paper and that of the negatives—must face each other.

The enlarger is used as a light source to expose the entire contact sheet at once. To do this, the empty negative carrier is left in the enlarger, and the enlarger head is moved up a bit *(step 1, above)* to compensate for the slightly higher contact printing frame. This gives the light beam the same size and intensity as it had before, so the exposure that made the best test print can continue to be used. The same lens aperture, f/5.6, also is used. After being developed and dried according to the procedures that were used in processing the test prints, the contact sheet makes not only a guide for printing but also an excellent index and record of color pictures in a collection. □

# A Master of the Color Print

Using a fine-tipped brush, Dorothea Kehaya carefully applies a special watercolor to dust spots that appear on enlargements despite the care she takes in processing. Miss Kehaya examines the area around the spot with a magnifying glass to determine the touch-up color needed, then mixes the watercolors on a palette to obtain the desired shading. She advises beginners to dilute the color with stabilizer before applying—too much is hard to remove. Several layers of thin watercolor may be used to build up hues if necessary.

Dorothea Kehaya (left), is among those photographers who produce their own color prints. She has earned an enviable reputation as a professional photographer and printmaker despite the fact that she can seldom devote as much time as she would like to taking photographs or printing them. She has exhibited her work in many galleries —including New York's Metropolitan Museum of Art—and belongs to that elite group of photographers who sell individual prints to private collectors.

Miss Kehaya, gray haired, exuberant and quick witted, was born in New York City in 1925. She began studying painting while in her teens as a student at Manhattan's specialized public school, the High School of Music and Art, but soon turned to photography when a friend's work with a camera impressed her with the medium's ability to capture and interpret reality. For some years she operated a portrait studio that attracted many clients from the theater (the studio was her Manhattan apartment, the darkroom a closet). But eventually she abandoned studio work to concentrate upon the pictures she herself preferred. She now teaches photography at New York's School of Visual Arts, pouring as much time, money and effort as she can spare into picture taking and printmaking.

It is as a maker of color prints and enlargements that Miss Kehaya is now best known. Since her end product is an opaque paper print, she has made many of her most notable pictures on color negative film, which provides paper prints rather than transparencies. This choice of film in itself sets her apart from her colleagues, for color negative film is generally used by amateurs to make snapshots (most professionals, who shoot color mainly for reproduction in magazines rather than for exhibition, prefer the transparencies provided by color reversal film). But there is nothing at all amateurish about what Miss Kehaya does with color negative film. She makes the most of the many opportunities it affords for controlling the colors that appear in the final photograph.

Miss Kehaya performs every step of picture making herself. ("You don't ask someone to take your picture for you," she says. "So why ask someone to make your print?") But it is during the enlargement stage, when the combination of color filters in the "filter pack" (pages 186-187, 196-197) can be varied to adjust the colors of the print, that she exercises her artist's prerogative to emphasize some hues, change cool tones into warm tones and alter the balance of colors in the scene. Her technique is idiosyncratic; she makes the colors suit her taste and disregards, when she chooses, the standard procedures for balancing the filters in the filter pack. "It is not the color you saw that will necessarily make the most effective photograph," she explains; "it is the color that pleases you."

Miss Kehaya's manipulation of her colors is never violent, however; the results, while generally favoring the abstract beauty of color over literal detail, always render the hues of the natural world in a natural way. This mastery of color is demonstrated on the following pages, where a portfolio of Miss Kehaya's favorite pictures reveals her ability to infuse a variety of subjects with her own subtle melding of creativity and craftsmanship.

*Metallic Reflections, 1970*

*The shimmering gold, blue and silver reflections of passersby form semiabstract human shapes on the bent louvers of an auto radiator Dorothea Kehaya found abandoned on a New York City street. For this picture, she used a Micro-Nikkor lens, designed for close-up work, on her Nikon F. The enlargement was exposed for 15 seconds, longer than usual, to darken colors.*

*Intrigued by color blotches in the pavement at a New York City bus stop, Miss Kehaya aimed her Pentax H3$_v$ down into the street. A pale "skylight" filter absorbed some ultraviolet waves, normally present in daylight, which cause a bluish cast on overcast days. The tones were made warmer by enlarging with a filter pack that emphasized reds and yellows.*

*Bus Stop in New York,* 1968

*Groundcover, 1968*

*While photographing an extreme close-up of plants in her back yard, Miss Kehaya was struck by the subtle shades in the green leaves. The fact that she was unaware her subjects were actually sumac and poison ivy does not detract from the beauty of the print, which given a longer than usual exposure to create a darker effect, reproduces the rich greens she saw.*

*To capture the veiled quality of a landscape in a November rain, Miss Kehaya used a long exposure—½ second—with her Pentax H3v set on a tripod. This slightly overexposed the trees; their detail and colors were brought out in the enlargement by burning-in. Autumn tones were her goal, and these she delicately created with OOM OOY paper and a 30M 20Y filter pack.*

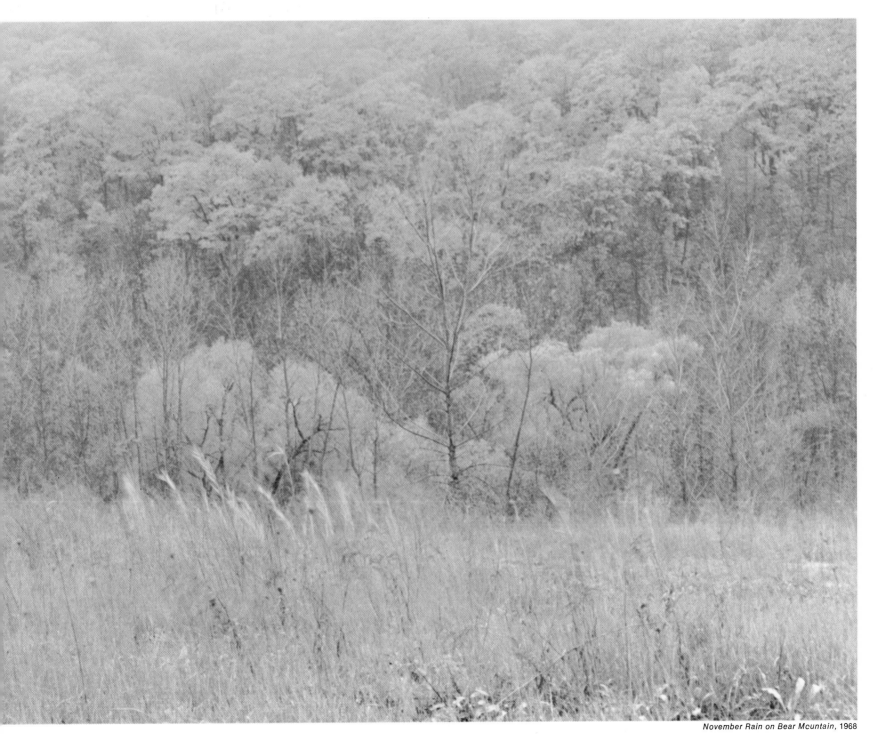

*November Rain on Bear Mountain,* 1968

*City Wall*, 1970

*Chalk smears on a masonry wall attracted Miss
Kehaya's attention because of the bright
hues and the scene the pattern suggested: a fir
behind a picket fence. The negative was
made with a Nikon F and a Micro-Nikkor lens;
the enlargement was produced with paper (00M,
00Y) and filters (30M, 20Y) selected to
reproduce the colors as naturally as possible.*

# A World of Synthetic Color 208

Tints Added by Hand 210

The False Hues of Infrared Film 212

Changing Colors to Opposites 214

A Machine to Alter Colors 216

Fantasy from  Sandwiching 218

Toning Black-and-White Images 222

Masking to Control Color and Image 224

Poster Colors from Plastic Sheets 226

Using Light to Add Color 228

The Startling Effects of Solarization 230

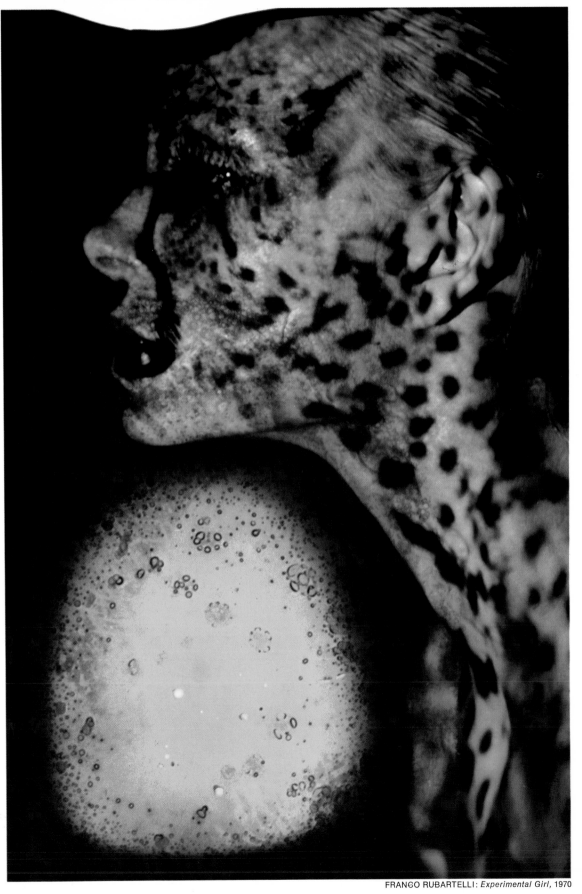

FRANCO RUBARTELLI: *Experimental Girl*, 1970

# A World of Synthetic Color

When humorist Gelett Burgess wrote in the 19th Century, "I never saw a Purple Cow, / I never hope to see one . . ." he obviously did not anticipate some of the more adventuresome color photographs of the second half of the 20th Century. A purple cow would certainly be unremarkable in a world that includes a blue lion, a magenta horse, a girl with a blue face and hair flecked with green and yellow, and a woman whose scarlet skull gleams inside a blue profile of her head, all of which may be seen on the accompanying pages. Nor is this flouting of realism restricted to the rendering of color. Images are distorted, combined in startling photographic fantasies, even mutilated. In some instances, film is literally cooked to achieve a desired effect. Before taking the picture that appears as the frontispiece of this chapter, Franco Rubartelli heated his film in a small pan on a stove for three or four minutes to change the emulsion's chemical response to color. After making the exposure and developing the film, he then used a match to burn away part of the emulsion. The result of these manipulations is the strangely spotted portrait of a pretty girl on page 207.

Although such techniques may seem bizarre, and some viewers may find the resulting pictures bewildering, the leading exponents of color manipulation are serious, creative photographers with little or no interest in shock value for its own sake. Nor do they disdain conventional color photography. (Almost all of them devote much of their time to "straight" photography; Rubartelli, for example, is a top fashion photographer in Italy.) And only with rare exceptions can their techniques be labeled experimental. Nearly all the procedures employed have been well known for years and have simply been adapted by the photographer to facilitate an intensely personal means of expression. Fred Burrell, a freelance photographer whose pictures appear on pages 226 and 227, explains his own manipulations of color simply: "A number of us have ideas that can't be realized by conventional techniques. Therefore we use others."

To create the pictures shown on the following pages, Burrell and the other photographers whose works are represented used techniques that range from the simple to the extremely complex. The oddly charming prints on page 210, for example, were made by hand-coloring the images—a technique that dates back to the Daguerreotype—and, in the case of one of the pictures, by cutting lines with a razor blade into the face. The cool blue nude dominating the darker blue-and-pink landscape on page 212 required nothing more complicated than a camera loaded with infrared color film, a type intended for scientific and military aerial photography, which turns ordinary colors topsy-turvy (it is very sensitive to blue light, and unless a yellow filter compensates for this the resulting pictures are predominately magenta). The reversed colors of pages 214 and 215 were obtained by processing

each transparency in the "wrong" developer—one meant for a different type of film. Still other color changes can be created by adapting techniques familiar in black-and-white photography: using color filters, sandwiching two or more pictures together to make a composite, reversing tones through solarization, or adding chemical dyes during processing.

Considerably more complex methods, however, achieve such strange color effects as those shown on pages 224 through 229. Producing them required meticulous timing and painstaking handling of materials and chemicals, and the application of several techniques in combination, such as dyeing and solarization. But many of them owe their appearance in large part to the process called masking, which gives the photographer wide-ranging control over the colors that will appear in his picture.

A mask does what its name suggests: it covers part of the picture or some of the colors to alter their appearance. It may be nothing more elaborate than a waterproof coating brushed over a section of image before a dyeing operation and afterward stripped off; the masked section, shielded against the dye, takes on none of the color that tints the rest of the picture. More often, however, the mask is a kind of photographic silhouette of the original image—a transparency that is made by duplicating the color original on high-contrast black-and-white film. It may be chemically dyed by the photographer to his taste. In its simplest use, the mask is superimposed over the original transparency (positive or negative) and the two are viewed or printed together, the blending of natural and man-made colors providing unusual effects. But in some cases, several masks are made, one from another in succession, and some or all are combined to produce a final result that is many steps from the original—and far distant from the world of natural color.

The arguments about the merits of using color interpretively instead of realistically in photography have been going on since the days of Louis Daguerre and William Henry Fox Talbot; the controversy will undoubtedly continue for as long as photographers feel strongly about the medium. But one has only to look at a picture like Fred Burrell's *Anxiety (page 227)* to recognize that the exponents of photographic surrealism are engaged in a powerful, if at times disturbing, means of expression, one that would be impossible to realize through conventional methods of color photography. □

# Tints Added by Hand

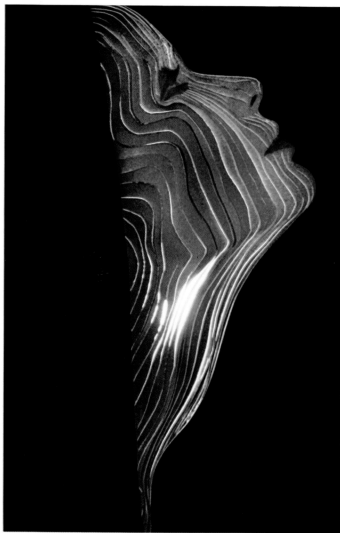

FRANCO RUBARTELLI: *Facial Contours,* 1969

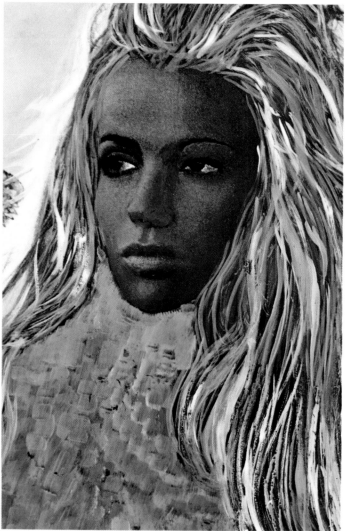

FRANCO RUBARTELLI: *Painted Colors,* 1968

A razor blade, marking crayons and food coloring helped transform two attractive girls into characters from science fiction, and imbued an old movie set with eerie mystery.

To create the pictures above, photographer Franco Rubartelli rephotographed hand-colored black-and-white prints. For the one at left, he first col-

ored the profile with marking crayon, next cut contour lines in the face with a blade, set a light behind the slits and then photographed the result on infrared color film through a blue filter. The other girl was simply photographed in black and white; the resulting picture was colored with watercolor, and photographed again on ordinary color film.

The Victorian façade opposite, a set for Alfred Hitchcock's movie *Psycho,* was photographed by Paul Paree on ordinary color film through a magenta filter. He later scraped off the emulsion from the image of a window—one in which the psychotic young man is seen in the motion picture—and tinted it with yellow food coloring.

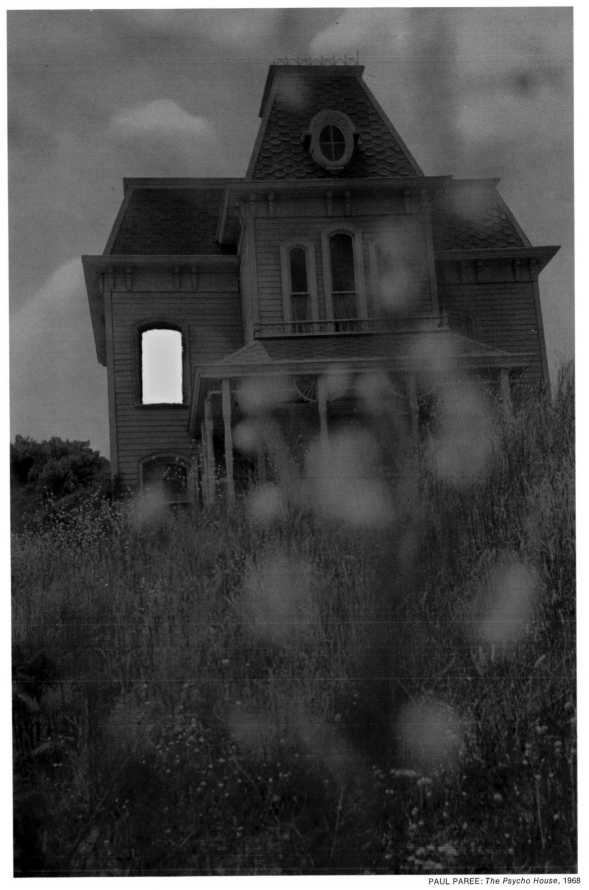

PAUL PAREE: *The Psycho House*, 1968

# The False Hues of Infrared Film

FRANCO RUBARTELLI: *Veruschka, 1965*

Countess Vera von Lehndorff *(above)*, known in high-fashion circles by her professional name Veruschka, is one of the world's most photographed models —but seldom in these colors. To add emphasis to the languorous, flowing quality of her form, Franco Rubartelli posed Veruschka, her body covered with heavy theatrical make-up, against a backdrop of an olive grove in Italy. Then he decided to add an element of cool sophistication by falsifying some colors with infrared color film. Normally, a yellow filter is used with infrared film to reduce its tendency to turn all colors magenta. Rubartelli, however, in an experimental mood, did not use a filter and, in addition, he shot at very high

TOM McCARTHY: *Blue Lion,* 1969

speed, a combination that led to the improbable colors shown here.

Tom McCarthy achieved a similar result in his picture of a lion at an animal farm in Florida. In his case, the odd color effects were even more accidental, for he had intended to use a yellow filter on his camera. But when the lion lunged for a piece of meat, McCarthy shot the picture before removing the green filter on his camera. That filter provided the startling blue shown here.

213

# Changing Colors to Opposites

By presenting colors as their "negative" complements—yellow for blue, cyan for red, magenta for green—Norman Rothschild makes lively abstractions from such ordinary scenes as a fire-hose pipe outside a building in New York City and a plot of tulips in the Brooklyn Botanic Garden.

The technique is very simple. Rothschild made both exposures on high-speed Ektachrome, film that is intended to be reversed during processing to produce positive transparencies. Instead the Ektachromes were developed in solutions meant for a quite different film that yields color negatives *(Chapter 6).* This not only made the colors on the film come out in their spectral opposites—the orange-red of the fire hydrant became green, the yellow tulips blue and the red tulips green—but reversed light and dark so that shadows became highlights and vice-versa.

NORMAN ROTHSCHILD: *Hose Connection,* 1965

NORMAN ROTHSCHILD: *Flowers*, 1964

# A Machine to Alter Colors

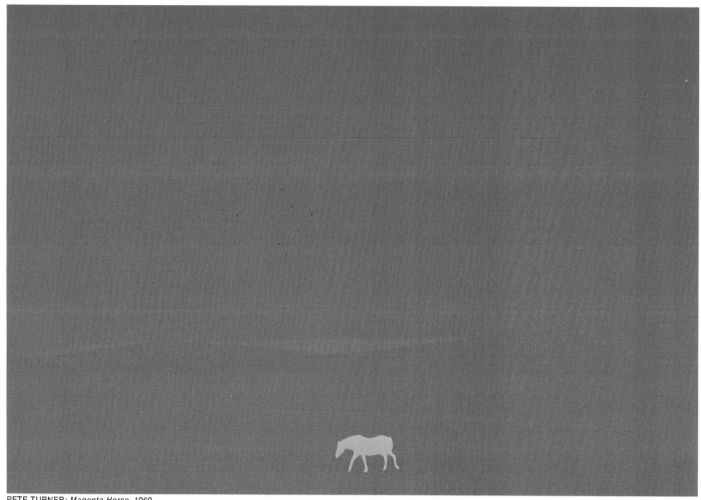

PETE TURNER: *Magenta Horse,* 1969

A lonely magenta horse almost lost against a limitless, fiery-red sky, and a menacing dark-blue cannon ball that dominates the somewhat lighter-blue scene of an Arab fort in Southeast Africa were created by the freelance photographer Pete Turner with the assistance of a color-slide duplicator.

A duplicator is simply a camera with which the photographer can make an exact copy of a transparency or, if he prefers, can increase or decrease the density and contrast of the image in the copy. When density and contrast are changed, the various colors are usually also altered. If the photographer wants to make major modifications of color, he places a color filter over the lens when making a copy.

Turner took the original picture of the cannon ball and fort at dusk with a blue filter over the lens and Kodachrome in the camera. But to generate the sense of power that is evident in the picture,

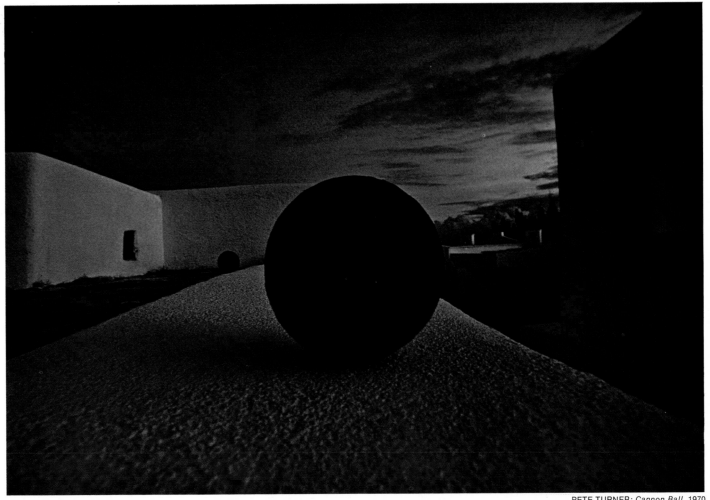

PETE TURNER: *Cannon Ball,* 1970

he increased its contrast by copying it —also onto Kodachrome film and also through a blue filter.

Making the picture of the horse was more complicated, requiring copying twice. Turner, who is known for his work in altering the colors of pictures, also made this original on Kodachrome film, using a blue filter. The horse came out black and the background blue. To make the striking version shown here, he placed that transparency in a color-slide duplicator and copied it on Ektachrome. By processing the Ektachrome as a negative *(page 214)* rather than reversing it to a positive transparency, he inverted the colors: the blue background became yellow, and the black horse a clear area. He now made a copy of the Ektachrome transparency on Kodachrome, using a magenta filter over the lens. The filter turned the yellow area red and gave the horse its lonely-looking magenta hue.

# Fantasy from Sandwiching

Sandwiching—or combining two color pictures to create a composite—was the technique used by Bill Binzen to send a man on an unlikely jaunt up the side of a building and to contrast a cold, dreary winter with burgeoning spring. The first of these composites was planned in advance, and both its pictures were taken with the idea of combining them. But the other sandwich suggested itself to Binzen when he was looking through his file of color transparencies.

One summer Binzen saw a grouping of four trees at the top of a hill in southwestern Connecticut. He remembered the scene and, the following winter when the ground was covered with snow, he photographed a man walking up the hill. That same winter he took the picture of the General Motors Building in New York City on a day when mist engulfed the top of the building. Then he combined the two 35mm transparencies to create the haunting composite photograph at right.

For the picture opposite, a photograph of New York's Jones Beach was also taken on a winter day when few people were about. The close-up of the hibiscus—whose red center provides a strange spot of color—was made in the spring. In this case, it is the contrast that makes the result so effective.

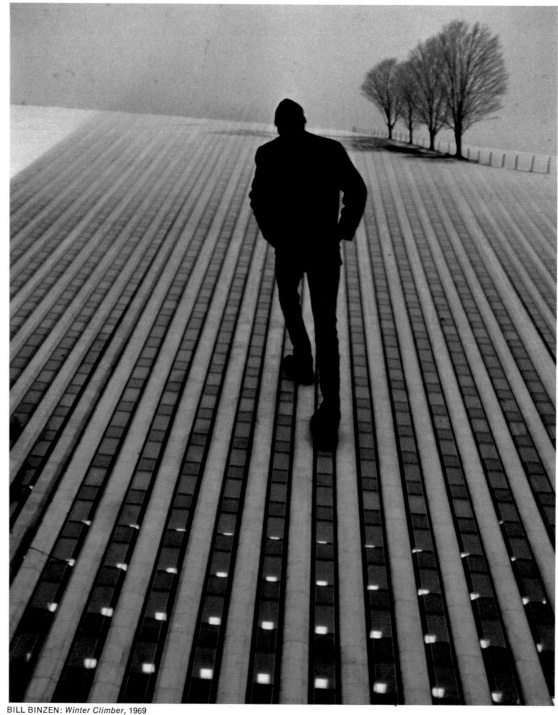

BILL BINZEN: *Winter Climber*, 1969

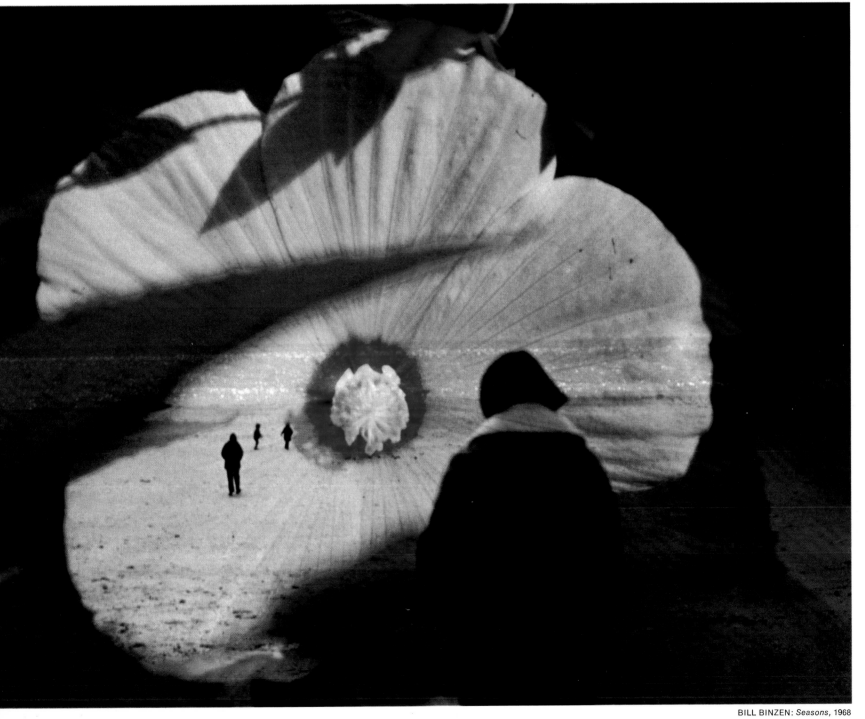

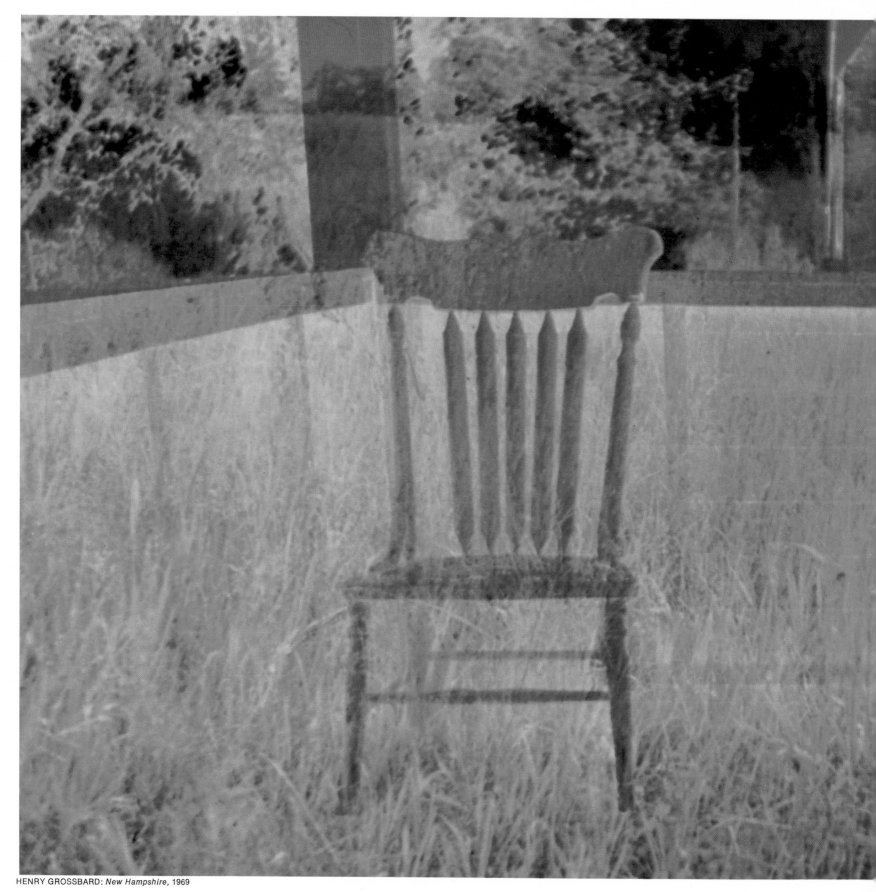

HENRY GROSSBARD: *New Hampshire*, 1969

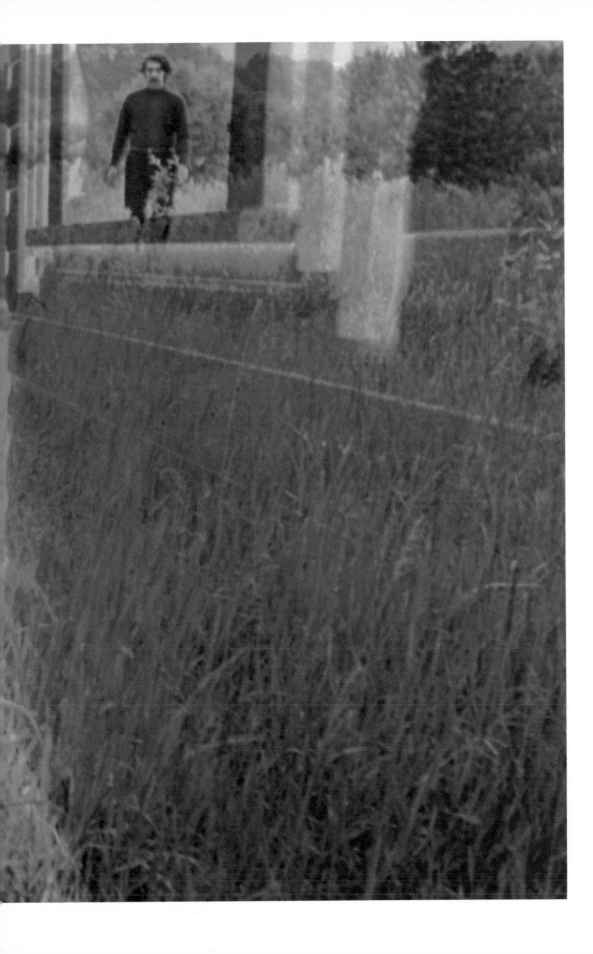

Henry Grossbard, who loves the old-fashioned countryside of New Hampshire, provided an unusual rural scene by sandwiching color with black and white. An Agfachrome transparency of Grossbard himself walking through a field (his wife clicked the shutter after he had composed the picture) was combined with a black-and-white negative of a farmhouse porch—contrasting the colors of outdoors against the cool monochrome of the interior.

The two pictures were not taken with the composite in mind. Grossbard had, however, been interested for some time in contrasting the realism of the color image with the less literal quality of black and white, the specific with what is only suggested. The two pictures he chose for this composite proved ideal for his purpose.

# Toning Black-and-White Images

Toning—adding color to a black-and-white print by placing it in a chemical solution—is a technique that dates back to the early days of photography, but it can produce wholly contemporary looking pictures when employed by such skilled photographers as Jerry N. Uelsmann and Naomi Savage.

Uelsmann, who produced the picture at right, began by making a paper print of two back-to-back sandwiched negatives of the girl's head, then a paper print of the house interior. A negative of the man lying in the sand was then printed, and before that print was developed, it was exposed through the two previous paper prints. The resulting black-and-white picture contained two negative images (the girl and the room) as well as one positive image (the stretched-out man). Next Uelsmann covered the image of the girl's face with rubber cement, a simple form of masking, and placed the print in blue toning chemical for five minutes. The cement-protected face was unaffected by the toner, but the rest of the print acquired a cold bluish tint. Finally he reversed that process, using a yellow toner to produce a gold face.

Mrs. Savage did not attempt to tone parts of her picture separately when she created the print on the opposite page. From a black-and-white negative, she made a paper print that was deliberately overexposed and overdeveloped in order to create deep, contrasting tones. This was then placed successively in blue, red and yellow tones, each additional color altering those introduced before. Since the process can be watched as it progresses, Mrs. Savage simply halted each stage when the color looked right to her.

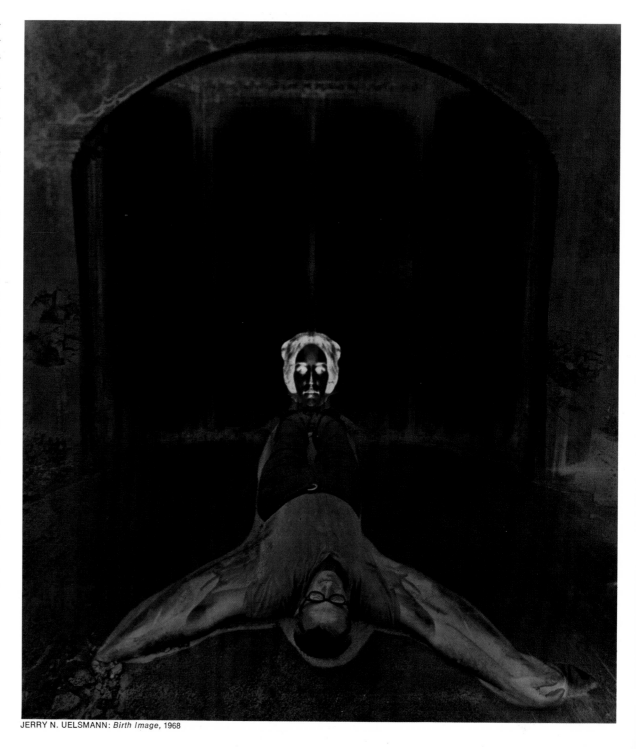

JERRY N. UELSMANN: *Birth Image,* 1968

222

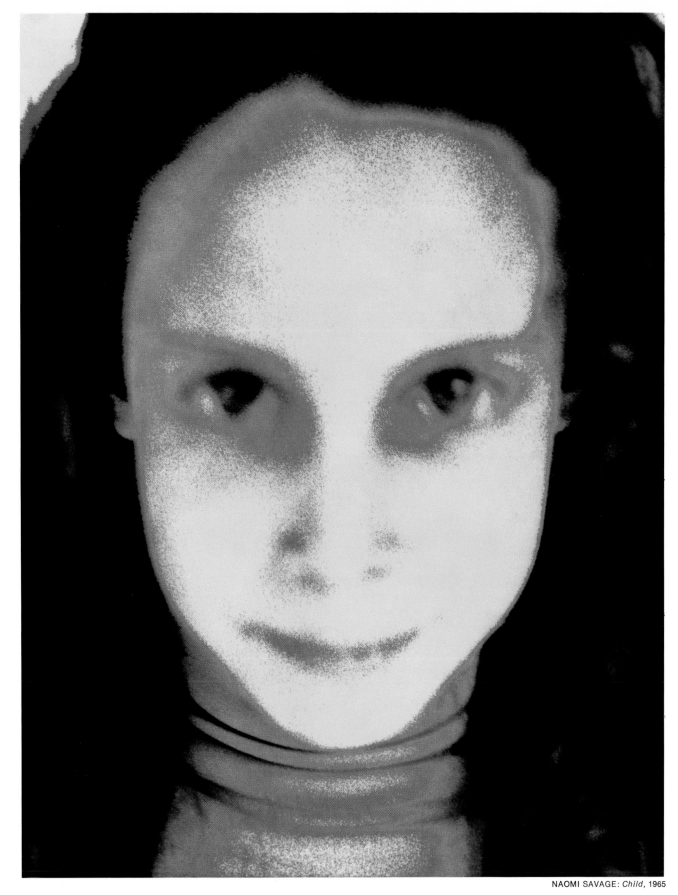

NAOMI SAVAGE: *Child*, 1965

# Masking to Control Color and Image

Masking gives the photographer his most effective tool for adjusting colors and images to his taste. He can spotlight an object of interest—such as the baseball fan and the bouquet shown here—and simultaneously he can lighten or deepen colors or even transform them to hues far from the originals.

For the picture at right, Robert Routh made one mask by copying the original transparency onto high-contrast black-and-white film. The original's brighter areas—sky and white house—became heavy black, while darker areas such as the bouquet and the porch light became clear. From this a positive transparency was made and bathed in acid to remove traces of image in the clear areas. This mask was dyed blue, the dye adhering only to the deposits in the darker areas. Then the dyed mask was sandwiched with the original: this provided the red and gold colors while transforming other background colors and permitting the bouquet to come through the clear portion unaltered.

A more complex procedure made the figure of a man stand out from a crowd. Three separate black-and-white masks were made: one from the color original, the second from the first mask, and the third from a sandwich of the second mask and the original. In mask number three—the "third generation"—the repeated printing on high-contrast film had greatly exaggerated the bright area of the shirt. This was still further enhanced by washing the mask in acid. The mask was then dyed and sandwiched with the original color transparency, producing a crisply colored, cheering fan isolated from the gold and blue haze of the passive crowd that surrounded him.

ROBERT D. ROUTH: *The Bouquet,* 1967

ROBERT D. ROUTH: *The White Shirt*, 1968

# Poster Colors from Plastic Sheets

FRED BURRELL: *Light Bulb*, 1967

The process Fred Burrell employed to produce these striking pictures is generally called posterization because the strong, bright colors it gives are reminiscent of those often used for the purpose of display.

For the light bulb that glows in a way no real bulb ever did, Burrell started with a black-and-white negative from which he made three positive masks of differing densities upon high-contrast film. The film's strong contrast eliminated most middle tones, leaving different transparent areas where color could later be added. Next, negative transparencies were made from each of these positives. At this point the colors were introduced by printing the negatives and the positives separately on sheets of a pigmented plastic called 3M Color-Key, which is insensitive to ordinary light but responds to ultraviolet light. It takes an image in any one of nine colors. Six Color-Keys—each a different color—were then superimposed for the final transparency.

The four-way composite on the opposite page, called *Anxiety* by Burrell, was made in much the same way—but required 34 separate black-and-white transparencies. Of the four original pictures (a window, a girl's back, a girl's face and a man's face), two were in color, necessitating the extra step of turning them into black and whites. Also, the size of each image had to be adjusted to fit Burrell's concept. Then groups of these were sandwiched and each of the four sandwiches was printed on 3M Color-Key separately. A tricky business, but one that Burrell brought off to convey the prison of tension and anxiety in which modern man often finds himself captive.

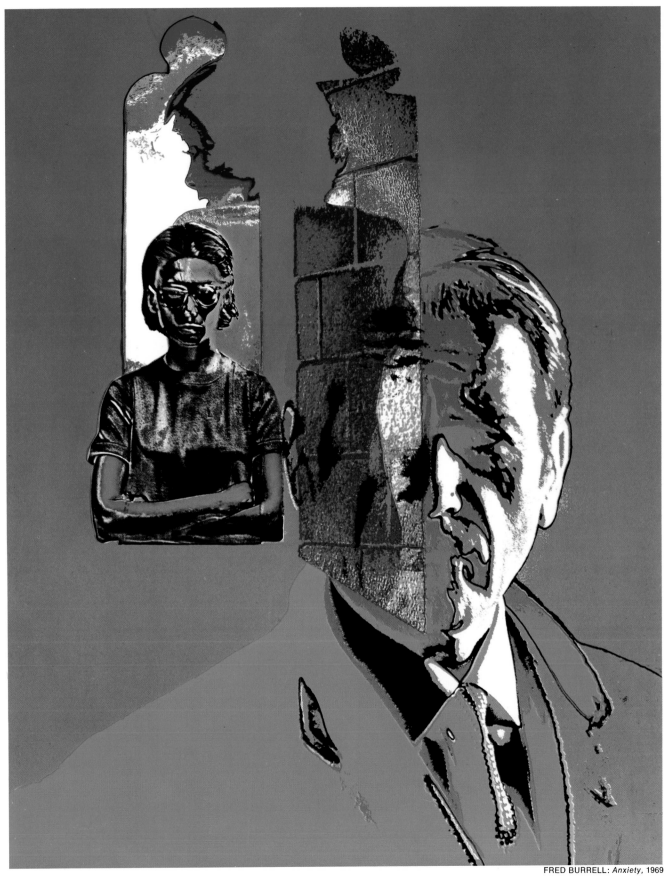

FRED BURRELL: *Anxiety*, 1969

227

# Using Light to Add Color

To obtain these strange, sometimes sinister, abstractions, John Svoboda combined black-and-white transparencies, ordinary color film and colored lights. For the portrait on the opposite page, for example, he began with a physician's X-ray of his wife's head, from which he made 4 x 5 copies, one positive, one negative, on high-contrast film. Then he took a silhouette of his wife with a 4 x 5 view camera and copied it on high-contrast film.

At this stage Svoboda was ready to add color. With two transparencies, one that showed a dark skull against a clear background and another one that showed a clear head against a dark background, Svoboda made a sandwich, laid it over a piece of Ektachrome film in a contact printer and exposed the film to green light. The result was a dark skull inside the head against a green background. Taking his third transparency—this one with a dark head against a clear background—and superimposing it over the unprocessed Ektachrome, Svoboda made another contact exposure; this time blue light was used to turn the head blue against the green. Finally the last exposure was made on the still unprocessed sheet of Ektachrome, using a transparency that showed a dark background and light skull. Red light was used and the picture achieved its ultimate form: a transparency of a red skull inside a blue head on a green field.

The other pictures shown here were made in essentially the same manner, using several generations of black-and-white transparencies printed singly and in pairs on color film, each exposure of the color film being made with a different hue of light.

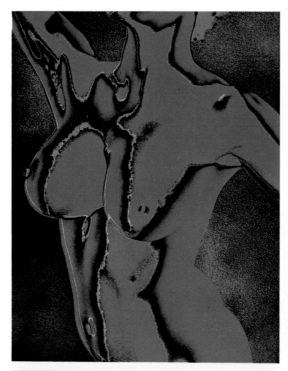

JOHN SVOBODA: *Experiments,* 1967-1969

JOHN SVOBODA: *Transparent Portrait*, 1969

# The Startling Effects of Solarization

Pictures of the peculiar African animal called an okapi often make it look vaguely like its relative, the giraffe —but when the photograph is solarized (that is, exposed to light during development), the okapi comes out looking like no other living creature on earth.

The okapi at right was photographed by Nina Leen in the San Diego Zoo. When she looked at the transparency later and noted the uncluttered background and the few dark shadows on the animal's body, she decided to see what effect would be achieved with the use of solarization.

In the TIME-LIFE Photo Lab a color negative was made from the transparency. As development began, the colors in the negative started to appear inverted to their complements—the natural reddish brown of the okapi's body, for instance, became a bluish green, and the yellowish-white head markings became blue. But this normal process was drastically altered after the negative had been in the developer for four minutes. A 10-watt lamp, covered by a yellow filter, was turned on for exactly 2/10 second to solarize the negative. This intensified several of the negative colors and changed others. After negative processing was completed, the negative was printed, turning the colors around again to give a fantastic okapi with a scarlet body and blue markings against a decorative background of blues and oranges. ☐

NINA LEEN: *Okapi,* 1970